Under Antarctic Ice

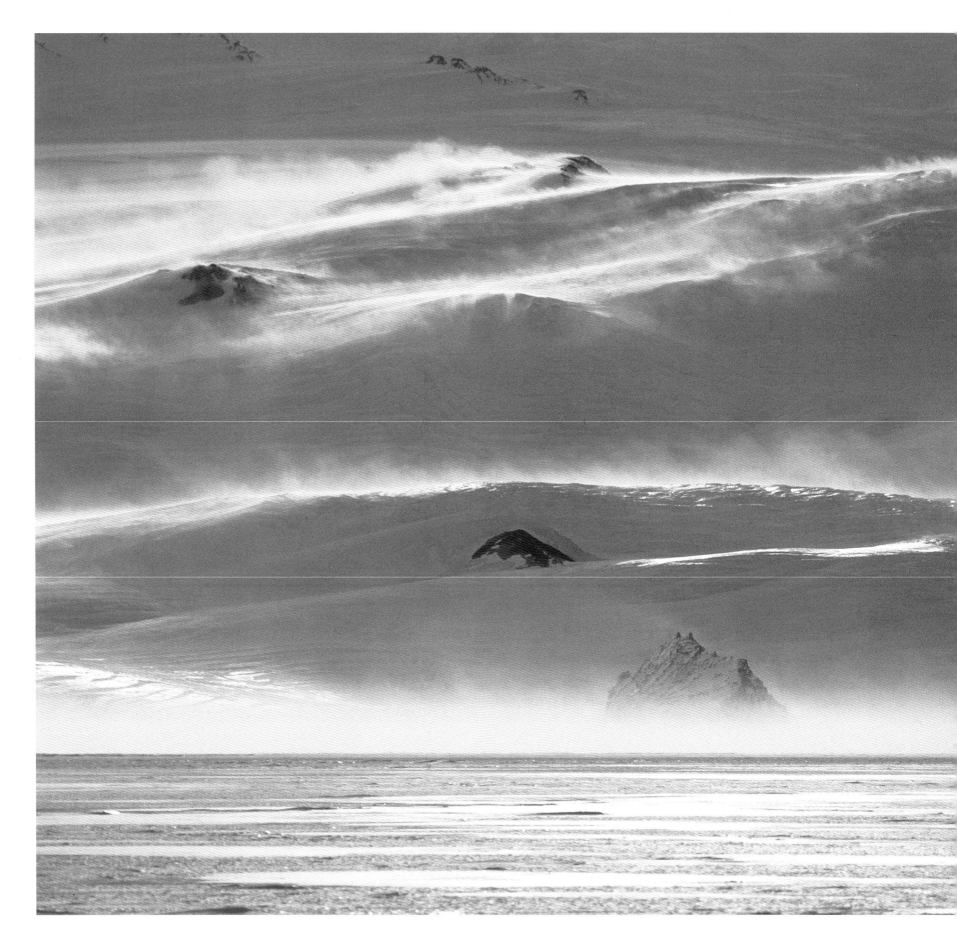

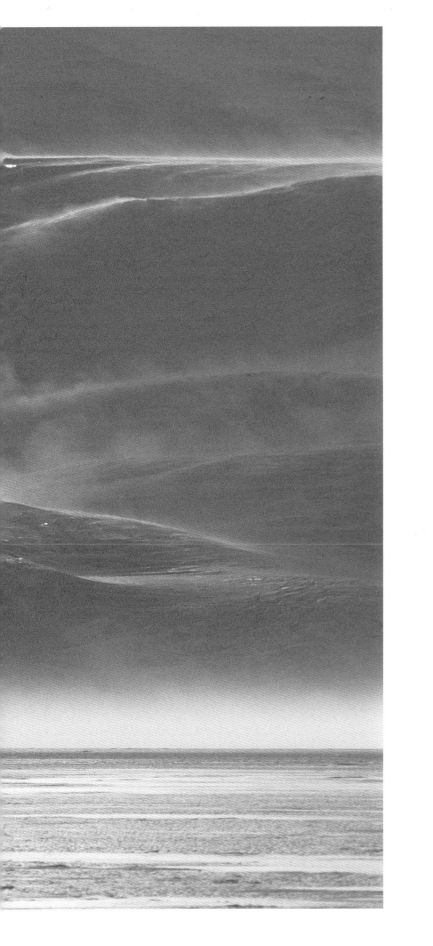

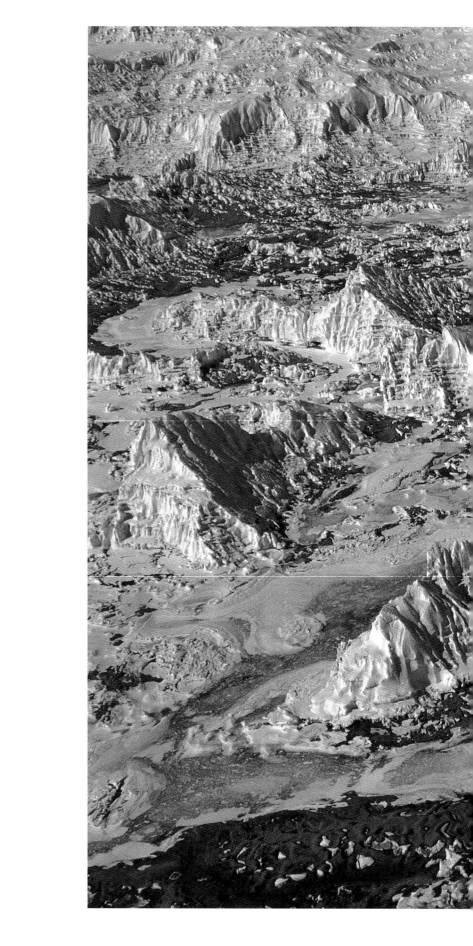

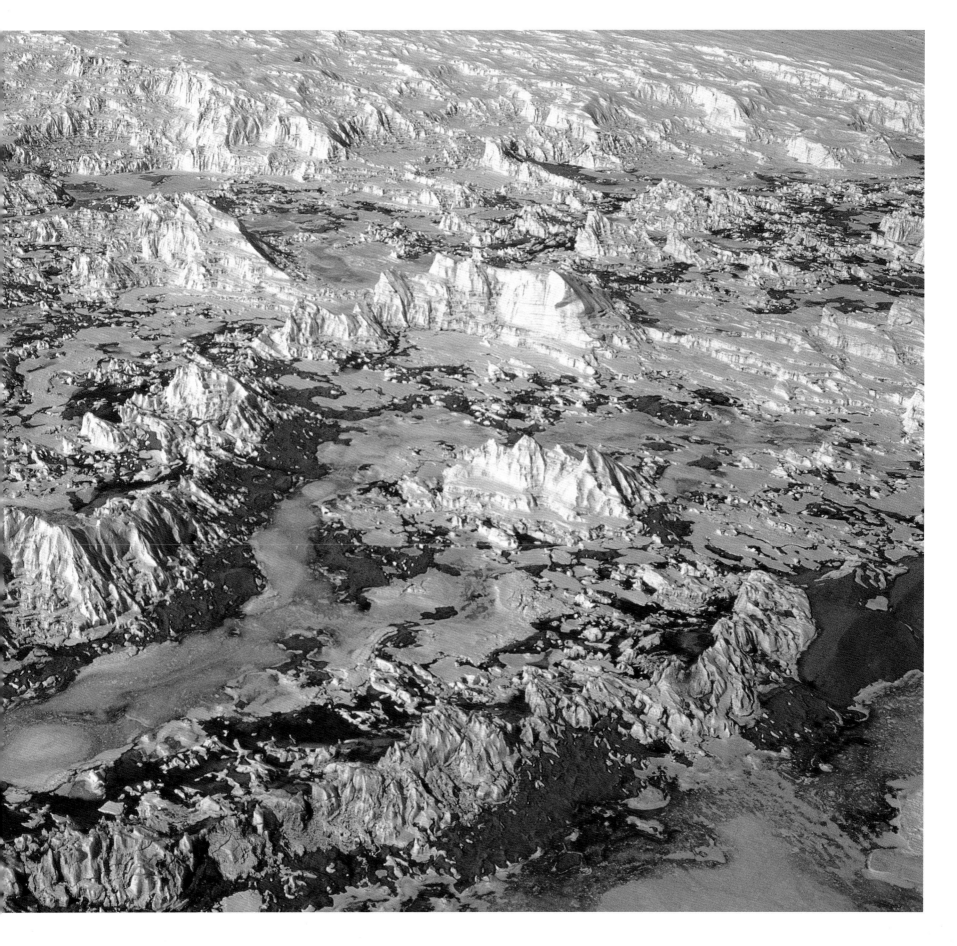

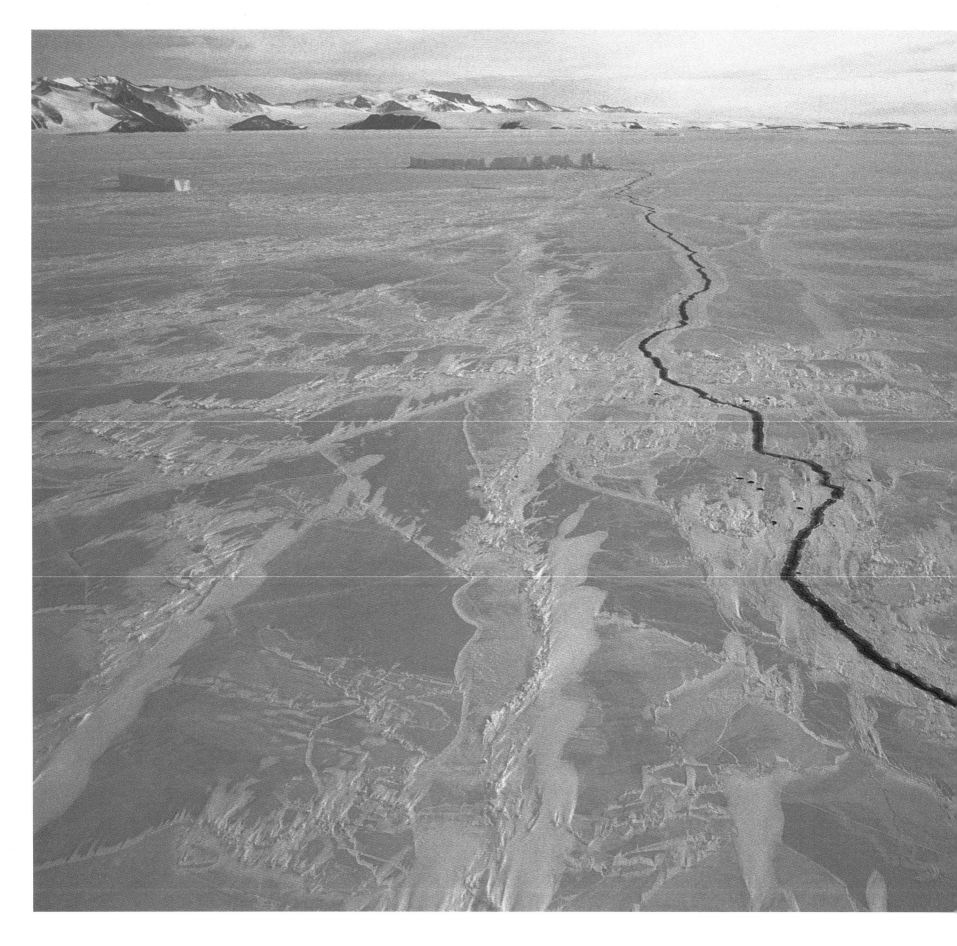

University of California Press BERKELEY LOS ANGELES LONDON

WITH TEXT BY Jim Mastro AND PHOTOGRAPHIC NOTES BY Norbert Wu Under Antarctic Ice

THE PHOTOGRAPHS OF NORBERT WU

IMAGES ON PREVIOUS PAGES: Little Razorback Island, a small island in McMurdo Sound, juxtaposed with the massive flank of Mount Erebus; the "Dirty Ice," McMurdo Ice Shelf; developing lead in the sea ice, Bay of Sails, McMurdo Sound; crack in sea ice spilling sunlight onto the seafloor, Granite Harbor.

OPPOSITE TABLE OF CONTENTS: Tabular icebergs, Cape Hallet.
OPPOSITE INTRODUCTION: Crevasse field, flank of Mount Erebus.
PAGE 10: Leading edge, Ross Ice Shelf, southern Ross Sea.

University of California Press

Berkeley and Los Angeles, California

University of California Press, Ltd.

London, England

Photographs © 2004 Norbert Wu. All rights reserved.

Text © 2004 Jim Mastro and Norbert Wu.

For information on licensing the photographs in this book, contact Norbert Wu Productions, www.norbertwu.com, fax 831-375-4319.

Library of Congress Cataloging-in-Publication Data

Wu, Norbert.
Under Antarctic ice : the photographs of Norbert Wu / with text by Jim Mastro and photographic notes by Norbert Wu.
p. cm.
Includes index.
ISBN 0-520-23504-5 (cloth : alk. paper).
1. Marine biology—Antarctica—Pictorial works. 2. Underwater photography. I. Mastro, Jim, 1953– II. Title.
QH84.2.W8 2004
779'.37'09167—dc21 2003006433
Manufactured in Singapore

13 12 11 10 09 08 07 06 05 04
10 9 8 7 6 5 4 3 2 1

To Beez Bohner, Peter Brueggeman, Christian McDonald,
Rob Robbins, and Dale Stokes: Thanks for the good times.

NORBERT WU

To all the Antarctic scientists who labor under difficult
conditions, often at great personal risk, in their efforts to unlock
the secrets of McMurdo Sound; and especially to Paul Dayton,
trailblazer of the Antarctic benthic community.

JIM MASTRO

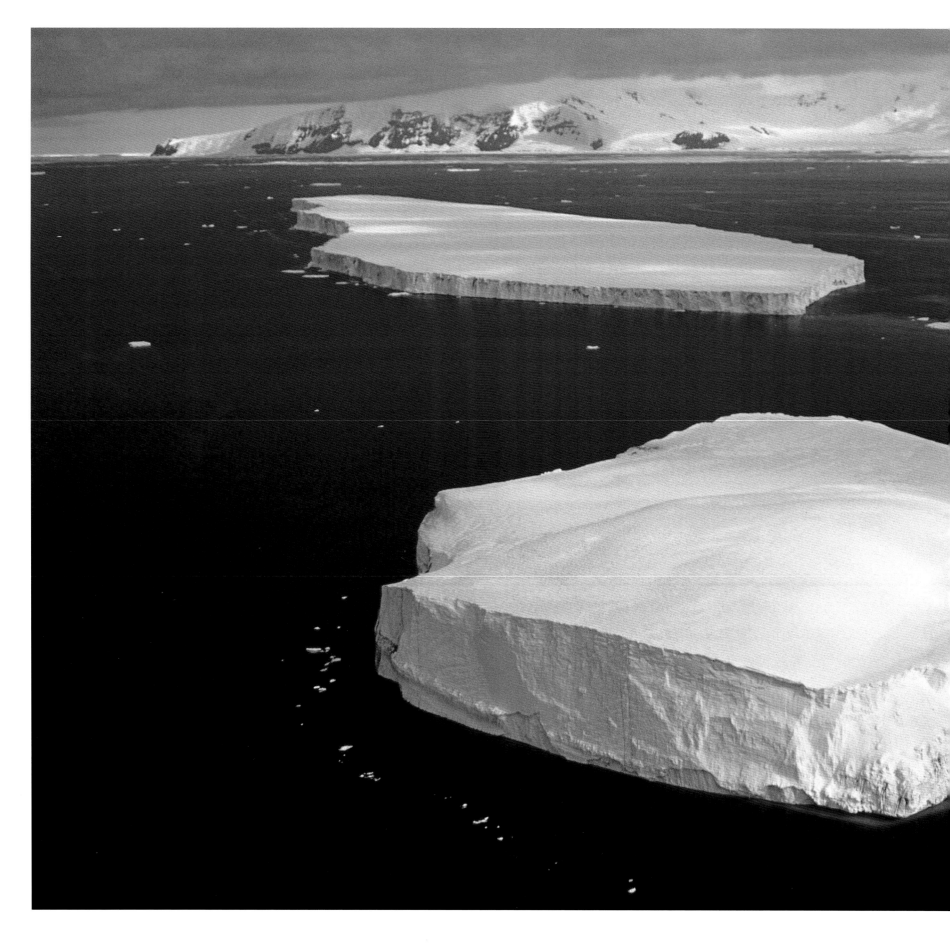

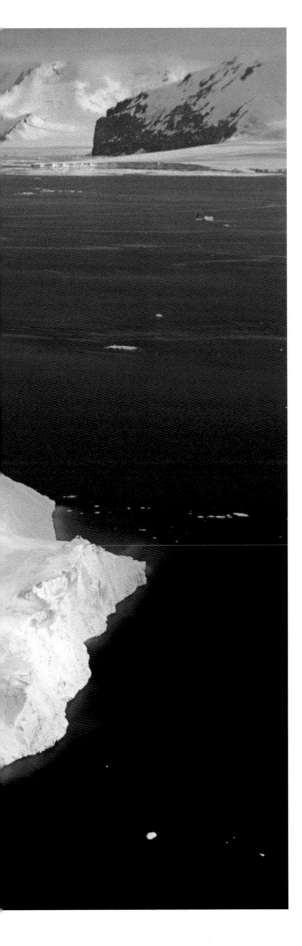

CONTENTS

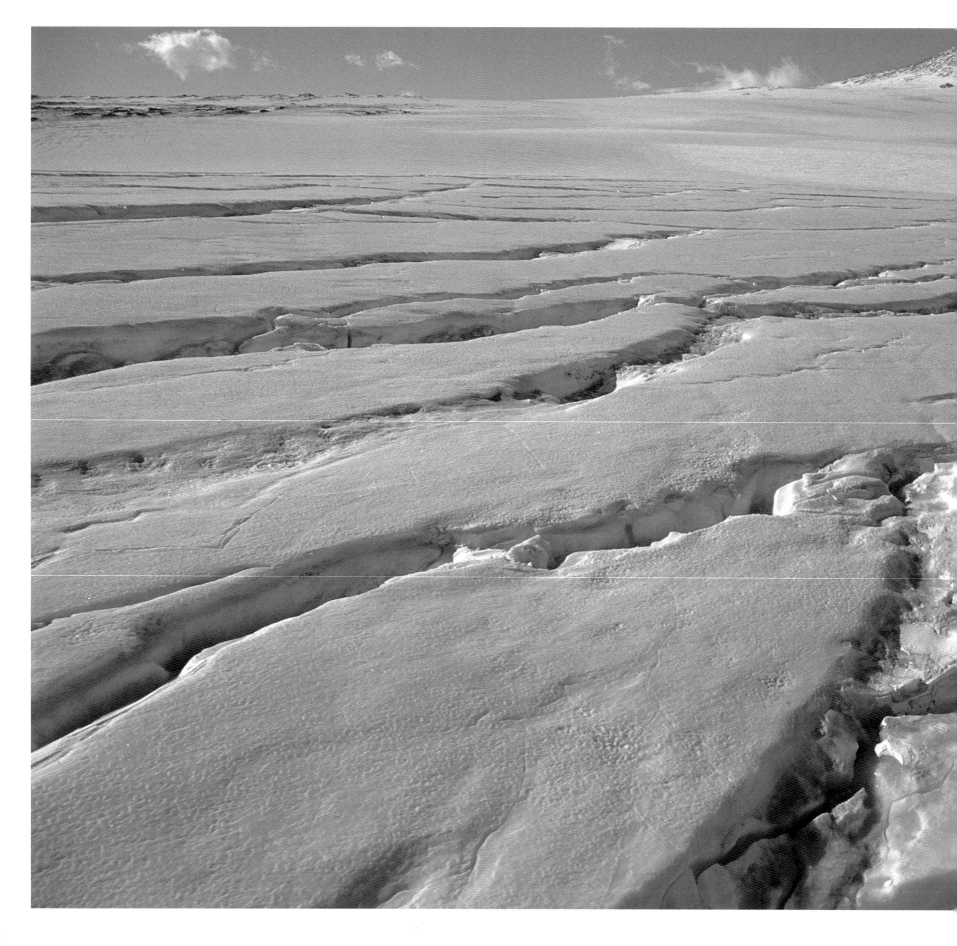

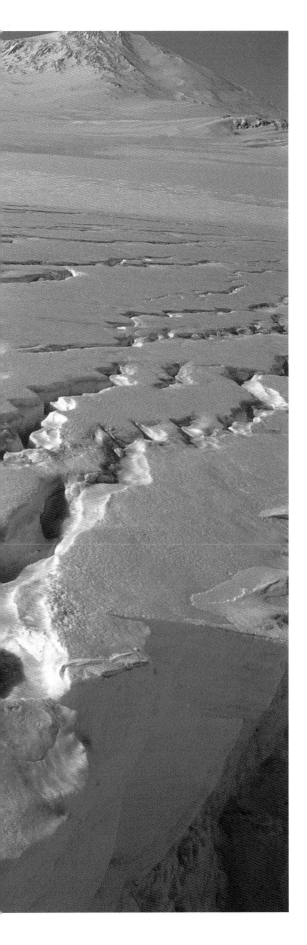

INTRODUCTION

From its ice-choked shores to its featureless and monotone interior, Antarctica is an unlikely candidate for the kind of attention humans have lavished upon it. There are no exotic spices, no virgin hardwood forests, no readily extractable mother lodes of gold and silver. Even the famous explorer James Cook, who circumnavigated the continent without seeing it and could only guess at its existence, ruminated that such an ice-covered, forbidding place was unlikely to be of much use to anyone. How surprised Captain Cook might be if he could see the Antarctica of today. Beginning with Carsten Borchgrevink's 1899 winter-over expedition and Captain Robert F. Scott's first assault on the South Pole in 1902, the southern continent has

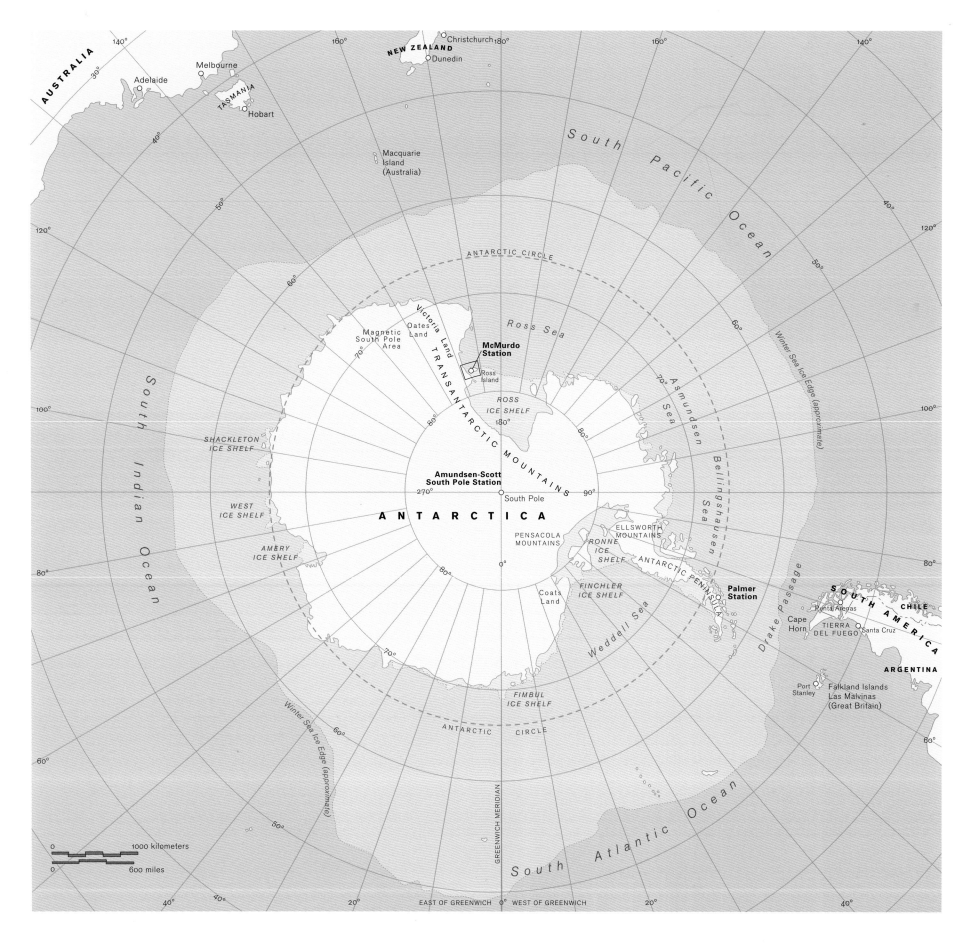

drawn people in increasing numbers. Today, while thousands of tourists cruise Antarctic waters, scores of scientists and their support personnel return to the continent over and over again, unable to resist its allure.

The nature of this allure, however, eludes precise definition. What is it about Antarctica that draws people like a magnet and refuses to let them go? Is it the pristine novelty of the place? Humans discovered Antarctica less than 200 years ago and only several decades later began to suspect its true size and continental status. Such an untouched and virgin land cries out for exploration. Or is the appeal based on the mind-bending realization that a place so immense is almost completely caked in ice?

The sheer scale of Antarctica is difficult to grasp. The numbers tell part of the story: at a bit over 13 million square kilometers (5 million square miles), the southernmost continent is larger than the United States and Mexico combined. But numbers are mere abstractions. Who can conceive in a meaningful way what 13 million square kilometers of ice means? An analogy might help.

Imagine flying from New York to Los Angeles, a distance of nearly 4,800 kilometers (3,000 miles). For five and a half hours, at 885 kilometers (550 miles) per hour, you look out of the tiny, round Boeing 767 window, and all you see is endless fields of ice. Occasionally, a lonely mountaintop pokes through the smothering white blanket, like an island in a frozen sea. Otherwise, only ice. As you approach Los Angeles, you notice that the Pacific Ocean, for as far as you can see from this high altitude, is white instead of blue. Your whole, once familiar world has been cloaked in ice.

If you take the three-and-a-half-hour trip by air from McMurdo Station on Ross Island to the South Pole, you get the same sense of immense scale, and no imagination is required. Massive, buried mountain ranges and plains of ice stretch to the far horizon, hundreds of kilometers away. And this is but a tiny fraction of the whole. It is not hyperbole to say that Antarctica feels like a completely different planet—not just another continent but an entirely new world grafted to the bottom of the Earth.

It is a world that assails the senses. To the human mind, reared and nurtured to its present form in verdant rain forests and on grass-covered savannahs, Antarctica defies logic. How can such a place exist? More to the point, how can a place be at the same time desolate yet rich with life, brutally harsh yet awe inspiring, austere yet almost in-

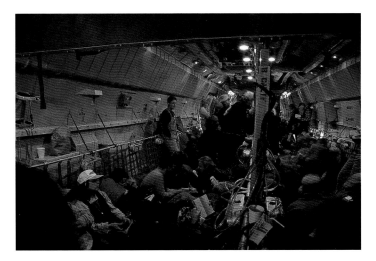

On the U.S. Air Force C-141 Starlifter jets that transport scientists and support personnel from Christchurch, New Zealand, to McMurdo Station, compressible ear protectors are supplied free of charge. Conversation is light to impossible. Meals are brown bags of cold sandwiches and canned fruit. In-flight entertainment consists of reading and adjusting one's position frequently on the cushion-free seats.

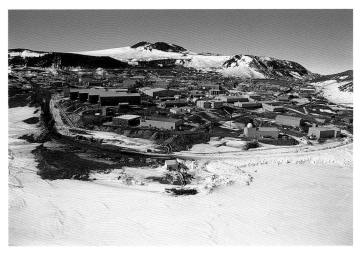

McMurdo Station, Ross Island, is not only the largest U.S. station in Antarctica, it is the largest station of any country conducting research on the southernmost continent.

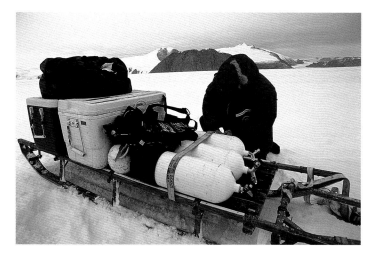

Scuba diving is an equipment-intensive activity anywhere, but it is especially so in Antarctica. Divers heading into the field must take with them shelter, food, emergency gear, and two-way radios in addition to their bulky dry suits, air cylinders, and other diving gear.

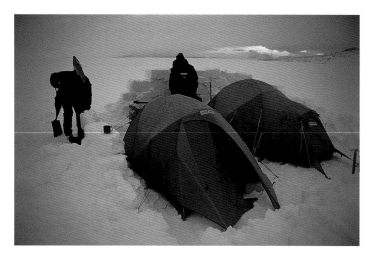

All scientific and field participants in the United States Antarctic Program must undergo snowcraft training, which includes cold-temperature survival techniques. At Happy Camper School, researchers learn how to construct snow shelters, set up a tent in a high wind, operate communications equipment, prepare food and melt snow for water, and properly package waste for later disposal.

describably beautiful? Antarctica takes your breath away. It is a crystal palace of glittering, terrible beauty and stunning vistas, regularly swept by storms of unbridled fury.

Perhaps it is these contradictions that draw people, or perhaps it is the beauty of the ice itself, a beauty different from any other on Earth. The low sun of spring and autumn splashes rainbow hues across an ice scape that obligingly reflects and refracts it, spreading a riot of color and illuminating the world in ways impossible elsewhere. Later, the high summer sun delivers glaring and almost painful brightness. The light penetrates every fissure and crevasse, where it turns into myriad shades of blue and purple.

Despite the allure, it's not easy to get to Antarctica, though it's considerably easier now than it once was. The early explorers braved deadly icebergs and even deadlier ice floes in fragile wooden ships, and most of them were unable to get close enough to the continent to go ashore. Many, like Ernest Shackleton, saw their ships and their dreams of Antarctic discovery crushed. Today, tourists make the journey in giant cruise ships, leaving the tricky business of dodging icebergs and uncharted reefs to experienced captains while they gaze in awe at the frozen, brittle world around them.

Most of these tour ships visit the Antarctic Peninsula region, that narrow finger that juts up toward South America. This is Antarctica's "banana belt," warmer than the rest of the continent, where accessible mammal and bird life abounds. A cruise ship can reach the continent and return in a reasonable amount of time. During the early years of exploration, most expeditions also aimed for the Peninsula, as it was a straight shot from Europe through the South Atlantic and into ice-caked waters.

Getting to high-latitude Antarctica was then, and is now, much more difficult. Cruise ships only occasionally make it to the southern Ross Sea and into McMurdo Sound, and only when ice conditions are favorable. Aircraft can fly over the treacherous sea ice, of course, but there are few places to land on the continent and even fewer places to refuel. The result is that most of the people who find themselves standing on the continent of Antarctica, especially high-latitude Antarctica, do so as part of a government program.

For U.S.-sponsored travelers, the journey begins in Christchurch, New Zealand, where the United States Antarctic Program (USAP) and the government of New Zealand have created a launching pad to the

frozen south. First, everyone is outfitted with the latest in extreme cold-weather clothing at the USAP's Clothing Distribution Center. This happens in a confusing, chaotic rush of parkas, thermal underwear, bunny boots, and gloves.

Next, scientists, support personnel, and official visitors (such as writers and photographers) board a ski-equipped LC-130 cargo aircraft or a C-141 Starlifter military jet (typically at an unreasonable hour of the morning). Neither plane is comfortable, but most people prefer the jet because the ride is three hours shorter. If a smooth ice runway for wheeled aircraft is not prepared, however, only the ski-equipped planes can land, which means an eight-and-a-half-hour flight in full Antarctic gear, jammed knee to knee in a thundering airplane designed to carry crates and vehicles rather than people.

Arrival at McMurdo Station is no less hectic nor less an assault on the senses. Passengers who embarked in the midst of New Zealand's lush greenness find themselves stumbling off the plane onto an alien Ice Planet, where the tissues in their noses freeze with every inhalation. Before they've had a chance to assimilate the startling newness of Antarctica, a bumpy and uncomfortable ride in a giant-wheeled bus delivers them into McMurdo Station and a whole new culture.

McMurdo Station is located on a rocky, volcanic promontory on Ross Island, at the southern end of the Ross Sea. It is the largest of three permanent research stations administered by the U.S. National Science Foundation's Office of Polar Programs. The other two are tiny by comparison. Palmer Station, on Anvers Island in the Antarctic Peninsula region, hosts a peak population of about 45 people, while Amundsen-Scott South Pole Station can accommodate around 200. McMurdo Station supports as many as 1,200 people at the height of the austral summer season. McMurdo also serves as the support hub for the South Pole and for a number of temporary field camps and expeditions. The vast majority of people who travel to Antarctica as part of the USAP go to or through McMurdo.

"MacTown," as the residents call it, has been aptly described as part military base, part college campus, and part mining camp. In the austral summer, all 1,200 people, from every imaginable walk of life, are jammed into an area the size of a large shopping mall, and all are frantically working to complete their jobs in the few short months before winter darkness closes in. At times, it seems like barely controlled chaos.

Orientation for new arrivals involves training in proper waste man-

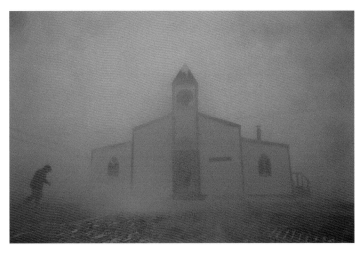

A United States Antarctic Program participant struggles through the wind and blowing snow in front of the Chapel of the Snows, the world's southernmost church building, at McMurdo Station.

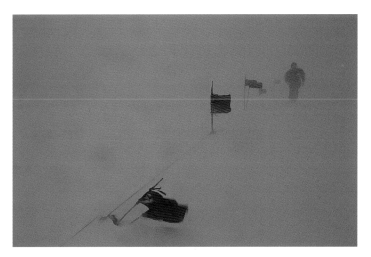

Spring storms are frequent at McMurdo Station. Bitter cold, high winds, and reduced visibility from blowing snow prevent scientists—and photographers—from going into the field to do their work, often for days at a time. Conditions are sometimes so bad that guidelines must be set up between buildings so people can walk from their dormitories to the cafeteria for meals.

An Adélie penguin *(Pygoscelis adeliae)* stands on the ice near a flagged road, in the shadow of Mount Erebus. Social birds by nature, when Adélies find themselves alone, they are typically drawn to dark, upright objects on the ice, perhaps because they assume the object is another penguin. Or maybe they are just curious. Either way, they seem surprised and confused to encounter things like flags and humans. After a quick look, they usually scamper off.

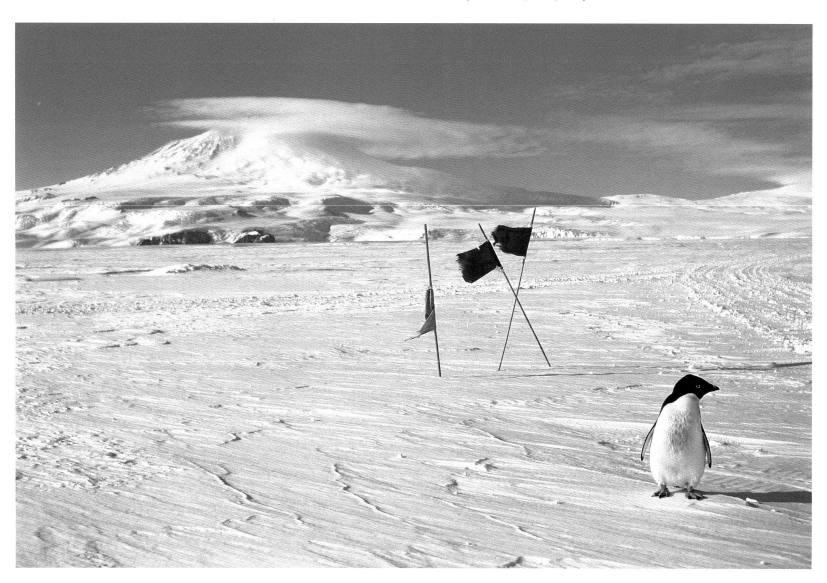

Just because a storm has passed doesn't mean work can resume immediately. McMurdo Sound "herbies," as these storms are called, can deposit enormous quantities of snow. Driven by hurricane-force winds, the fine crystals find their way through even the smallest cracks, filling up vehicles and dive huts alike. It may take several hours of shoveling and scraping before diving operations can begin. ¶ More important, the safety holes must be cleared. Each dive site consists of one primary hole and at least one safety hole. Most of the time a hut is placed over the primary hole, and the warm air inside helps keep the hole open. Safety holes are covered by Styrofoam plugs, but these only slow the freezing process. In October and early November, when it is still quite cold, the water in a safety hole can freeze to a thickness of several centimeters in one day. If a hole isn't cleared for several days, as may happen during a storm, it can become unusable. Clearing the hole involves chipping around the edge with a heavy steel bar, then fishing out the resulting chunks with a net. The bars frequently are lost when they slip out of the diver's hands and plunge through the ice to the ocean bottom. ¶ Safety holes are needed for two reasons. If a diver has a sudden emergency and cannot make a direct ascent to the primary hole, the safety hole offers an alternative exit. Also, 450-kilogram (nearly 1,000-pound) Weddell seals (Leptonychotes weddellii) often make use of dive holes to breathe, thereby making the holes unavailable to divers.

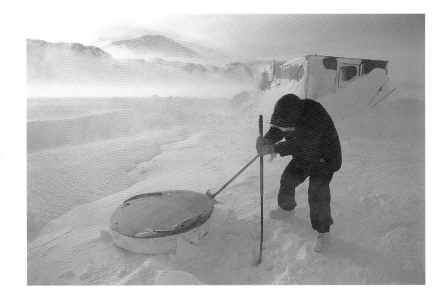

agement (McMurdo recycles over 70 percent of its waste), a safety lecture, and snowcraft survival training (otherwise known as Happy Camper School). For a freshly arrived Antarctic diver, the most rigorous challenge is yet to come. Indeed, the nights spent sleeping in a snow trench for survival training have nothing on getting under the ice itself.

Diving in McMurdo Sound is neither easy nor routine, though forty years of collective experience have helped make the process more efficient. When divers first poked their heads below the ice, they did so in wet suits, through holes blasted by dynamite or laboriously cut out with chain saws. It was hard work, and hands and bodies froze both at the surface and below the water.

Now, a motorized auger cuts a four-foot-diameter hole through six feet of sea ice in about ten minutes. Then a bulldozer positions a heated hut over the hole so divers can change into and out of their gear in relative comfort. As long as the oil stove keeps working, it's not a bad deal. But often divers arrive at their dive hut to find that the last storm has blown out the stove and filled the hut—and their dive hole—with snow. Hours of chipping and shoveling are required to reopen the hole. Then the divers must suit up in the freezing-cold air in order to enter

the freezing-cold water. More than the discomforting fact that the surface is completely solid except for one or two small access holes, it's the intense cold that makes diving in Antarctica challenging.

In McMurdo Sound the water is a stable -1.86 degrees Celsius (± 0.2 degrees), or approximately 28.6 degrees Fahrenheit, all year. This is the freezing point of seawater (lower than that of fresh water because of the ocean's salt content). Because that temperature will suck the life out of an unprotected human in just a few minutes, diving in McMurdo Sound requires wearing a daunting amount of gear. This includes thick undergarments, dry suits, bulky gloves, extra lead weight to compensate for the buoyancy of the insulating clothing, and extra regulators and gauges—almost 120 pounds of equipment. The logistics of diving are correspondingly complicated. It's generally an all-day proposition just to suit up for the dive and then degear afterward. And that's when nothing goes wrong. If any fresh water comes in contact with the diving gear, it freezes instantly, causing regulators and inflator valves to fail—and fail spectacularly: regulators free-flow, blowing air into the diver's mouth and face, and dry suits can turn into balloons in moments.

Underwater photography compounds the level of effort even more.

Research divers check up on a long-term benthic experiment. Although McMurdo Sound's solid ice cover eliminates the annoying surge that plagues researchers in other marine environments, working under the ice poses its own challenges. The bulky mitts required to protect the hands limit underwater dexterity, making the manipulation of experimental apparatus and instruments difficult. In addition, once samples are collected they must be transported from their stable -1.86°C (28.6°F) marine environment to a distant laboratory, through air that may be -30°C (-22°F). The danger is that they may freeze en route.

A professional photographer has to juggle several camera bodies, housings, and strobes on each dive. Time is short. You must cram as many rolls of film into as many working dives as possible in the few weeks allotted. Complicating matters is the fact that most of the life to be found in McMurdo's water is found deep, below 30 meters (100 feet). Diving this deep increases risk and decreases available underwater time.

So with all the effort required, why McMurdo? For underwater explorers, the answer is simple: McMurdo Sound is the southernmost accessible water in the world, as far south as one can go and still enter the ocean with scuba gear. Relatively unexplored, McMurdo Sound presents divers with an opportunity to dive where few others have been and to see things few other humans have witnessed. And if that isn't attraction enough, there is the underwater visibility—as much as 275 meters (900 feet) in the spring and early summer. This visibility obviates the need for cumbersome under-ice tethers, and it gives divers the sensation that they are flying over an alien landscape where ice covers the sky, coats the earth, and glitters in the air around them. No other dive location in the world can compare.

Most striking is the jarring contrast between the surface world and the world beneath the ice. On the surface, temperatures plummet to -40 degrees Celsius (and Fahrenheit) or lower, and hurricane-force winds scour the frozen land and sea. Both are largely barren, hostile, and devoid of life. On the bottom of the ocean, however, just 30 meters from the forbidding surface, life explodes in abundance. In some places, the sea floor is covered so thickly with animals that it is impossible to see the substrate. There is as much life here, in biomass and diversity, as you might expect to find on some tropical coral reefs.

If Antarctica is a treasure, then McMurdo Sound is one of its crown jewels. There may be no other place like it, not even in Antarctica. The strange creatures that live there can do so only because their biochemical processes have adapted to a temperature and an environment that would almost instantly kill just about everything else on the planet. (By the same token, even a slight rise in temperature often proves fatal to these Antarctic marine animals.) McMurdo Sound is therefore a place scientists find fascinating. How does life pull this one off? How does this incredible system work?

Forty years of diligent and sometimes dangerous scientific work have provided some tantalizing answers, revealing a natural history like no other. Norbert Wu's photos give vision to this story, the story of life at the very bottom of the Earth.

Crevasses are spectacular tears in a glacier or ice sheet, with sheer walls 30 meters high or higher. When capped by a snow bridge, the crevasse becomes an ice cave filled with eerie blue light and a profound silence. Here an experienced mountaineer explores a dangerous crevasse.

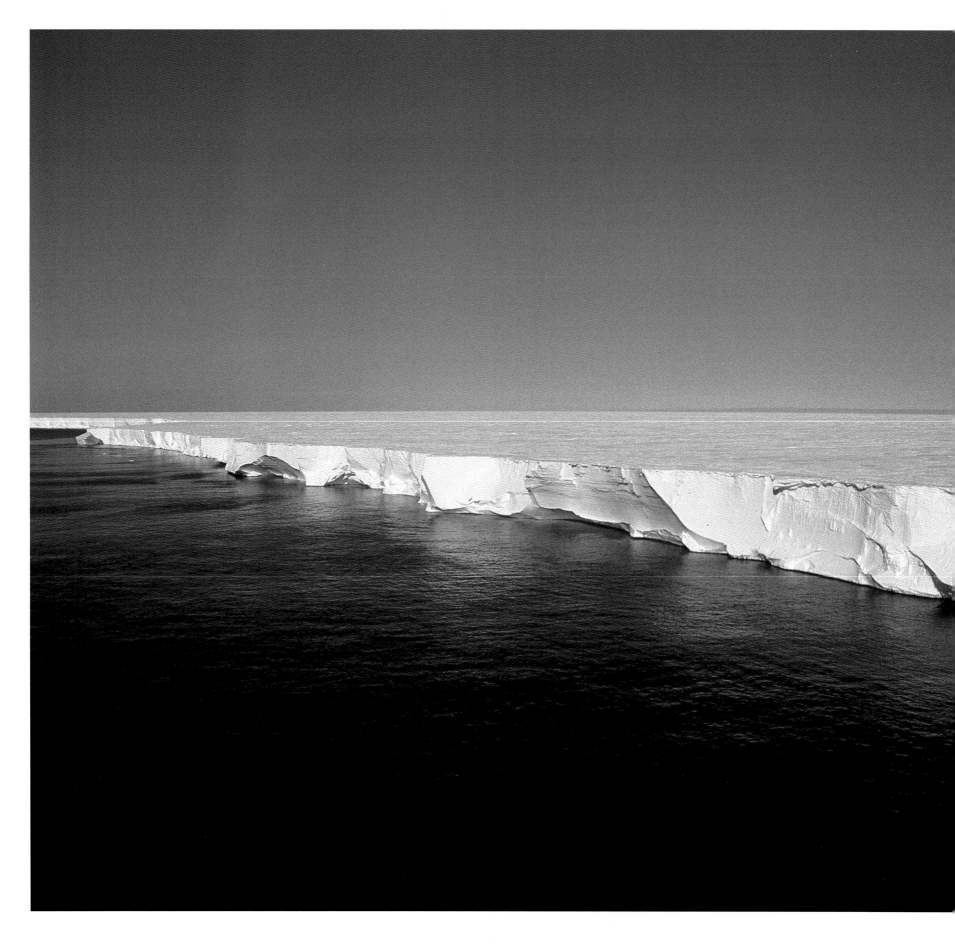

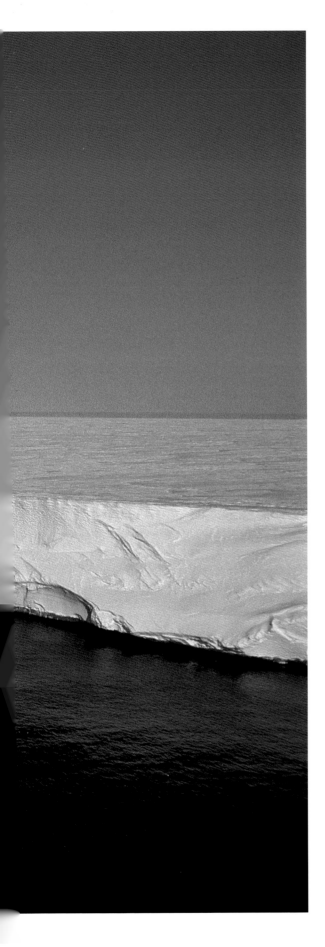

A NATURAL HISTORY of McMURDO SOUND

Standing at the edge of the annual sea ice in McMurdo Sound, Antarctica, is like standing on a precipice. The transition from hard, milky-white ice to pellucid blue water is abrupt and final, like a knife cut across the world. When not a single breath of wind, not a single ruffle or wave, mars the flat, glassy surface of the sea, it is possible to dangle one's boot tips over the edge and peer nervously into the depths. The ice appears as a thin underwater shelf—frighteningly thin in the midst of all that oceanic space. Below it, beams of light slice downward into the water. Blue turns to black in the bottomless depths. ¶ This seems at first glance to be a largely empty universe, a great desert of frozen and liquid sea. The annual ice is a

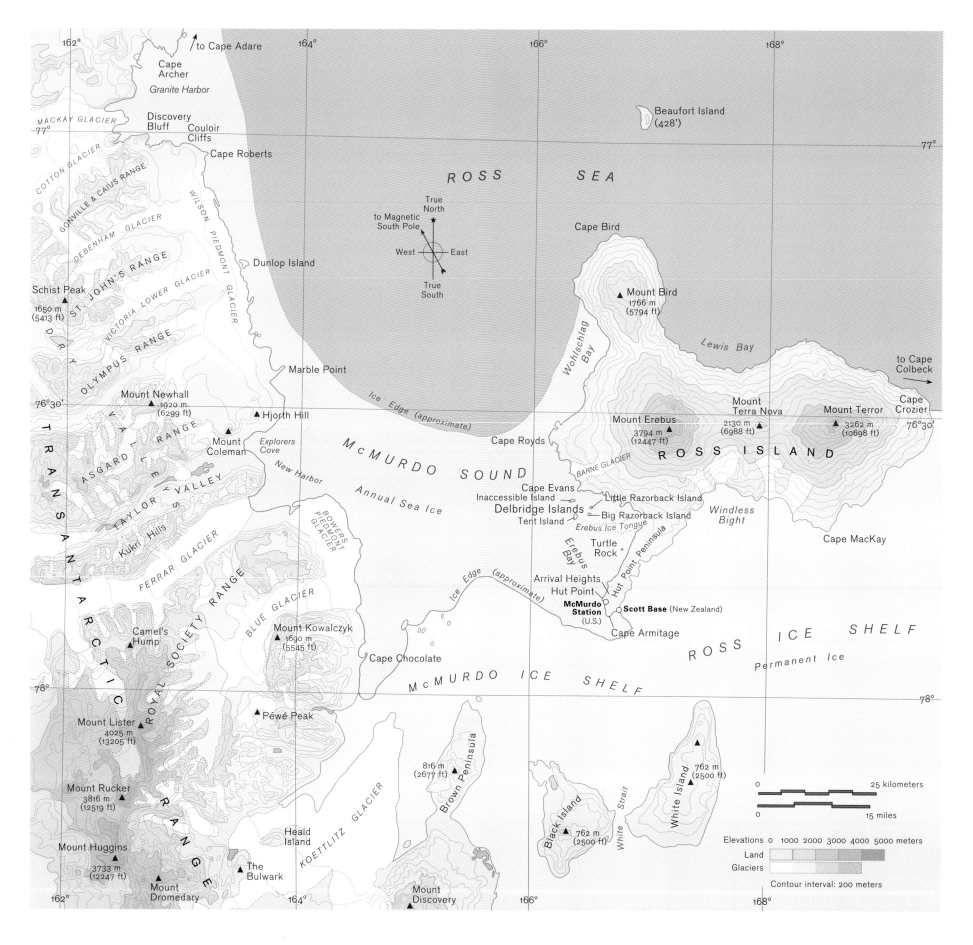

glaring, barren plain stretching to the south, the sea an equally barren three-dimensional expanse. In the dancing sunbeams, though, colorful jellies and a few other scattered bits of plankton drift slowly southward, leaving the brightness of the open ocean to disappear into the darkness under the ice. The movement of this plankton provides a clue that things are not as they seem.

More obvious clues arrive with the flutter of flipperlike wings and explosive exhalations from giant lungs. Like most physical boundaries, the ice edge is a magnet for life. Adélie penguins appear out of nowhere, rocketing out of the water to land improbably on their webbed feet. Emperor penguins poke their heads out of the smooth sea, glance around, and dive again. Their sleek forms slice through the water, pirouetting around sunbeams and leaving shimmering trails of bubbles in their wake. Minke whales, the smallest of the rorquals but still impressive beasts, roll up to the surface, blow, and plunge into the depths. Though tied to the open water, they push as far as they can under the ice, seeking to fill their gaping, baleen-lined mouths with some of the vast clouds of crustaceans and silverfish that hide under the frozen sea. Orca whales behave in the same way, angling down under the ice to hunt for the giant Antarctic toothfish. Untold miles of open water are available to them, but the whales purposefully cruise the edge, looking for a way to move further south, deeper into McMurdo Sound.

Later in the summer, when the sea ice breaks up and autumn winds blow it away, the whales move in to repeat this foraging behavior under the permanent and much thicker McMurdo Ice Shelf. Further south they go, always further south, until they can go no more.

In the nineteenth and early twentieth centuries, men acted the same way. There were unknown lands, mysteries, and perhaps even riches hidden at the bottom of the Earth, and the only way to find them was to go further south. The British explorer James Clark Ross succeeded where many others failed. In January 1841—a year that had, probably, less pack ice than average—he chose the correct meridian at which to turn south. He and his men were the first in all of human history to lay eyes upon the spectacular, mountainous shores of Victoria Land, the fuming summit of Mount Erebus on "High Island" (now Ross Island), and the imposing vertical barrier of ice now known as the Ross Ice Shelf. His two tiny wooden ships, *Erebus* and *Terror,* sidled up to that mammoth wall, and Ross lamented that, at about 200 feet, the ice was higher than his mastheads and he was prevented from seeing over it.

Nonetheless, he had reached a point farther south than any other human beings had ever gone.

Later, while exploring the north of High Island, Ross noted "a very deep bight" extending "far to the south-west from Cape Bird." Wind and ice conditions prevented him from exploring it, but he named it McMurdo Bay, after the senior lieutenant of the *Terror.*

That body of water, now called McMurdo Sound, was not seen again or explored for sixty years, until, in 1902, Captain Robert Falcon Scott and the men of the *Discovery* made their way a little further south than Ross and into the sound itself. They anchored in Winter Quarters Bay, at the tip of Hut Point Peninsula (still considered the southernmost place a ship can go). The men spent the next year engaged in scientific research, and Scott attempted to reach the South Pole. Plucking and dredging strange creatures from beneath the frigid water, the scientists of the *Discovery* found there was far more life under the ice than there was above it.

Sixty years after that, when biologists began using scuba equipment to see firsthand the world beneath McMurdo Sound's ice, previous research might have given them some inkling of what they would find. Still, they were no doubt surprised by the richness and diversity of the benthic community around Ross Island. A bigger surprise came when they explored the sea floor on the western side of the sound, at a spot only 60 kilometers (37 miles) away. Not only was the bottom there comparatively barren, but the sparse animal assemblages that did exist were composed largely of species different from those found to the east. Essentially, the two sides of McMurdo Sound were geographically close but biologically an ocean apart. The big question was, Why?

Forty years of research have yielded an answer. The dramatic difference between the two sides is the result of a complex interaction between geography and ocean currents. While that sounds straightforward enough, to fully appreciate what it means one must first take a closer look at the geologic, oceanographic, and biological forces that have shaped, and continue to shape, the rich ecosystem of eastern McMurdo Sound.

McMurdo Sound lies in the southwestern corner of the Ross Sea, tucked away between Ross Island on the east and the icebound shores of the southern Victoria Land coast to the west. Its southern boundary is defined by the permanent McMurdo Ice Shelf, an extension of the great Ross Ice Shelf. For nine or more months of the year, most of McMurdo Sound is covered by a cap of land-fast, annual sea ice, 1 to

3 meters thick, that stretches north from the ice shelf, hugs the Ross Island coast to somewhere between Cape Royds and Cape Bird, and arcs across the sound to the continent. The water temperature in the sound is stable year-round, top to bottom, at about -1.86°C ± 0.2°C. It is the coldest and southernmost accessible water in the world.

The animals that live in McMurdo Sound constitute an ancient community. Estimates vary on how long Antarctica has been frozen, but it is generally accepted that the cooling commenced in earnest when the Antarctic Peninsula separated from the South American landmass around 25 million years ago. The resulting opening of what became Drake Passage led to the development of a powerful eastward flow of the Southern Ocean around the continent. This Antarctic Circumpolar Current excluded warm, northern surface waters and effectively isolated Antarctica, both thermally and, to a large extent, biologically. Thermal isolation led to the near-total glaciation of the continent, including that large part of the Ross Sea Basin now covered by the Ross Ice Shelf, and to the establishment of a marine environment that is both predictable and tremendously stable. These properties, as well as biological isolation, have permitted the evolution of a unique and largely endemic family of creatures.

Stability plus time equals diversity, and the benthic invertebrate assemblages in eastern McMurdo Sound are indeed diverse. The sea floor is rich with animals, but the first diving biologists quickly recognized that the abundance is not uniform. In most places the macrofauna exhibits an obvious and dramatic vertical zonation.

From the shoreline to a depth of about 15 meters, the rocky sea floor is relatively barren. There are numerous motile animals, such as sea urchins, sea stars, nemertean worms, giant isopods, and pycnogonids (sea spiders), but sessile animals like soft corals and sponges are conspicuously absent. In the region between 15 and about 30 meters, fast-growing soft corals and sea anemones dominate. Then, below 30 meters or so, the sea floor becomes suddenly very richly populated, with sponges the most conspicuous organism. In some places they cover 55 percent of the available substrate and account for 74 percent of the biomass.

The sponges provide food and shelter to a large array of organisms. Sea stars and nudibranchs eat them. Some benthic fish species lay their eggs inside them, annelid "scale worms" cluster at their bases, and tiny white and purple hydroids grow on their tops. The sponges also provide structure to the habitat, making it conducive to colonization by other animals. Ascidians, both colonial and solitary, poke up here and

there. Featherduster worms spread their feeding appendages from pencil-thin stalks. Bright yellow lamellarian gastropods sprinkle the bottom like discarded tennis balls. Sea spiders, nudibranchs, and sea stars crawl across the bottom in search of prey. There are bivalves, brachiopods, bryozoans, soft corals, and fish. The list goes on. In abundance and diversity, the McMurdo Sound sponge community rivals some of the richest marine habitats on the planet.

But why does the party start at 30 meters? Ecologists soon unraveled the mystery of this zonation. Each spring and early summer, a layer of "anchor ice" forms on the rocks of the sea floor. Composed of randomly oriented crystals about half a centimeter thick and several centimeters in diameter, the ice coats the sea floor down to about 15 meters' depth with a blanket that is 0.5 to 1 meter thick. Anchor ice also occurs below 15 meters, down to about 30 meters, but at these greater depths it varies in thickness and extent from year to year. Below 30 meters' depth, where increased water pressure impedes ice formation, anchor ice is rare.

This ice essentially scours the shallow sea floor. When it grows thick enough, large chunks break loose, ripping rocks and animals from the bottom. These masses drift upward and freeze into the underside of the fast ice. The annual scour prevents sessile animals from becoming established, and even motile animals like urchins are sometimes trapped by fast-growing ice and lifted away.

Fluctuations in anchor ice have had observable effects on benthic community structure. During the 1970s, anchor ice formation from 15 to 30 meters was reduced and there was a massive recruitment of the rapidly growing sponge *Homaxinella balfourensis*. At one point, *Homaxinella* covered nearly 80 percent of the substrate in local patches at Hut Point, near McMurdo Station. Although predators also increased during the 1970s "bloom," they were unable to contain the population explosion. In the early 1980s, anchor ice formation increased again and nearly all the *Homaxinella* was eliminated.

It was obvious, then, that anchor ice was a key factor in McMurdo Sound's benthic ecology. When scientists dug further, however, they found that anchor ice was merely one part of a larger picture. In fact, it is a complex pattern of ocean currents, along with proximity to the Ross Ice Shelf, that defines the physical parameters of the sound's benthic communities.

Three things are well established: first, in the winter and spring, the eastern sound receives a northerly flow of supercooled, plankton-poor water from below the Ross and McMurdo Ice Shelves. Second, in the

summer, plankton-rich water from the Ross Sea moves south into the eastern sound, displacing the ice shelf water. And third, the western sound is bathed with impoverished ice shelf water year-round.

But where do these currents originate? And why do they flow the way they do? This is where it gets complicated.

A clockwise gyre exists in the Ross Sea, almost certainly a consequence of the Antarctic Circumpolar Current. Some of the south-moving water in this gyre flows underneath the Ross Ice Shelf. Although this massive and permanent ice field, which fills the southern half of the embayment containing the Ross Sea, is floating at its northern limit, farther to the south it is grounded on the sea floor, hundreds of meters below sea level. No one knows how far south the water pushed under this shelf goes or how long it remains there, but one researcher has estimated an under-shelf life of 3.5 years. If true, this could mean the water is pushed into the depths, all the way to the grounding line.

Apparently the water is ultimately deflected toward the west, because some of it ends up flowing south of Ross Island and under the McMurdo Ice Shelf. It resurfaces in McMurdo Sound, heading north. Because the water comes from very deep, and because it has been in contact with the much colder ice of the Ross Ice Shelf, it is cooled to a temperature lower than the freezing point of surface seawater. As it approaches the surface and hydrostatic pressure is reduced, it becomes supercooled and begins to freeze. Tiny crystals of ice fill the water column, like numberless floating diamonds. The supercooled water and the floating ice crystals are responsible for the formation of anchor ice. The stronger the northward flow of this cold ice shelf water, the thicker and more widespread the anchor ice.

Unfortunately, cold and ice are about all the ice-shelf water has to offer. From its long sojourn in the stygian depths, it is nearly devoid of food. All of McMurdo Sound would be impoverished if this winter fare were its only diet. Fortunately, it's not. Conditions change dramatically when summer approaches.

During the winter, most of the Ross Sea is covered by ice, with only certain restricted areas remaining open. One of these polynyas (regions of open water surrounded by ice) runs along the entire northern border of the Ross Ice Shelf from Cape Colbeck to Cape Crozier. As summer progresses and Antarctica warms up, the polynyas expand and merge until most of the western Ross Sea is open. The development of this enlarged polynya appears to be coincident with a significant change of currents in McMurdo Sound.

It is not altogether clear why this should be the case, but one prominent oceanographer has developed a working hypothesis based on a known meteorological phenomenon. It goes something like this: Frigid air from the polar plateau, because it is dense, flows naturally downhill, toward the coast. This gravity-driven, or katabic, wind can be fierce, at times reaching 200 kilometers per hour. It roars off the plateau, across the Ross Ice Shelf, and out to sea. When the sea is covered with ice, the wind has no effect on water movement. Once the polynya opens up, the wind begins to move water, possibly disrupting the normal flow pattern of the Ross Sea Gyre. At the very least, the katabatics apply a northward pressure that, because of Ekman transport (the tendency of currents to move nearly perpendicular to offshore airflow), pushes polynya water strongly to the west, toward Ross Island.

Somehow, this polynya water swings around Cape Bird and flows south into eastern McMurdo Sound, along the shores of Ross Island. Whether it is pushed into the sound by outside pressure or pulled in by an as yet undetermined bathymetric suction (or some combination of the two) is not known. But move in it does, and by mid-November it is replacing the northerly, supercooled ice shelf water that had been flowing into that side of the sound.

The difference is dramatic. Because it is relatively free of light-limiting ice and is exposed to twenty-four-hour sunlight, the polynya water experiences a massive phytoplankton bloom. The water mass moving into McMurdo Sound is top-heavy with plankters, including diatoms; a superabundant, dimethyl-sulfoxide–producing colonial flagellate called *Phaeocystis antarctica;* and a host of protistan grazers. A large percentage of the *Phaeocystis* sinks rapidly to the bottom, which suggests that this smelly flagellate (and all the other associated plankters) ends up in the guts of various benthic suspension feeders—a regular, predictable feast for the sea floor community. Plankton-rich polynya water, in other words, is eastern McMurdo Sound's chuck wagon.

Yet that is not the whole story. If the benthic communities of the eastern sound had to depend strictly on trucked-in *Phaeocystis* for chow, things might be different. That, however, is far from the case.

The sea ice covering McMurdo Sound is not just a lid of frozen water; it is a microorganism condominium. Numerous bacteria, diatoms, ciliates, flagellates, copepods, amphipods, and other organisms colonize the ice the moment it begins to form. Over 200 taxa have been identified as living in, on, or in association with the sea ice in Antarctica.

That ice may look like a solid sheet to the scientists driving or walking on it, but it is honeycombed with pockets and channels, all remnants of the formation process, and all home to various ice-adapted organisms. Some of these organisms are highly salt tolerant, thriving in brine pockets where the salinity is more than three times that of the ocean. When the summer sun returns, the sea ice microbial community goes into high gear. Ultimately, most of the resulting production winds up on the sea floor, nourishing the benthic community.

Sea ice productivity, however, can be either limited or enhanced by something called platelet ice. In the spring, when anchor ice is forming on the sea floor, the supercooled ice shelf water also generates a loose conglomerate of ice crystals, called platelets, on the underside of the sea ice. This layer looks very much like anchor ice. In fact, when clumps of anchor ice crystals dislodge from the bottom and float up, they are incorporated into the platelet ice.

The randomly intertwined platelets provide a substrate for algal growth, as well as shelter for a host of grazers and predators. Research has shown that the thickness of the platelet layer is tremendously important in determining the level of ice algae productivity. Too thin a layer, and the diatoms are denied space to grow. Too thick, and nutrient mixing from the water is impaired. A platelet layer about 0.5 meters thick provides considerable surface area for growth while still permitting ample nutrient delivery from the underlying water. A platelet layer 2 meters thick impedes mixing from the water column and reduces light transmission as well. The stronger the supercooled current, the thicker the platelet ice layer. In a fascinating if somewhat counterintuitive intersection between physical oceanographic processes and biology, the level of sea ice primary productivity—and hence the amount of food ultimately available to benthic organisms—is directly affected by the strength of the supercooled and impoverished current from beneath the ice shelves.

Of course, the water column and the sea ice are not the only places algae can grow. In areas where the platelet layer is thin or nonexistent (and sea ice algal production correspondingly limited), diatom growth on the sea floor can more than take up the slack.

Cape Evans is often just such a place.

This small promontory lies a few kilometers south of the ice edge and about 25 kilometers (15 miles) north of McMurdo Station. Here, in a shallow cove directly in front of Captain Scott's 1910 hut, the sea ice is almost completely free of snow. The raised land of the cape shields the cove from winter's southerly winds. Blizzard-driven snow builds up on the windward side of the cape, and of the small islands that sprinkle Erebus Bay, while their leeward sides are left bare. The difference under the ice can be dramatic. Snow-covered areas are dark, and plankton growth is generally limited, sometimes to the point where it is nonexistent. Snow-free areas, in contrast, are bright in the summer sun, and plankton growth is profligate.

The wide, shallow sea floor at Cape Evans is indeed well illuminated. Early in the spring, before the soupy Ross Sea polynya water moves in, the water is so clear as to be almost invisible. While the frequent absence of a platelet layer may limit sea ice algal growth here, strong light transmission ensures that benthic diatom growth is robust. Some studies have even shown that benthic diatom growth correlates more closely with sea floor community biomass and diversity than does sea ice productivity. Again, the eastern sound holds the winning lottery ticket. Overall, the sea ice in the east is thinner than in the west, and the nearshore fast ice, protected by the bulk of Ross Island, often has a reduced snow load. More light equals more growth. At Cape Evans in particular, benthic diatoms form a brown film over the bottom.

This benthic diatom mat is aggressively grazed by a ubiquitous circumpolar echinoid called *Sterechinus neumayeri*. These urchins occur truly everywhere in the shallow water around Ross Island, but they are especially abundant in the lush diatom gardens of Cape Evans. The shallow sea floor at Cape Evans is also carpeted with thick beds of macroalgae typically not seen farther south. The broad-leafed *Iridaea cordata* often covers most of the substrate in water depths of 3 to 4 meters. The smaller-leafed *Phyllophora antarctica* grows in large patches from 12 to 18 meters' depth, covering 35 to 60 percent of the bottom every year. Despite their reputation as voracious algal grazers, the urchins apparently do not consume either species of macroalga. Bioassays on both *Phyllophora* and *Iridaea* show that both are chemically defended. *Phyllophora* in particular is known to produce cytotoxic secondary metabolites that may inhibit grazing, and the same can probably be assumed for *Iridaea*.

The urchins don't completely ignore *Phyllophora*, though. In a bit of deception, they gather up bits of the alga and cover themselves with it. When an urchin stumbles up against its primary predators, the anemones *Isotealia antarctica* and *Urticinopsis antarctica*, the cnidarians' tentacles brush against the algal "hat." Sometimes the anemone simply pulls away. Other times, it grasps the alga, only to release it later.

If the urchin is aware of the anemone's tentacles, it drops the alga and moves away. In either case, the urchin blithely escapes. Uncovered urchins are quickly scooped up and devoured.

The urchin isn't the only one to benefit from the arrangement. Much of the alga that *Sterechinus* appropriates is loose because it has been dislodged by anchor ice. Were it not for the urchins, this alga might drift into deep water or be washed ashore after the sea ice breaks up. Carried on the urchin's back, the alga remains in its preferred depth range and can contribute spores to the next generation.

A snowball's throw south of Cape Evans, the jagged volcanic ridge of Little Razorback Island pokes out of the sea ice like the fossilized back of a dinosaur. Its underwater topography is equally dramatic. A shallow shelf extends out for a few meters from the northern side of the island; then the sea floor drops abruptly in a slope so steep that 1 horizontal meter translates to 1 meter of depth. In the dim light and the clear water, it presents a stunning underwater vista, with deep ravines and vertical walls covered with invertebrate life.

The underside of the sea ice at Little Razorback is usually coated with a layer of platelet ice. By mid-November, just as the south-flowing current is moving in, the once-translucent blue ice has turned brown from algal growth. The amount of light transmitted to the water column, typically only about 1 percent of surface radiance under the best of conditions, is now considerably reduced, and the underwater world at Little Razorback is correspondingly dark. Long filaments of pennate diatoms hang from the ice like so many whiskers, occasionally breaking off and drifting to the bottom. Plenty of heterotrophic organisms, from flagellates to amphipods, graze on this bounty, but they do not consume enough to stem the explosive growth. When the warmer water of the southerly current dissolves the platelet layer, its load of organic carbon will be released in a massive pulse of food. This pulse is at least as important as the imported plankton to the deep benthic community.

Little Razorback's benthic assemblages are typical of the vertically zoned environment around Ross Island. The shelf, like all other shallow places, is home to an orgy of *Sterechinus;* the equally ubiquitous sea star *Odontaster validus;* the usual worms, isopods, and sea spiders; and of course a healthy coating of anchor ice. Between 15 and 30 meters are the standard anemones, soft corals, and echinoderms. Below 30 meters, a rich and diverse sponge-dominated community covers the steep bottom and the adjacent vertical walls. The sponges come in all shapes and colors, from crooked fingers to fuzzy balls, pipes, vases, fans, and brains, and from bright red to deep green, iridescent yellow, and pink.

In other areas along the coast of Ross Island, such as on the steep benthic slope below Arrival Heights near McMurdo Station, sponges provide most of the vertical structure of the sea floor community. Over the millennia, the undecomposed siliceous spicules from untold generations of sponges have built up into a mat that is anywhere from 0.5 to 2 meters thick, and this provides a home to many creatures. This spicule mat, and to an extent this community, exists because there are no large creatures in McMurdo Sound that root around on the bottom and stir things up, as many fish, rays, and marine mammals do in the rest of the world. The benthic community in McMurdo Sound is old, it is quiet, and it is slow. Everything moves in slow motion, including the metabolism of the residents. In early experiments, scientists placed sea stars in cages with presumed prey species, took photographs, and left them for the winter. When they returned nine months later, some of the stars were in exactly the same position as when the scientists left.

The researchers were interested in the stars for the simple reason that in Antarctica asteroid echinoderms fill the trophic level that is normally filled by fish in temperate and tropical ecosystems. There are certainly fish in McMurdo Sound, but they are bit players in the benthic drama. Instead, sea stars, along with a few nudibranchs, are the apex predators of the sponge community. Competition between the sponges and these predators, and between the predators themselves, is in large measure responsible for the structure of the community.

The relationship between the sponge *Mycale acerata* and the sea star *Perknaster fuscus antarcticus* is a perfect example. *Mycale* has been dubbed the "slimy sponge" for its tendency to exude copious amounts of mucus when disturbed. *Perknaster,* however, seems completely immune to this mucus, and it happily gorges on *Mycale* whenever it runs across it. In fact, adult *Perknaster* pretty much eat only *Mycale*. This is a good thing, because, in complete defiance of the Antarctic rule that dictates slow growth for all ectotherms, *Mycale* is a fast-growing sponge and might easily overrun the benthos were it not for *Perknaster* keeping it in check.

Interestingly, *Perknaster* larvae and adults are chemically defended by an alkaloid compound called fuscusine, and predation on them appears to be uncommon. What seems to keep this predator in check is its own appetite for consuming its primary food source.

The use of chemistry for defense is a system Antarctic benthic invertebrates have apparently perfected over the millennia. The incredible stability and predictability of the environment have reduced the importance of physical factors in structuring benthic communities. The scouring action of anchor ice (plus the occasional iceberg scour) is the only physical action that really matters, and it matters hardly at all below 30 meters. At that depth and deeper, the world is the same year in, year out, millennium in, millennium out: -1.86°C water and an annual pulse of food floating down from above, as regular as clockwork. Thus, the structure of the deep sponge community is forced by competition and predation, the constant—and in this case, slow-motion—struggle between competing animals, predators, and prey.

It makes sense for chemical deterrents to be common. After all, sponges and soft corals can't run away, so the best way to survive and reproduce is to taste so bad that no one wants to eat you. Scientists continue to isolate and identify biologically active secondary metabolites not only in these animals but in other Antarctic organisms as well. Secondary metabolites are compounds that are not necessary for any basic life function, but which more often than not serve a defensive or offensive purpose. These metabolites are frequently associated with pigment, which goes a long way toward explaining why some of the animals of the Antarctic benthos are brightly colored even though hardly any light reaches the bottom, and none of the major predators possess organs of sight. The red sponge *Kirkpatrickia variolosa,* the green sponge *Latrunculia apicalis,* the yellow sponges *Dendrilla antarctica* and *Isodictya erinacea,* and the orange soft coral *Alcyonium antarcticum* are all endowed with nasty compounds that deter predation and, in some cases, reduce fouling by algae.

In this chemical soup, though, a lack of color is no guarantee of tastiness; some of the many white sponges are also protected by chemical defenses. And sponges are not the only organisms to achieve better living through chemistry. The white soft coral *Clavularia frankliniana* manufactures chimyl alcohol, which the predatory nudibranch *Tritoniella belli* manages to store in its own tissues, giving it a handy defense against its own potential predators. The gastropod *Marseniopsis mollis,* which preys on the ascidian *Cnemidocarpa verrucosa* and which may also consume the numerous epizoic bryozoans and hydroids living on that tunicate, contains a compound called homarine that seems to halt predation by sea anemones and sea stars. Whether *Marseniopsis* manufactures its own homarine or obtains it from its prey is un-

known, although the epizoites living on *Cnemidocarpa* do contain homarine.

One of the most unusual cases of chemical defense involves the abduction of a chemically defended creature by another that is not. The common pelagic pteropod *Clione antarctica* produces a compound called pteroenone that makes it distasteful to fish predators. The pelagic amphipod *Hyperiella dilatata,* a common prey of the ice-dwelling fish *Pagothenia borchgrevinki,* actively abducts individual *Clione* to take advantage of the pteropod's defense. The amphipod grasps the pteropod firmly and then swims around with what is essentially a big, heavy lump on its back. Apparently it's worth it. *Pagothenia* will readily consume unprotected *Hyperiella,* but if the amphipod has an attached *Clione,* the fish will invariably spit the combination out or avoid it altogether.

Hyperiella also attach themselves in large numbers to the bell of the medusa *Diplulmaris antarctica,* where they may rely on the nematocysts of the jelly to protect them from predation. Their shameless use of two other, more powerful members of the planktonic community for their own protection might imply that *Hyperiella* are the most street-smart of Antarctic organisms. However, since most of the amphipods attached to medusae are females and juveniles, some scientists have wondered if they aren't using the jellies as mating grounds.

Those organisms not chemically defended may be protected indirectly by the complexity and intricacy of the benthic community. Take, for instance, the relationship between the big volcano sponge *Anoxycalyx (Scolymastra) joubini* and the sea star *Acodontaster conspicuus. Acodontaster* is a reasonably large sea star that eats several sponges, especially *Anoxycalyx.* ("Eat," of course, is a relative term. A single *Acodontaster* may spend months slowly digesting a single sponge.) But there are a fairly large number of *Anoxycalyx,* and not that many *Acodontaster.* What keeps *Acodontaster* from increasing in number and removing all the *Anoxycalyx?* It's true the common sea star *Odontaster validus* preys on adult *Acodontaster,* but that may not fully explain the low *Acodontaster* density. Another clue exists in the virtual absence of juvenile animals in McMurdo Sound. Some benthic ecologists have proposed that relentless grazing by *Odontaster* scoops up most settling larvae of other invertebrates, thus severely reducing the recruitment of new animals—including *Acodontaster.*

It's a good hypothesis, for the following reason. Research on soft-bottom infaunal communities in the sound has shown that two particular crustacean predators, the tanaid arthropod *Nototanais dimor-*

phus and the amphipod *Heterophoxus videns,* effectively control the structure of their community by preying on the larvae and juveniles of the polychaetes, cnidarians, crustaceans, and the various other phylogenetic riffraff that live there. In doing so, they limit recruitment, and the result is a community dominated by large and long-lived forms.

It's reasonable to suppose that *Odontaster validus* may have a similar effect on the epibenthic community. After all, *Odontaster* is both the goat and the piranha of the shallow Antarctic sea floor. The little red stars are everywhere, and they eat nearly everything. They pile on top of any large food item and all over one another like football players going after a fumbled ball. Near seal colonies, they consume feces. Elsewhere, they eat sponges, benthic diatoms, other sea stars, dead seals, and just about anything else they find in their path. Besides anemones, their only known predator is the giant sea star *Macroptychaster accrescens.* These asteroid monsters can be 45 centimeters across, but they are not particularly common. Why should this be the case, when there is so much juicy *Odontaster* meat to be had? Again, *Odontaster* may be limiting *Macroptychaster* recruitment by devouring the larger star's larvae.

Most Antarctic benthic invertebrates either brood their larvae or produce nonfeeding, lecithotrophic (yolk-rich, self-contained), demersal (bottom-associated) larvae. Both strategies produce relatively small numbers, and both sets of larvae are painfully slow to metamorphose, compared to the larvae of temperate and tropical invertebrates. These traits may make the demersal larvae particularly susceptible to *Odontaster* grazing. In an interesting twist, both *Odontaster validus* and *Sterechinus neumayeri,* the two most numerous echinoderms, produce abundant pelagic, plankton-feeding larvae by broadcasting their eggs and sperm in late winter. This tactic keeps them off the bottom and safe from grazing *Odontaster.* The larvae browse on bacteria until the summer bloom arrives to provide them with heaps of algal food.

Harvesting bacteria as a contingency or even primary food source seems to be a fairly common practice in McMurdo Sound. In fact, bacterial nitrification (i.e., primary production) may be a key link in the McMurdo Sound food chain. Since bacteria do not need sunlight for this process, they may represent the only viable food for many benthic, planktonic, and sympagic (ice-dwelling) organisms during the winter. Research has shown that as much as 95 percent of winter sea ice bacterial production is consumed, particularly by ice-dwelling and planktonic grazers. Far from going into torpor, the McMurdo Sound sympagic-pelagic-benthic community may continue to operate at a low level during the winter, with many herbivores feeding even in the absence of photosynthesis.

The sea ice and the benthos are closely linked. Although the primary production of polynya plankton and benthic diatoms is important, the phenomenal productivity of the sea ice microbial community in summer clearly remains a critical energy source for McMurdo Sound fauna. Whereas almost all winter bacterial primary production is consumed locally, over 95 percent of summer sea-ice algal primary production remains uneaten by planktonic and sympagic grazers and is thus available for the benthic community. When the sea ice breaks up, and especially when the under-ice platelet layer disintegrates, a tremendous amount of material falls to the sea floor. Underwater video cameras have filmed *Trematomus bernacchii,* a benthic fish, gulping down large streamers of pennate diatoms falling from above. For the filter and suspension feeders of the benthos, this is the summer feast they depend on, the bolus of energy they need for growth and reproduction.

They are not the only ones. The sea ice autotrophic population provides food for untold numbers of copepods, amphipods, euphausiids, and other grazers. These in turn provide food for much of the sound's fish population, like the cryophilic *Pagothenia borchgrevinki* and especially the Antarctic silverfish, Antarctica's anchoveta, *Pleuragramma antarcticum.*

Though no one has actually seen them en masse, it is generally accepted that *Pleuragramma* is the most abundant fish in Antarctica. This unprepossessing little pelagic fish is presumed to occur in enormous schools in the depths of McMurdo Sound, where it feeds on a variety of plankters throughout its life cycle. Most adult *Pleuragramma* pulled from the bellies of the Antarctic toothfish *(Dissostichus mawsoni)* and the bellies of Weddell seals (which is how the elusive silverfish are usually captured) are full of copepods. Between sea ice production and the rich algal bloom that advects into McMurdo Sound, there is apparently enough energy to sustain huge populations of *Pleuragramma,* even through the winter. Ecologists know this because winter is when Weddell seals are fattening up for the summer breeding season, and they are doing so largely on *Pleuragramma.*

Pleuragramma, in fact, appears to be a key link—perhaps *the* key link—in the sound's pelagic food web. The silverfish is the primary food source for Weddell seals, *Dissostichus mawsoni,* and emperor penguins. Leopard seals eat penguins. Orca whales prey on the fat-rich *Dissostichus* and may eat *Pleuragramma* as well. Even the minke whales

that forage along the ice edge in the summer may be diving below the ice to scoop up giant mouthfuls of *Pleuragramma.*

How such a large population of fish can exist in a habitat that seems essentially in starvation mode for the better part of the year is still not entirely understood. In fact, much of McMurdo Sound's pelagic biology is a mystery. Over the millennia, the pelagic animals, just like the benthic fauna, have apparently adapted to take full advantage of the brief summer energy pulse, whereas during the rest of the year their low metabolic rates allow them to survive until the next bacchanalian feast. Unlike most notothenioids (all of which lack a swim bladder), *Pleuragramma* are neutrally buoyant and therefore need expend no energy to maintain depth. Besides manufacturing the glycopeptide antifreeze molecules that keep them from turning into fish popsicles (probably their biggest metabolic cost), all they have to do is hang out and maybe browse on the occasional winter-over copepod that happens by. It must be enough to keep these fish going until summer arrives again.

An even greater mystery lies in the black depths of the sound. Over the years, a variety of odd creatures have been pulled up from the deep, including an octopus estimated to weigh 45 kilograms (100 pounds), amphipods that look like trilobites, bizarre fish, and hard pink coral. Clearly, a robust benthic community lies at 500 meters in McMurdo Sound. Whether they are surviving on the rain of material from the summer bloom or on a different energy source is unknown.

By mid-December, summer is in full swing in McMurdo Sound. The imported Ross Sea water has pushed south to McMurdo Station, and the air over the sea ice smells of dimethyl sulfoxide. *Phaeocystis* has arrived, and the underwater visibility has plummeted. The current swings past Cape Armitage and is swept under the McMurdo Ice Shelf, its final destination and fate unknown. Some scientists presume that this water mixes with the north-flowing ice shelf water that continues to bathe the western sound. If it does, it is only after it has been driven to the depths, chilled, and depleted of organisms. When it resurfaces under the thick sea ice of the southern Victoria Land coast, it is an empty grocery bag.

This conspiracy of currents and geography explains why the western sound, at its closest point a mere 50 kilometers (31 miles) from the faunally ostentatious east, is so completely different. The west never takes delivery of pure, food-rich polynya water. Instead, in summer as well as winter, supercooled water continues to bubble up from the frigid belly of the ice shelf, making the sea ice along the west coast much thicker and much less likely to break out in the summer. Most of the ice here is multiyear ice, up to 5 meters thick or more, and coated along the bottom with a platelet layer that can be several meters deep. The thick ice drastically limits light penetration, and the ultrathick platelet layer limits nutrient mixing, with the result that sea ice and benthic primary production are severely curtailed. Add to this the further insult that what meager summer advection actually makes it over to the west is depleted by its passage across the sound, and it's a triple whammy: no food in the ice, no food on the bottom, not much food in the water.

Nonetheless, life perseveres on the sea floor in the western sound. It is sparse compared with the east, but it is there. The sea floor at Explorers Cove is an ideal example. Located at the mouth of the Taylor Valley, Explorers Cove is subjected to both wind-driven sand from the bare land of the valley and silt-filled runoff from a glacial melt stream. Over the millennia, these processes have produced a soft, silty bottom. Water circulation in the cove is nearly nonexistent (measurements have recorded a flow of less than 1 centimeter per minute). The actions of scuba divers can stir up enough sediment to obscure visibility in one spot for hours, and the suspension of extremely fine particles can reduce visibility for days. Advection of water from the already impoverished north-flowing current in the western sound is minimal. The ice here rarely breaks out and so is typically about 4 meters thick, uneven, and covered with snow and sand. Light penetration is low. Explorers Cove is a dark environment, with generally low benthic primary productivity.

Yet there is life. A few erratic boulders litter the bottom, providing a precious hard substrate for sponge attachment. Scallops (*Adamussium colbecki*) are scattered everywhere across the sea floor. In shallow water (4–6 meters) the density of scallops can reach eighty-five individuals per square meter. At these depths, they are apparently able to take advantage of a narrow region of high primary productivity, caused by a moat of melted ice and runoff that forms each summer along the shoreline of Explorers Cove. In an otherwise impoverished environment, this moat supports a substantial algal bloom, which in turn supports a high scallop biomass and a relatively high turnover. Even at 30 meters there are twenty scallops per square meter, still a respectable density for a single macroorganism.

The enduring mystery here is why there are so many of these eminently edible bivalves. Their shells are thin, like the shells of deep

abyssal bivalves. This is a consequence of the cold water, which makes it difficult and energetically costly to precipitate calcium carbonate. They should therefore make easy prey, but by all indications this is a population of old animals. An 8-centimeter individual—an average size—may be as much as twelve years old. (This is an uncertain estimate; the scallops may be much older.) There seem to be few juveniles below 20 meters. In fact, only a few 2-centimeter individuals are present, and none smaller than that. Yet predation seems to be limited. Divers have noted one very large anemone sitting on a rock at about 30 meters, surrounded by dead scallop shells, but they haven't often seen predatory activity by other organisms. Indeed, the main cause of adult mortality seems to be environmental: large numbers of scallops succumb to the relatively warm hyposaline lens of water that drew them to the shallows (and thus to the algal bloom) in the first place.

But why so little predation? The sea stars *Lophaster gaini* and *Notasterias armata* and the brittle stars *Ophiosparte gigas* and *Ophionotus victoriae,* though known to eat scallops, seem unable to put much of a dent in the population. The fact that *Adamussium colbecki* can swim to escape predation surely must be a factor in their survival rate, but other forces may be at work as well. For one, even though there are plenty of scallops, there doesn't seem to be a large number of sea stars. Even the *Odontaster* population is small in Explorers Cove—nothing at all like the density seen in the eastern sound.

Perhaps an explanation can be found in another remarkable property of the cove. The silty bottom here is home to a dense and diverse community of giant foraminiferans. Foraminiferans are one-celled creatures, most of which are too small to see without a microscope. The Explorers Cove forams, however, are veritable giants, up to a centimeter in diameter in some cases. Most of them are agglutinated forms that use sand grains of different size and composition (depending on species) to create hard, protective shells. Some are arboreal forms that send appendages up into the water column to collect diatoms. But among these gentle grazers lives a veritable monster of the deep, a carnivorous foram called *Astrammina rara.*

Astrammina rara sends out sticky pseudopods of protoplasm that find and firmly grasp its prey. Frequently this prey consists of crustaceans and other animals much larger than the foram, which the protozoan literally tears apart with its pseudopods. One foram expert has wondered whether the dense population of *Astrammina* could be limiting the recruitment of much larger animals, such as predatory sea stars, by consuming settling larvae. In a reprise of the epibenthic and infaunal stories from the eastern sound, this could potentially explain both the scarcity of juvenile scallops and the low number of predators in an environment relatively well stocked with plump molluscan food.

The dense assemblage of foraminiferans highlights another unique aspect of Explorers Cove. Many of these foraminiferans are related to or identical to deep abyssal forms. In fact, because of its impoverished state, its extreme temperature stability, and its low current flow, Explorers Cove mimics the deep sea. The abyssal environment is reflected in the cove's unique animal assemblage. In addition to its large numbers of thin-shelled bivalves and its diverse foraminiferan community, the cove is home to other animals rarely or never seen in shallow waters in the eastern sound, but which are common in deep water, such as crinoids *(Promachocrinus kerguelensis),* pencil urchins *(Ctenocidaris perrieri),* and brittle stars *(Ophionotus victoriae* and *Ophiosparte gigas).* There is also the strange, rare, and beautiful giant soft coral *Gersemia antarctica.*

Gersemia antarctica is unusual in many respects. *Gersemia* colonies are pink, and they stand as much as 1.5 meters tall, towering over the bottom like giant sequoias of the Antarctic. Each colony is composed of a thick central stalk and thousands of individual polyps. Soft corals generally require a hard substrate for attachment, but *Gersemia* thrives on the silty bottom of Explorers Cove by anchoring its main stalk to a small rock or scallop shell partly buried in the sediment. Though *Gersemia* may derive some nutrition through passive suspension feeding, filtering small crustaceans and invertebrate larvae from the water column as heterotrophic soft corals lacking symbiotic zooxanthellae usually do, it seems to obtain most of its food by deposit feeding. This is a strategy ideally suited to Explorers Cove, and it makes *Gersemia* unique among soft corals.

A colony first inflates its central stalk to stand tall. Then it alters the hydrostatic pressure on one side, allowing it to bend over and touch the sea floor. The polyps sift through the sediment for epifaunal and infaunal prey, such as foraminiferans. When a particular site has been swept, the colony deflates and reinflates the stalk, then bends over to sift through the sediment in another spot. Fully inflated, a single colony can graze a circle in the sediment 3 meters in diameter.

This behavior is remarkable enough in itself, but a *Gersemia* colony can also travel. It disengages its anchor from the sediment, then alternately deflates and inflates the central stalk to move in inchworm fash-

ion across the sea floor. When it reaches a new site, it reestablishes its substrate anchor and begins the feeding process again. No one knows exactly how far or how fast *Gersemia* colonies can move, but they are clearly peripatetic. During one season, divers counted only two of the soft corals at a particular dive site. Ten months later there were at least thirty in the same spot. *Gersemia* are animals, of course (colonial animals with no brain, in fact), but for divers accustomed to normal soft coral behavior, seeing that was like waking up one morning to find that all of one's house plants had moved themselves to another room.

Outside the cove, north of Marble Point and near the northwestern limit of McMurdo Sound, little is known about current flow. Some of the Ross Sea polynya water, so crucial to the eastern sound, appears to reach here, but its contribution to benthic biomass is questionable. Sea floor communities remain relatively sparse until Cape Roberts and Granite Harbor. Even there, benthic coverage is spotty. For reasons unknown, the incursion of Ross Sea polynya water into Granite Harbor does not seem to be strong, and it occurs late in the season. The summer sea-ice algal bloom also appears to arrive late in Granite Harbor. In early January, when the water near Ross Island is an opaque soup, Granite Harbor can still have 60-meter visibility. Nonetheless, evidence of a greater abundance of both light and food than exists in the western sound is reflected in the benthic assemblages here.

Granite Harbor is a hard-bottom community, with a granite substrate, numerous boulders, and plenty of places for invertebrates to attach. Curiously, though, the coverage is sporadic. At one spot below the wind-scoured granite face of Couloir Cliffs, the sea floor is thickly covered with organisms. Here are found animals common to both the eastern and western sound: numerous sponges (one of them a volcano sponge big enough for a diver to hide inside), tunicates, crinoids, sea whips, hydroids, sea cucumbers, pencil urchins, bryozoans, nudibranchs, urchins, and sea stars, to name a few. It is one of the richest benthic communities ever observed. But at another spot under the cliffs, just a few tens of meters away, the bottom sports only a few scattered animals, mostly sea stars. Farther to the west, below Discovery Bluff, the sea floor hosts an occasional soft coral, beds of featherduster worms, and a few smaller volcano sponges. For the most part, though, it is bare rock.

The odd heterogeneity of this sea floor, with both rich and impoverished communities literally within a stone's throw of each other, is yet another of the Ross Sea's many enigmas, along with the unanswered questions regarding water movement under the ice shelf, the mystery of *Pleuragramma* and the pelagic community, and the curiosities popping up from the abyss. Their solutions await the same painstaking and meticulous research that solved the riddle of vertical zonation and opened the door to an appreciation of McMurdo Sound as a unique and constantly fascinating corner of the vast Antarctic.

Under Antarctic Ice

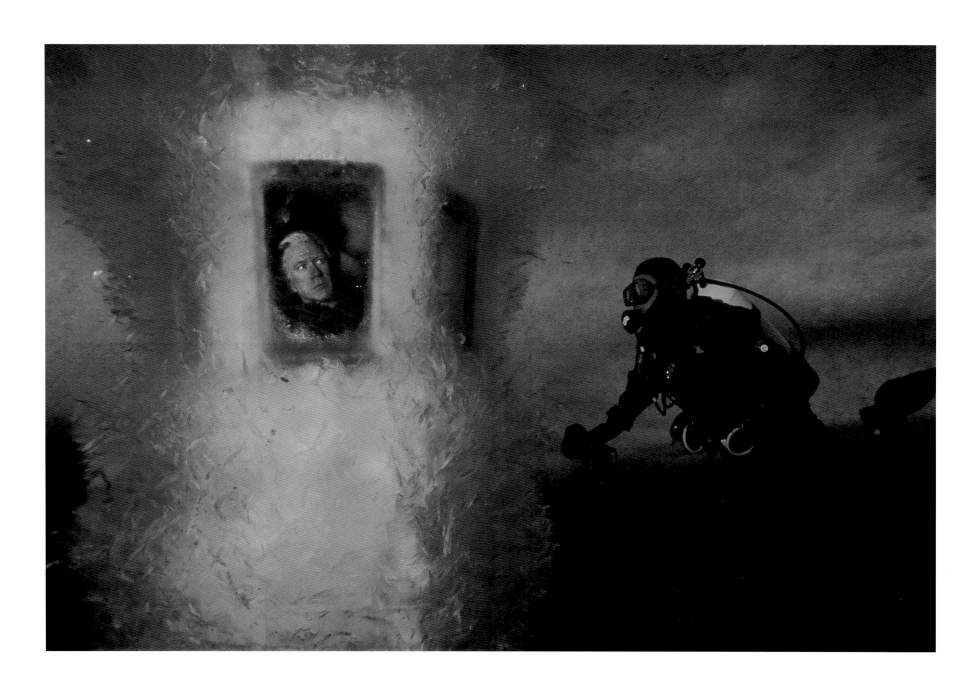

McMurdo Station's underwater observation chamber was designed and built in the early 1960s to allow biologists to observe Weddell seals in their natural habitat. The chamber is still used for that purpose, but more recently scientists have used it to observe the diving behavior of emperor penguins. Access to the chamber is through a tube barely wide enough to accommodate a thin person wearing a parka. The chamber extends 7.5 meters (25 feet) below the surface, shallow enough to become encased in anchor ice—which divers must clear from the windows on a regular basis. On occasion, nonscientists are permitted a glimpse of the strange world beneath the ice. Here, Guy Guthridge, director of the Polar Information Department at the National Science Foundation's Office of Polar Programs, watches divers through the tube's thick glass ports.

Hovering above a field of anchor ice and against a backdrop of sea ice, a diver peers over a bed of anemones *(Urticinopsis antarctica* and *Isotealia antarctica)* on the sea floor below Arrival Heights, on Ross Island. The lack of anchor ice below about 15 meters (50 feet) allows fast-growing cnidarians like soft corals and anemones to thrive.

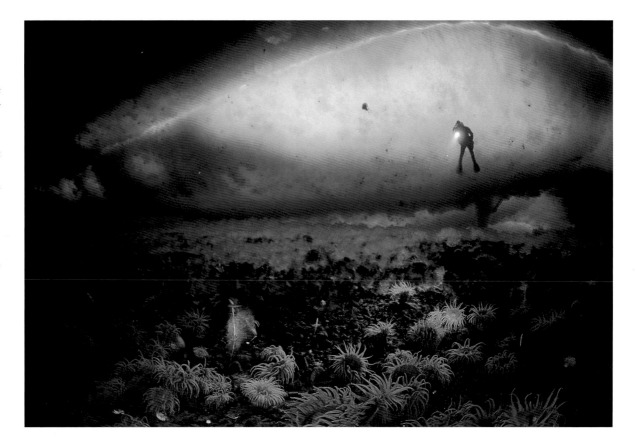

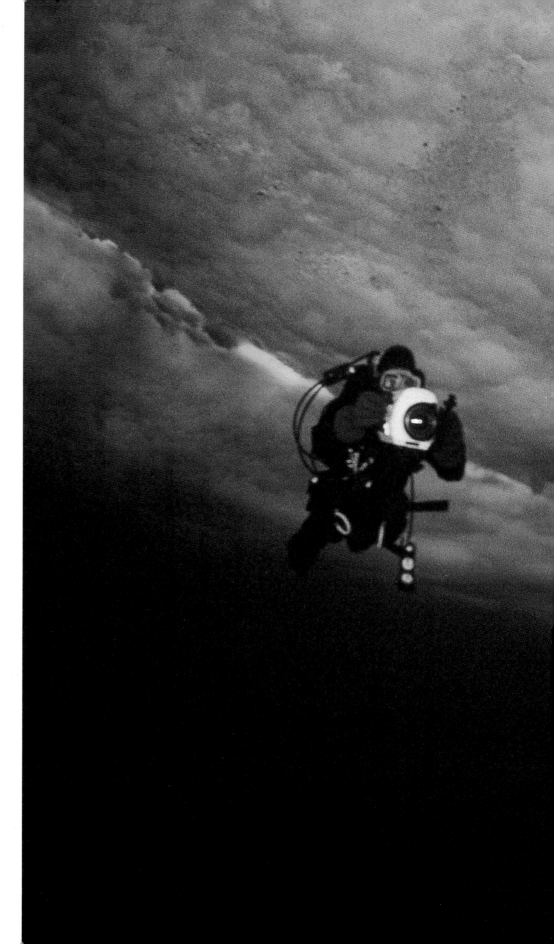

The largest and most impressive member of the plankton community in McMurdo Sound is the giant scyphomedusa *Desmonema glaciale*. The umbrella of this gelatinous carnivore can be over 1 meter (3.3 feet) in diameter, and its thick, cordlike tentacles can be over 9 meters (30 feet) long. *Desmonema* is found throughout the Southern Ocean, where it trolls shallow continental shelf waters for a variety of pelagic and benthic prey items including euphausiids, fish, and sea stars. This giant jelly is also one of the few predators of the noxious nemertean worm *Parborlasia corrugatus*.

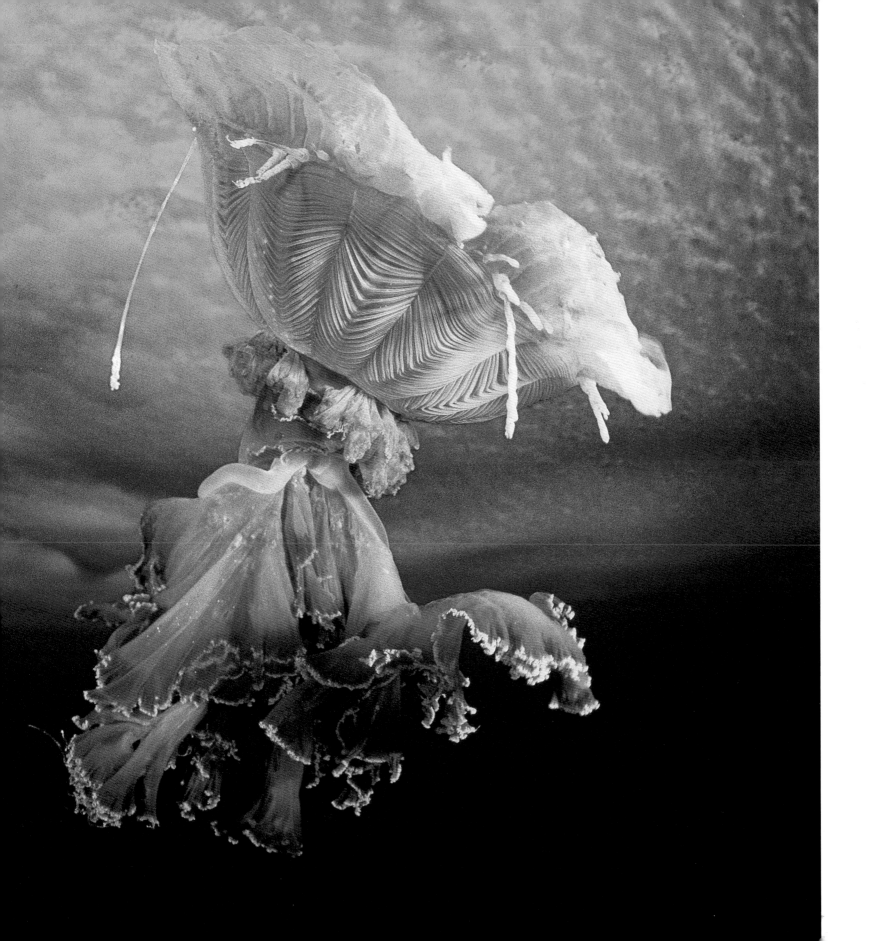

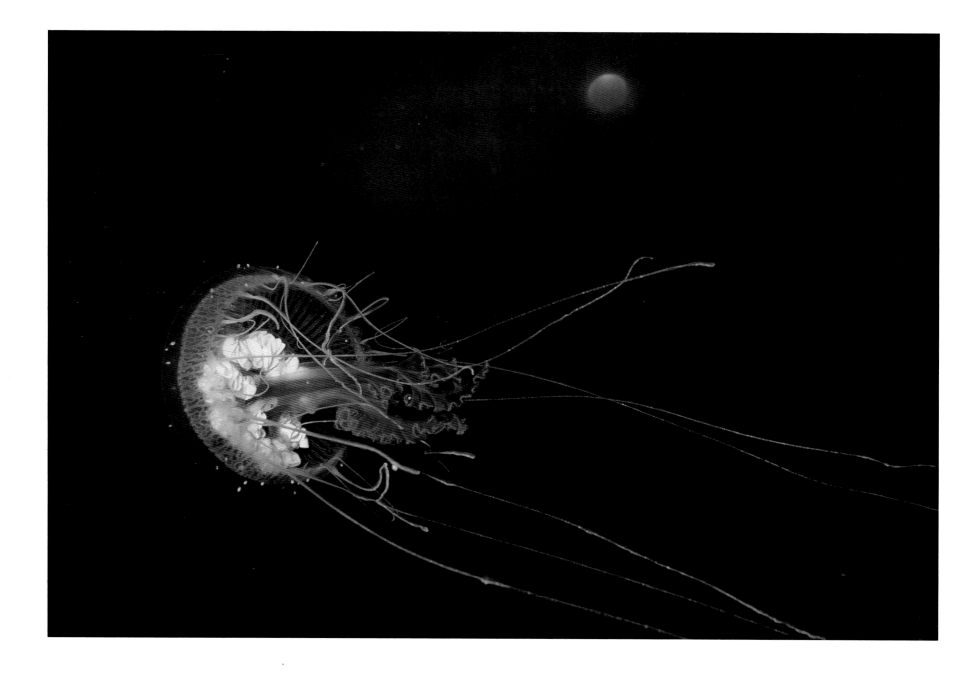

The common Antarctic medusa *Diplulmaris antarctica* drifts through a sea of darkness, beneath the perfect circle of a distant dive hole. These jellies are abundant in McMurdo Sound, where they feed on other medusae, copepods, ctenophores, pteropods, and a variety of invertebrate and fish larvae. Each jelly plays unwitting host to a number of hitchhiking amphipods, particularly of the species *Hyperiella dilatata*. Since most of the freeloading amphipods are juveniles and females, scientists speculate that they are using the medusa as a refuge from predation, and perhaps as a mating station.

Urticinopsis antarctica and the very similar *Isotealia antarctica* are two of the largest and most conspicuous inhabitants of the 15- to 30-meter (50- to 100-foot) zone around Ross Island. *Isotealia antarctica* also inhabits the sponge community below 30 meters and is found as deep as 600 meters (1,970 feet). ¶ Both anemones are known to consume medusae that drift to the bottom. Indeed, jellies make up about one-fifth of the diet of *Urticinopsis antarctica*. Since these anemones often grow very near one another, two or more may simultaneously attack a medusa, with the hapless jelly being pulled to pieces in the ensuing tug-of-war.

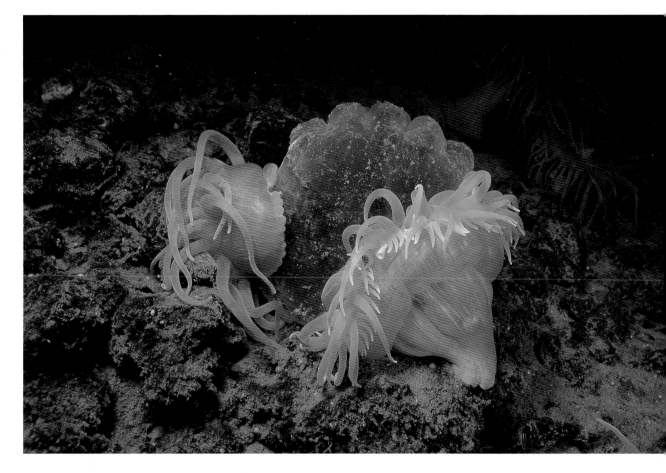

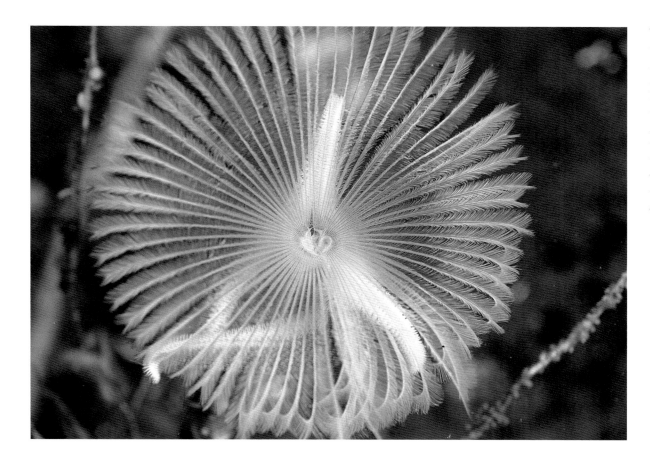

The common red sea star *Odontaster validus* is the omnivore of the Antarctic benthos, the goat in the Antarctic backyard. *Odontaster* tastes run from sponges to other sea stars to seal feces. Here an *Odontaster* climbs up the stiff stalk of the Antarctic featherduster worm (probably *Perkinsiana littoralis*). The moment the star's arm touches the worm's feathery feeding appendages, the worm will withdraw them. However, the worm's tubelike home may not protect it from the star, which can extrude its stomach and digest the worm in its own lair.

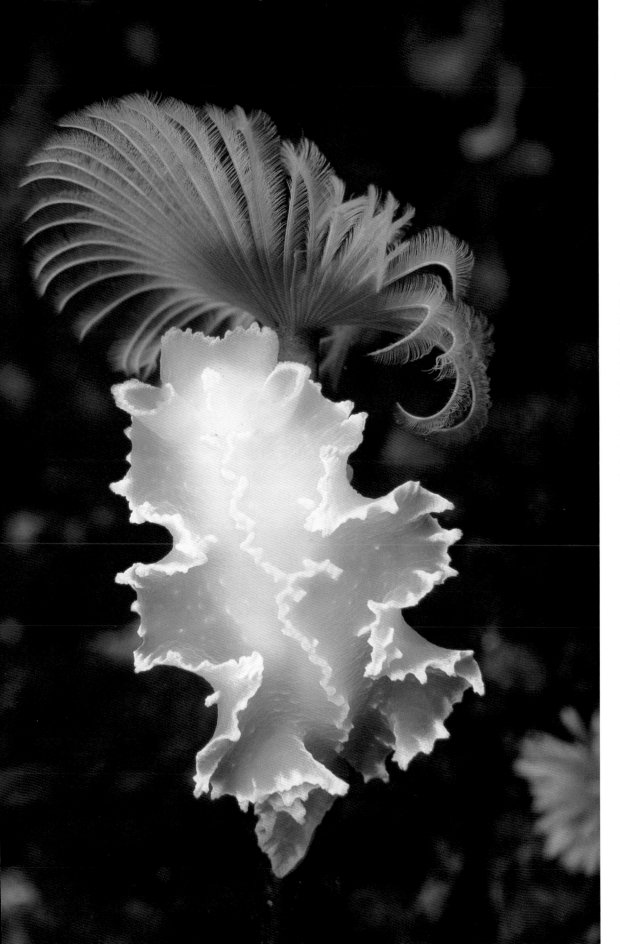

31

The nudibranch *Tritoniella belli* is fairly common in McMurdo Sound, where it apparently feeds on the colonial hydroid *Ophiodes arboreus* and on the soft coral *Clavularia frankliniana.* The soft coral manufactures chimyl alcohol, which the nudibranch incorporates into its mantle as a chemical defense against predation. *Tritoniella belli* has also been observed on the sponges *Homaxinella balfourensis* and *Kirkpatrickia variolosa* and on the soft coral *Alcyonium antarcticum* and may consume those organisms. Here, *Tritoniella belli* is climbing the stalk of a featherduster worm, where it is may be feeding on attached hydroids.

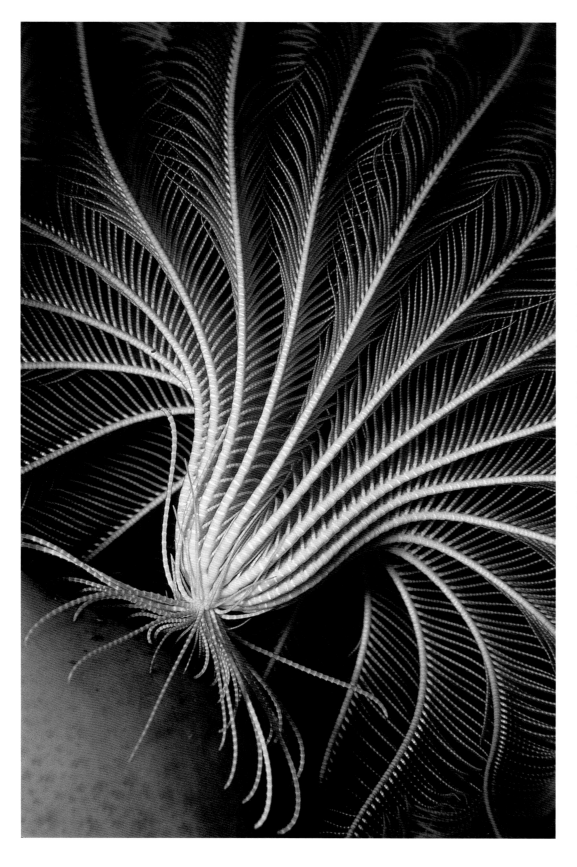

The crinoid *Promachocrinus kerguelensis* sits like a lush fern atop a sponge, its branchlike arms splayed out to collect food. Crinoids are suspension feeders, dependent on planktonic organisms and detritus drifting down through the water column or pushed by currents. The arms capture the food, which is then transported by cilia in grooves toward the central mouth. ❡ *Promachocrinus kerguelensis,* though oddly uncommon in the shallow waters around Ross Island, is numerous in the oligotrophic backwater of Explorers Cove. Generally it is the most abundant and widely distributed crinoid in Antarctic waters. It is usually found perched above the substrate on sponges or rocks. It grasps hold of its perch with special structures called cirri, which the crinoid also uses to walk.

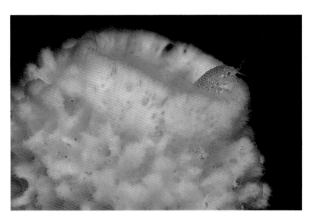

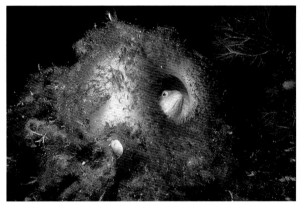

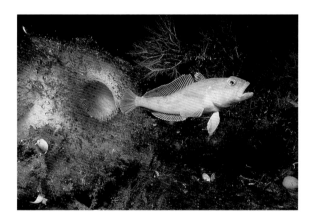

Sponges provide food, shelter, and breeding habitat for a plethora of other creatures. Without them, it is unlikely the benthic community below 30 meters' depth (100 feet) would be as rich and diverse as it is. Many, perhaps most, of the existing symbiotic relationships have yet to be discovered and described. Here, a flabelliferan isopod *(Natatolana* sp. or *Aega* sp.) pokes its head out of the osculum of a sponge, probably *Haliclona dancoi.*

Benthic fishes occasionally take advantage of the shelter provided by sponges. Here, an emerald notothen *(Trematomus bernacchii)* rests in an unidentified sponge, then suddenly shoots into the open water. ¶ *Trematomus bernacchii* is the fish most frequently seen by divers in McMurdo Sound. Like all *Trematomus* species, *T. bernacchii* tends to sit on the bottom and move infrequently. When it does stir, it typically does so by sculling along with its oversized pectoral fins, reserving caudal muscle use for prey capture or predator avoidance. *Trematomus bernacchii* consumes a large variety of prey items, including polychaetes, nematodes, crustaceans, echinoderms, tunicates, and molluscs. This species spawns in December and January in McMurdo Sound and lays eggs either on the sea floor or inside certain hexactinellid sponges, such as *Rossella nuda.*

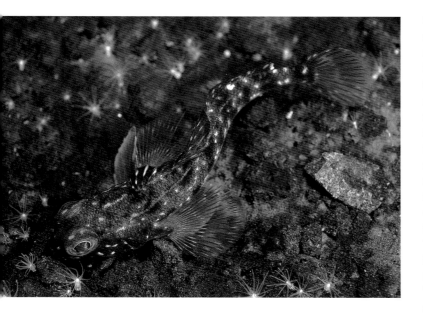

Camouflaged by protective coloration, a sharp-spined notothen *(Trematomus pennellii)* sits quietly on the bottom. The Antarctic fish fauna is dominated by a single group of perciform fishes called notothenioids, of which there are more than 120 known species, 95 of them endemic to Antarctica. The single most significant feature of the Antarctic notothenioids, and the reason they have been so successful in Antarctica, is that they are all loaded with glycopeptide antifreeze molecules. (Unlike invertebrates, which are iso-osmotic with seawater, fishes are hypo-osmotic and would freeze solid in McMurdo Sound's frigid waters were it not for the glycopeptides.) These sugar-protein molecules work by adsorbing to small ice crystals in the fishes' blood or tissues and preventing the crystals from growing. This key adaptation (which is not perfect: divers sometimes find fish curled up and stiff on the bottom, as though nearly frozen) has allowed the notothenioids to radiate and fill niches and roles that would normally be occupied by other fishes. Their dominance in the Southern Ocean is also abetted by the lack of competition from other fish groups. ◗ All notothenioids lack a swim bladder, and most are negatively buoyant. Thus, the vast majority of species are benthic and can take advantage of the great variety of food and habitat found on the sea floor. Most benthic notothenioids are slow moving and often can be caught by hand.

Anchor ice begins to form in the Antarctic spring and early summer, when supercooled water moves north from under the McMurdo and Ross Ice Shelves. Although this water is only 0.1–0.2°C colder than the water in the sound, the difference is enough to promote ice growth. Tiny crystals form, shimmering in the water column. Larger crystals also begin to form on the shallow sea floor, where they soon grow into a blanket of interlocking plates that can be over 60 centimeters (2 feet) thick. ◗ Scientists believe that anchor ice is the primary cause of the clear horizontal zonation observed around Ross Island. From the shoreline to about 15 meters' depth (50 feet), anchor ice essentially scours the bottom of sessile organisms like sponges and anemones. The sea floor in this region is therefore barren except for motile animals like fish, sea stars, and sea urchins. From 15 to about 30 meters (100 feet), depths at which anchor ice forms only sporadically, the benthos is dominated by sea anemones and soft corals, with a few fast-growing sponges. Still, there is usually plenty of bare rock. Below about 30 meters' depth, where anchor ice is rare or nonexistent, the sea floor is covered with a rich and diverse sponge community.

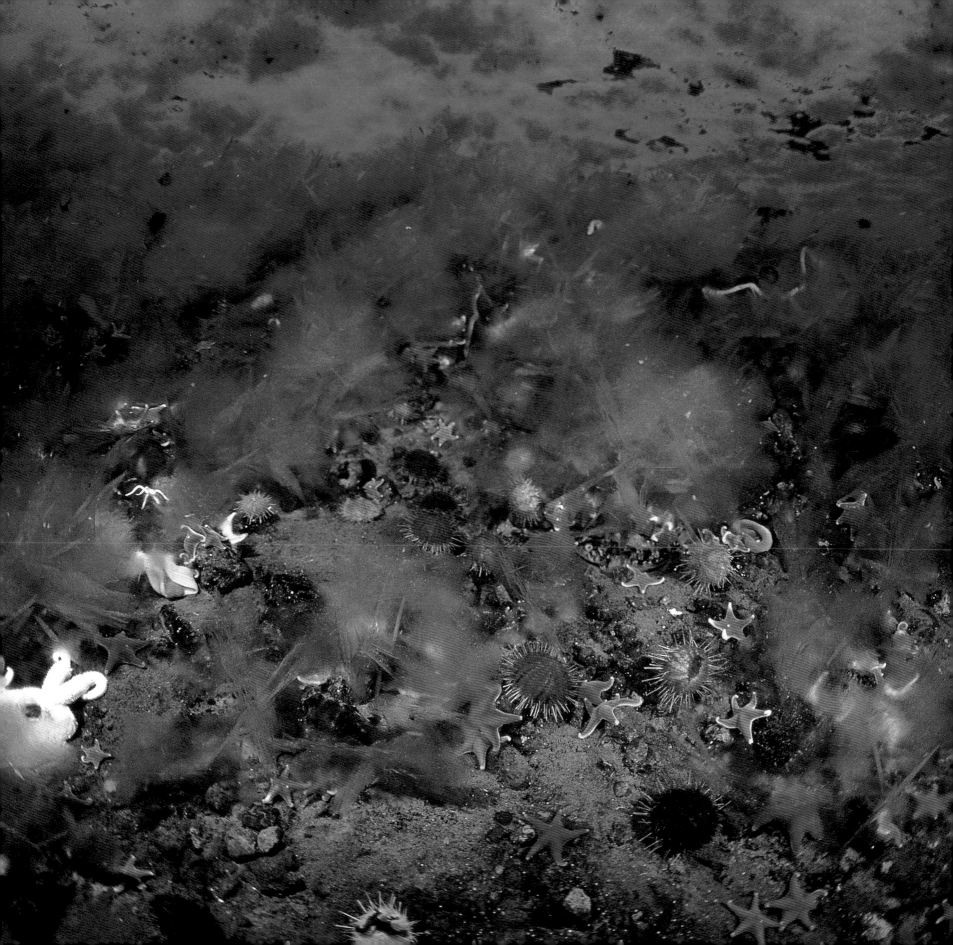

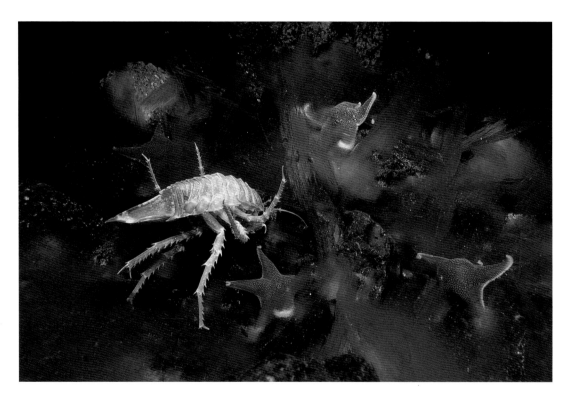

A giant isopod, *Glyptonotus antarcticus,* picks its way through anchor ice near some red sea stars *(Odontaster validus).* There are 346 known Antarctic isopod species, of which 302 are endemic. In some cases, isopods have evolved to fill the niches normally occupied by crabs and lobsters, which are not found in Antarctica. ¶ Like most of its distant relatives, the Antarctic sea spiders (pycnogonids), this isopod is an example of cold-water gigantism, wherein normally small organisms grow to unusually large sizes; *G. antarcticus* can reach a length of 20 centimeters (8 inches). As befits its science-fiction-ugly appearance, *G. antarcticus* is a voracious predator that devours just about anything it encounters, including brittle stars, sea urchins, other crustaceans, polychaete worms, molluscs, and carrion. Researchers have learned not to place captured *G. antarcticus* in aquariums with other animals, for soon only the isopod is left.

Here a sea star *(Odontaster validus* or *O. meridionalis)* is climbing the anchor-ice-coated stalk of a bushy sponge *(Homaxinella balfourensis).* Since these stars normally consume *Homaxinella,* the anchor ice may actually be serving a protective function. Any benefit, however, is likely to be short-lived. ¶ The fast-growing *Homaxinella balfourensis* thrives in the relatively open 15- to 30-meter zone (50–100 feet), but only in years when anchor ice accumulation is minimal. When anchor ice formation is more robust, it crystallizes thickly on the sponge. Soon its buoyancy lifts the sponge off the bottom and floats it up to freeze into the underside of the sea ice. In heavy anchor ice years, most of the *H. balfourensis* down to 30 meters is removed in this manner.

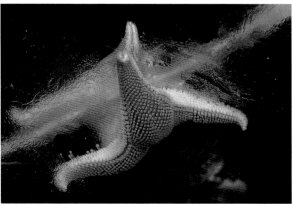

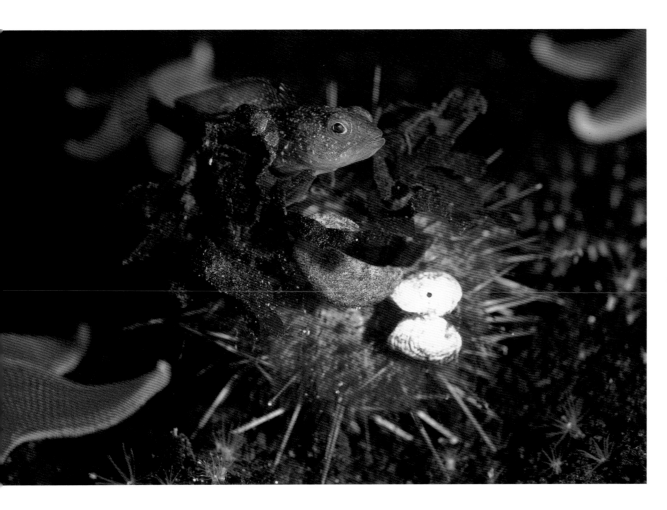

The sea urchin *Sterechinus neumayeri* is one of the most common Antarctic marine organisms. It is especially prevalent in water above 15 meters (50 feet), where it grazes on benthic diatoms, hydroids, bryozoans, polychaete worms, foraminiferans, and seal feces. The demersal larvae of other benthic invertebrates may also be consumed. *Sterechinus neumayeri* grows very slowly and may take forty years to reach a diameter of 7 centimeters (2.75 inches). ¶ To protect itself from predation—especially by the anemone *Urticinopsis antarctica*—the urchin covers itself with a variety of objects, including bivalve shells, rocks, other invertebrates such as sea cucumbers and the soft coral *Clavularia frankliniana,* and the macroalga *Phyllophora antarctica.* When an urchin brushes up against an anemone, tentacles reach down and latch onto the macroalga (or other cover), which either the urchin drops, making its escape, or the anemone soon releases. Uncovered urchins are invariably devoured.

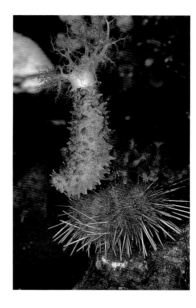

When an urchin needs camouflage, almost anything will do, it seems. Here, a *Sterechinus* has picked up a hitchhiker in the form of a sea cucumber (possibly *Echinopsolus acanthocola*). The sea cucumber will get the short end of the stick if the pair stumbles into a sea anemone. When the anemone's tentacles touch the cucumber, the urchin will drop it immediately and scamper away (relatively speaking), while the unfortunate cucumber will be pulled into the anemone's mouth and devoured.

Odontaster validus is one of the most colorful and prominent members of the Antarctic benthic community. It is also the most abundant sea star species in shallow shelf waters. Though found in highest density from 15 to 200 meters' depth (50–650 feet), *Odontaster* have been observed as deep as 914 meters (almost 3,000 feet). ¶ Like most animals of the Antarctic benthos, *O. validus* stars are slow-growing. It takes them about nine years to reach a weight of 30 grams (1 ounce), the mean size of shallow-water individuals near McMurdo Station.

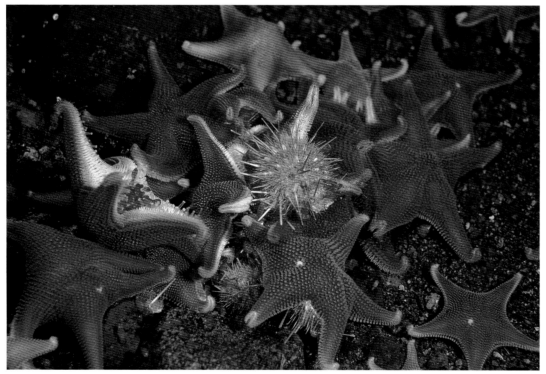

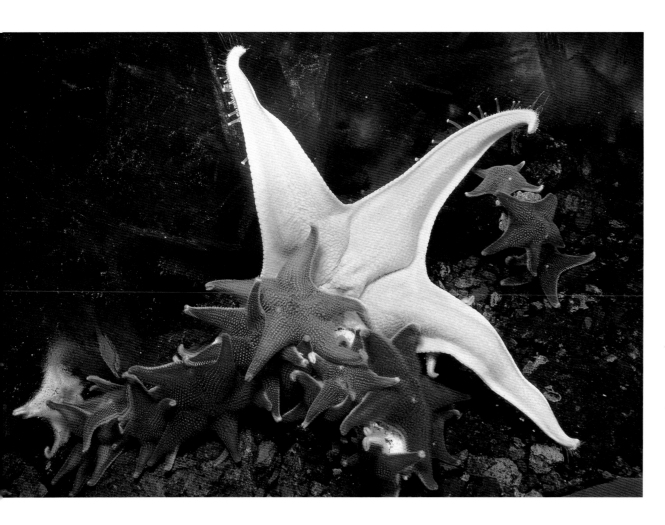

Although the red star *Odontaster validus* is an omnivore that frequently browses on benthic diatoms and detritus, it is also a voracious predator. Divers often find individuals clumped together in slow-motion feeding frenzies. Drawn by some chemical signal, *O. validus* will swarm over a food item, each star trying to snatch a share of the bounty. Here a mob of them is attacking and consuming the much larger *Acodontaster conspicuus*. A single *O. validus* encountering an *A. conspicuus* may climb on a ray and evert its stomach to begin digesting. The release of coelemic fluid from the *A. conspicuus* probably attracts other *O. validus* individuals, which overwhelm and devour the hapless *A. conspicuus*. ❡ Both *A. conspicuus* and *O. validus* are key members of the McMurdo Sound sponge community. *Acodontaster conspicuus* eats sponges, particularly the rossellid sponges (like *Anoxycalyx* [*Scolymastra*] *joubini*), and would probably become numerous enough to devastate the sponge community were it not for the actions of *O. validus*. The smaller star preys on the larvae, juveniles, and adults of *A. conspicuus,* thereby keeping its population in check.

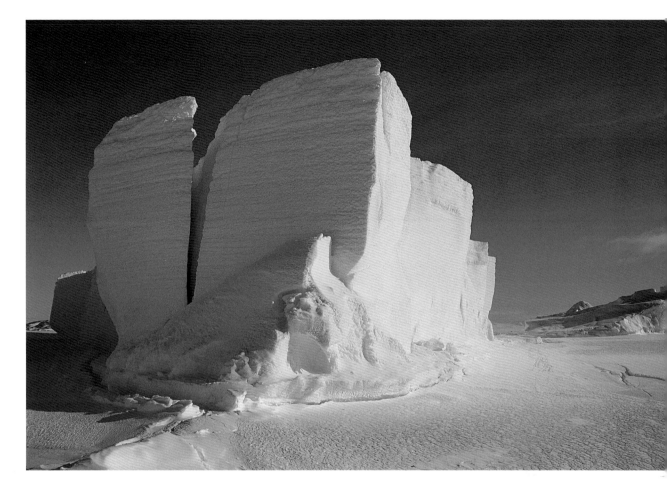

Tabular icebergs like this one (left) are unique to Antarctica. Their production by calving from ice shelves and floating glaciers is evidence that Antarctica's ice cover is in constant flux. The process begins on the polar plateau, where the snowfall of thousands of years is compressed into ice. The resulting ice sheet flows downhill and toward the coastline, where it breaks off into icebergs. The system has been in equilibrium for millennia, and recent research on the West Antarctic Ice Sheet has shown that the loss of ice through icebergs continues to be balanced there by ice accumulation inland. Nonetheless, the recent disintegration of the Larsen Ice Shelf on the Antarctic Peninsula is taken as a warning that global climate change may be disrupting the balance in other areas.

The tip of an iceberg juts above the sea ice in shallow water south of Cape Evans (above right). Icebergs like this one continually calve from the McMurdo Ice Shelf, as well as from the glaciers that jut into McMurdo Sound and nearby waters. Driven by wind and current into shallow water, the iceberg gouges a swath through the bottom community of animals until it is frozen in place by the sea ice. The barren scour it leaves in its wake is quickly settled by pioneer species, the first step in succession. As more and more taxa move in, with some later species replacing the early ones, the scour ultimately begins to resemble its original state. Apart from the activity of anchor ice, iceberg scour is the only significant physical disruption of the benthos.

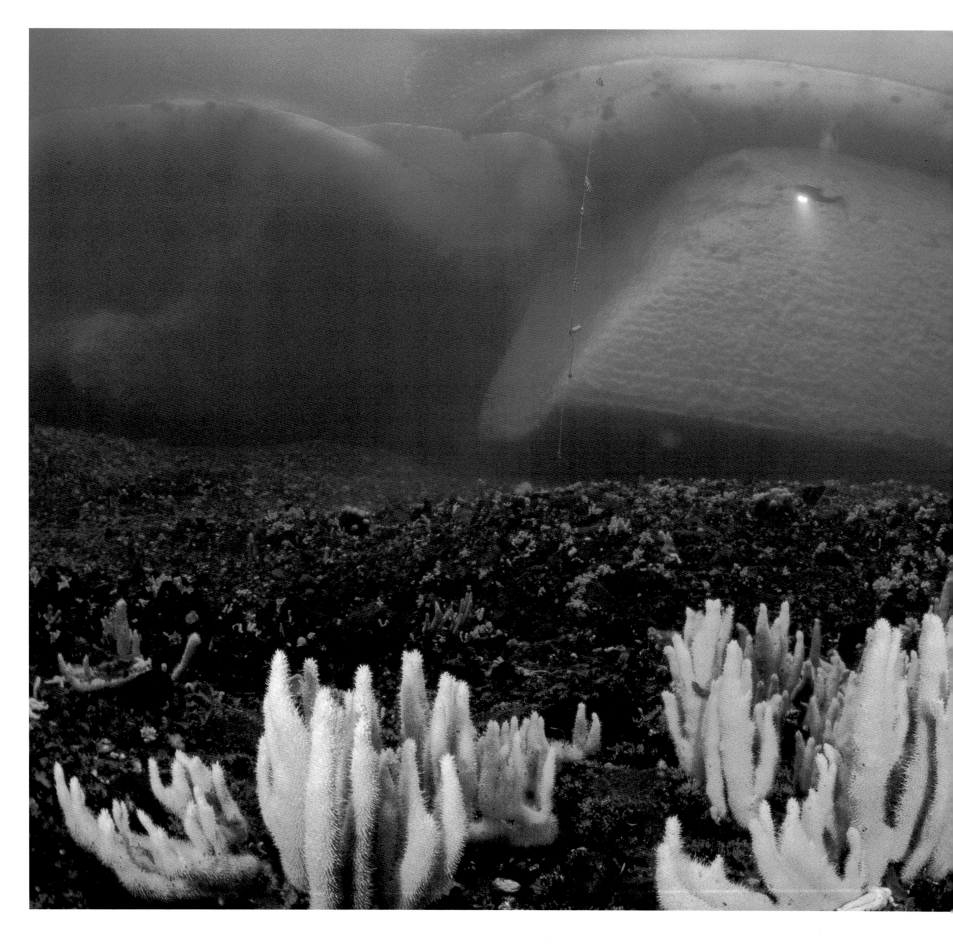

Against the backdrop of a grounded iceberg, a diver shines his light toward a cluster of bright yellow polychaete sponges *(Isodictya erinacea)*. Because they cannot run from predators, many sponges have developed other means of protecting themselves. One such method involves producing chemical compounds that are either toxic or bad tasting—and sometimes both. These compounds, called secondary metabolites because they have no clear metabolic function, often impart a bright color to their host. Scientists studying the chemical ecology of the Antarctic benthic community therefore pay particular attention to brightly colored sponges in their search for novel and interesting compounds. In experiments, for example, certain compounds extracted from samples of *I. erinacea*—which has no known predators—caused the tube feet of the sponge-eating sea star *Perknaster fuscus antarcticus* to retract. Another of these extracts exhibited antifungal and antibacterial activity.

Isodictya erinacea is one of the most striking and colorful of the sponges in McMurdo Sound. With its branched structure and spines, it looks much like a cactus growing from the sea floor. (Early researchers thought it looked like a polychaete worm, hence the name.) Here the sponge provides a temporary resting place for an emerald notothen *(Trematomus bernacchii)*.

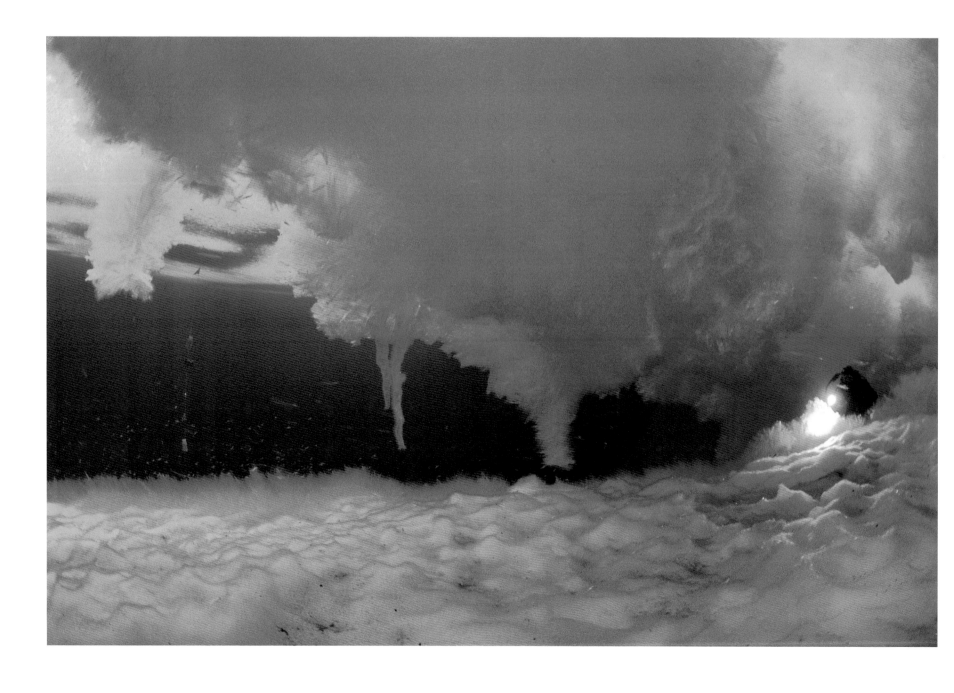

A diver explores a cavelike environment between the sea ice and a grounded iceberg. The dimpled surface of the berg is covered with cryophilic algae and grazing amphipods.

Antarctic notothenioid fishes wage a never-ending battle against ice. All of them produce glycopeptide antifreeze molecules that inhibit the growth of microscopic ice crystals in the body. But the tiny crystals are constantly entering through the gills, through the mouth with ice-laden water and food, and even through the skin. Close contact with large chunks of ice can even cause microscopic ice crystals to form in the blood and tissues. Unlike most other fish, which seem to avoid this contact, the bald notothen *(Pagothenia borchgrevinki)* actively seeks it out. Although a benthic form is found as deep as 695 meters (2,280 feet), many "borchs"—which grow to a length of 28 centimeters (11 inches)—live in close association with sea ice, glaciers, ice shelves, and icebergs. Contact with this ice exposes these fish to more ice crystal incursions than their benthic and pelagic cousins experience. Yet the borchs thrive, perhaps because they produce eight different forms of antifreeze molecule, more than most other notothenioids.

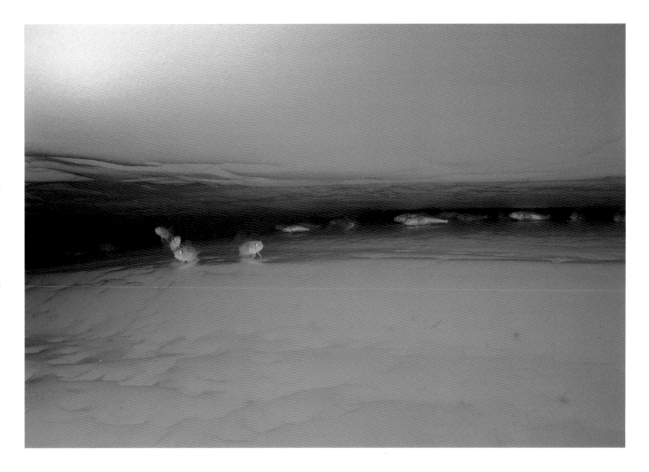

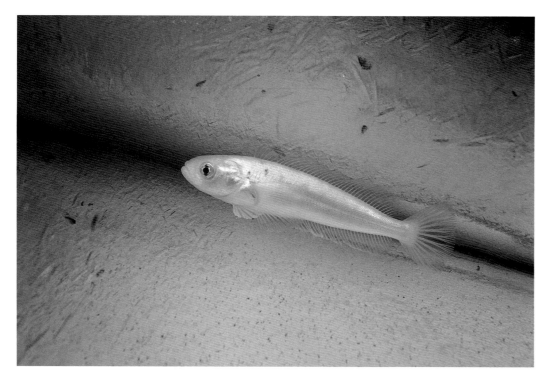

Pagothenia borchgrevinki and its notothenioid cousins are supremely adapted to the low but extremely stable water temperature of McMurdo Sound (-1.86°C ± 0.2°C). The flip side of this adaptation is that these fish are exquisitely sensitive to temperature changes. They die at 6°C (42°F), the lowest heat-death temperature known for any animal. In fact, the notothenioids seem to require a constancy of cell temperature (albeit a cold one) more reminiscent of mammals than of fish. In a way, they can be thought of as ectothermic homeotherms, terms that are normally considered mutually exclusive.

Pagothenia borchgrevinki inhabit nearly every iceberg or floating glacier, where they ensconce themselves in narrow cracks and tiny holes. They are also often found in the under-ice platelet layer, where they hunt algae-grazing amphipods and hide from predators—the latter not always successfully. Head-mounted cameras on emperor penguins and Weddell seals, which prey on these fish, have recorded both predators plucking borchs from the platelet ice. The seals even exhale bubbles into the ice to flush out the fish (see page 63).

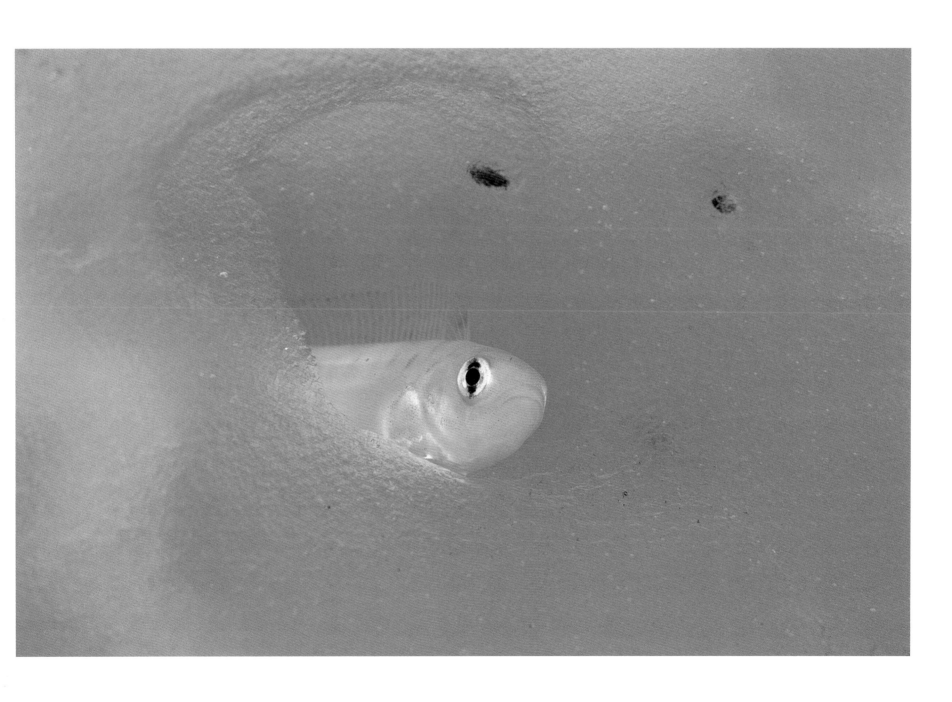

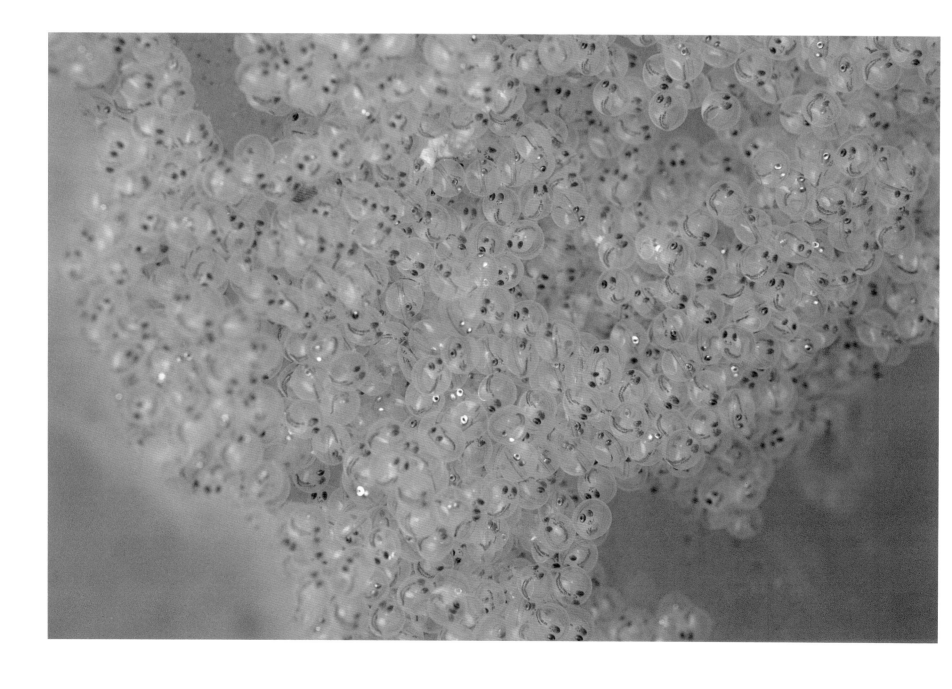

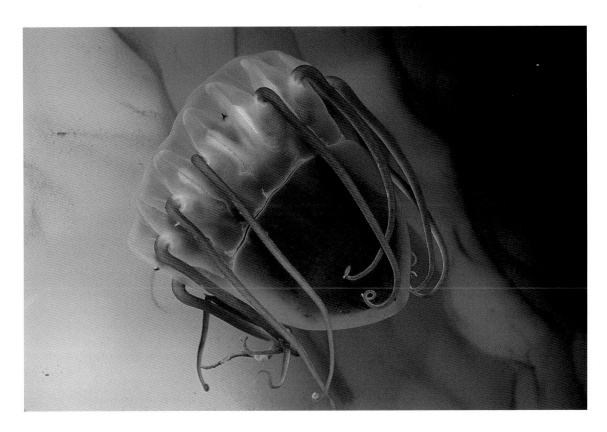

This mass of pellet-sized *Pagothenia borchgrevinki* eggs (far left) was found in a small pocket in a grounded iceberg. Bald notothens may be unique among fish species for laying their eggs on ice. Like the adults, the eggs are protected from freezing by glycopeptide antifreeze molecules.

The helmet jelly, *Periphylla periphylla,* is the most abundant and widely distributed scyphomedusa in deep water worldwide. It also ventures to the surface at times, especially at night and at high latitudes. In McMurdo Sound, where the water temperature and the darkness under the ice approximate the conditions of the deep sea, *Periphylla* is often found near the surface. This strange beast can reach 35 centimeters (14 inches) in diameter and frequently is seen swimming upside down. When unfortunate zooplankters are captured by *Periphylla*'s twelve short tentacles, it swings the tentacles inward to bring the prey to the mouth.

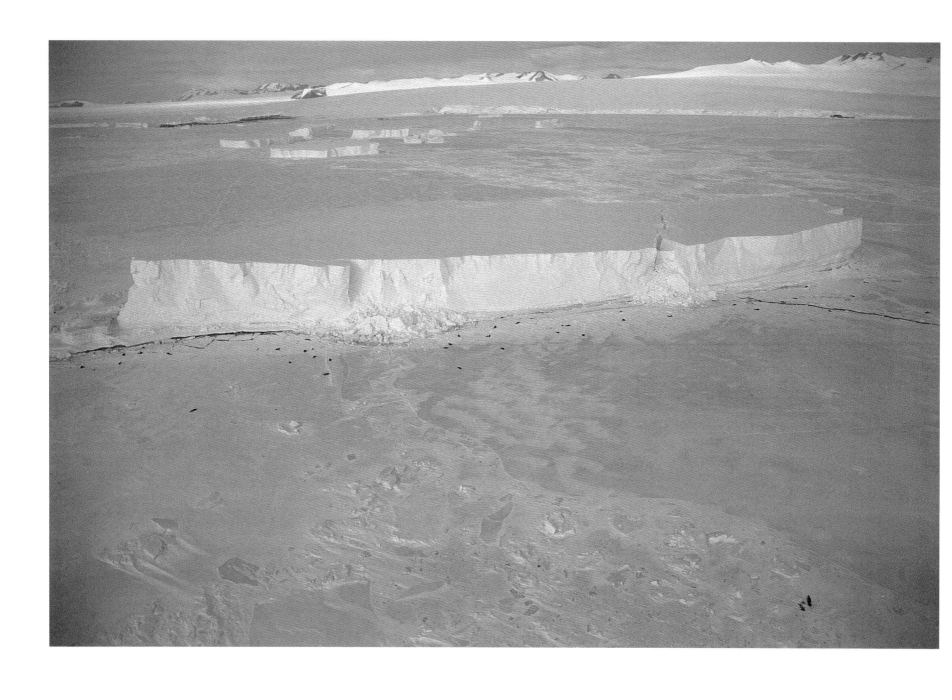

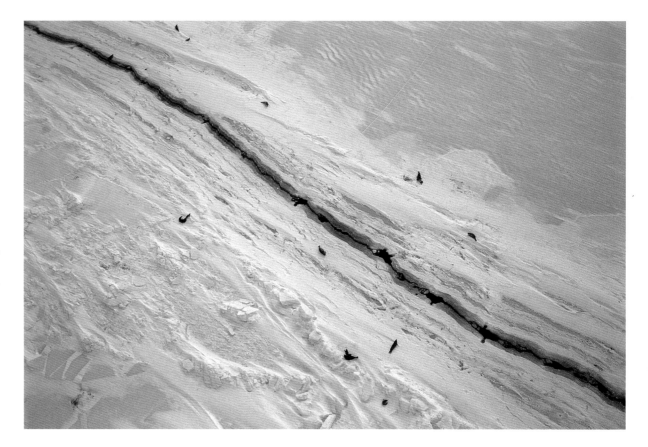

The fast-ice sheet that covers McMurdo Sound is subjected to constant pressure by the slow northward movement of the McMurdo Ice Shelf. This pressure forces the sea ice against obstructions, such as promontories, islands, and icebergs. The process deforms the ice sheet, creating cracks and pressure ridges. Tidal activity also causes cracking near shorelines. Whatever their cause, cracks are like seal magnets, and the sea ice around islands and icebergs is often littered with basking Weddell seals—seen here (left) as black dots near the berg. Historic, predictable cracks like those near islands and promontories are used as breeding areas. Cracks near icebergs serve as handy rest areas, but they are too ephemeral to serve as breeding colonies. Next season, the iceberg may be gone.

Here (above right), Weddell seals have taken advantage of an active crack to haul out onto the sea ice. During the winter and early spring, Weddell seals tend to stay in the water to avoid the bitterly cold air and the raging storms. Also, their breathing holes during those cold months are often not large enough for the seals to pass through. During the summer, though, with its milder temperatures and wider sea-ice cracks, large numbers of seals will relax on the ice.

A mother Weddell seal and her newborn pup rest on the sea ice near a pressure ridge at Little Razorback Island. Few animals endure as dramatic a change in environment as a Weddell pup when it is born. The pup is ejected from a 37°C (98.6°F) liquid womb onto hard ice, where the temperature might be -20°C (-4°F) and a wind might be blowing at 30 knots. Fortunately, the pups are covered with a thick natal coat of gray fur called lanugo. After about two weeks, they begin to molt into a silver-gray, spotted coat like that of adults.

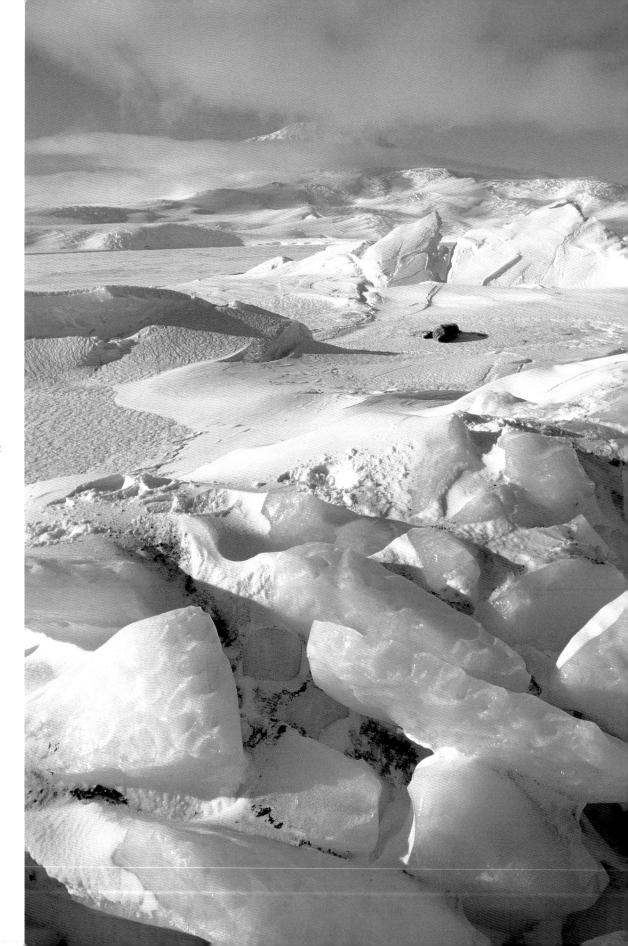

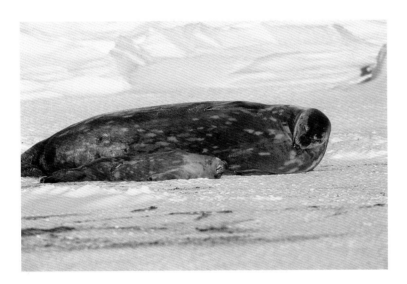

Most Weddell seal pups are born by early November. The mother stays with the pup constantly for the first two or three weeks, after which she may leave it alone on the ice while she makes short dives. The mother's milk starts out at about 30 percent fat and becomes progressively richer until it is as much as 60 percent fat. With that kind of diet, the pups are able to put on about 2 kilograms (4.5 pounds) a day, and they begin to lay down the thick blubber layer that will ultimately protect them from the cold. When they wean, at about seven weeks, they weigh 100 kilograms (220 pounds) or more. The mother, on the other hand, will have lost 100 to 150 kilograms (220–330 pounds) of her original 450 kilogram (990 pound) weight.

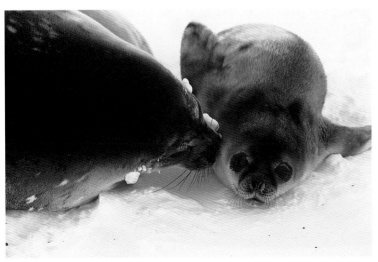

A mother Weddell seal sniffs her newborn pup. Smell seems to be an important means of identification between mothers and pups, though they also frequently call to each other. The mother sniffs the pup often and will turn away pups that don't smell right. If her own pup has been contaminated with the scent from another, she may reject it.

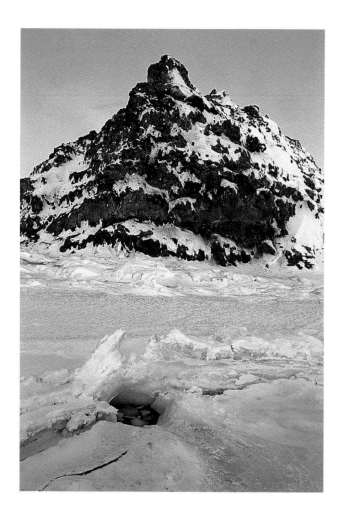

Of the five species of true seal that inhabit Antarctic waters, Weddell seals *(Leptonychotes weddellii)* are the only ones adapted to life in a fast-ice environment. They are also the only naturally occurring mammal to live this far south year-round. Weddells possess forward-angled upper incisors that allow them to ream breathing holes in the ice and keep them open during the winter, when standing water freezes quickly. At times, the hole they maintain is barely big enough for their nostrils. Nonetheless, the ability to live under nearly solid ice allows Weddell seals to thrive where no other mammal could even survive. Not only does this mean less competition for food resources, but the fast ice also affords them unparalleled protection against predation. In fact, only when the fast ice clears out of McMurdo Sound in late summer are Weddells at risk of attack by their only significant predators, the orca whale *(Orcinus orca)* and the leopard seal *(Hydrurga leptonyx).* ¶ Weddell seals eat a large variety of vertebrates and invertebrates, including fish, squid, octopus, and euphausiids. Although they consume many fish species, including on occasion the giant Antarctic toothfish, or cod *(Dissostichus mawsoni),* and the ice-dwelling bald notothen *(Pagothenia borchgrevinki),* a majority of their diet consists of the Antarctic silverfish *(Pleuragramma antarcticum),* which biologists believe lives in large schools in the midwater depths of the sound.

Exploring the shallow water near a seal colony can be both exhilarating and eerie. The otherworldly trills, buzzes, and thumps of Weddell seals fill the water and reverberate through the diver's body. The surface ice forms a multitude of caves and tunnels from which and into which seals are constantly slipping, like wraiths in a haunted house.

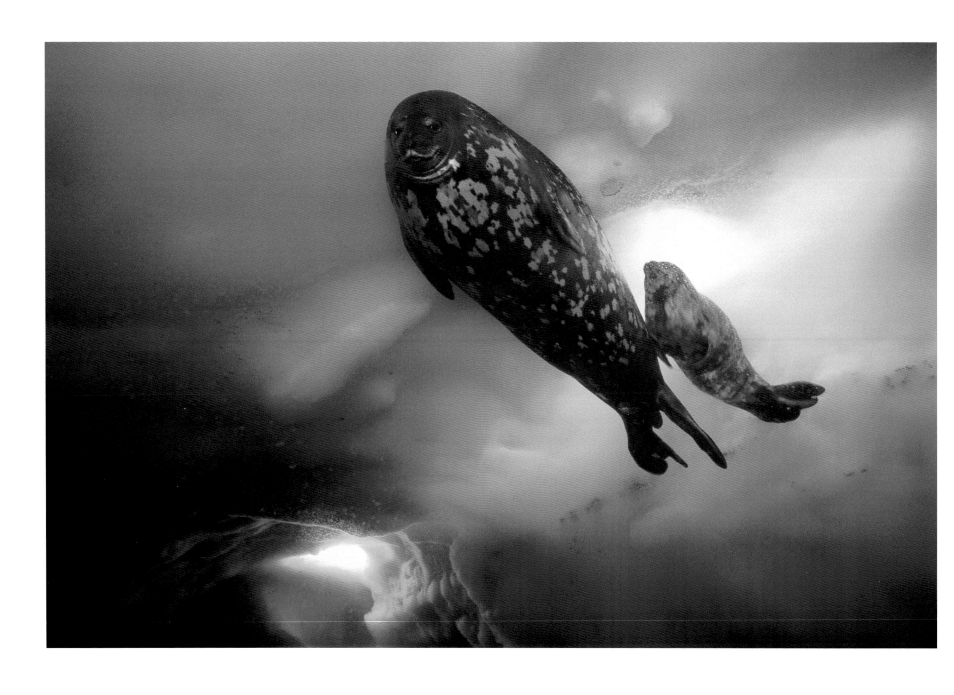

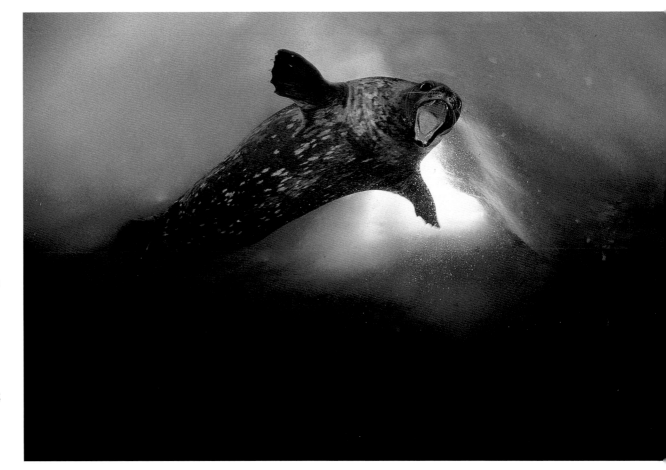

Shortly after losing their lanugo, at about two weeks, Weddell seal pups start taking to the water. The mothers encourage them, even forcing them in at times. The youngsters have only a short time to learn the fundamentals of caring for themselves and navigating the world under the ice before they are left to their own devices. When the two are in the water, the mother stays close by. If a bull or another female gets too close, the mother will chase it away. If the pup has trouble getting out of the water, the mother will assist by pushing from below. At the age of seven weeks, the pups are able to dive to 100 meters (330 feet) and hold their breath for 5 minutes. Within fifty days of birth, their mothers desert them.

A Weddell seal feigns aggression toward a diver, practicing for the day when he will have to defend a territory against other males. Much as other pinnipeds do on land, Weddell seal males establish well-defined territories underwater, which they defend aggressively against challengers, often engaging in violent undersea battles. During the October to mid-December breeding season, even the act of breathing can be danger-ous: a male with his head in the air is a fair target for nips at flippers and genitals. For this reason, males tend to take quick breaths and keep their heads in the water as much as possible, always looking down and around. (For the same reason, discerning divers exit a dive hole as quickly as possible if territorial seals are nearby.) On occasion, Weddell males will assume a head-down posture with rear flippers in the air as they attempt to prevent other seals from using a hole.

Weddell seals are among the world's most proficient divers. Instruments attached to adult seals have recorded dives of up to 82 minutes' duration and to depths in excess of 700 meters (2,300 feet). Since this represents the bottom of McMurdo Sound, it is entirely possible they can go deeper. Weddell seals manage these feats through a series of physiological adaptations geared to increasing diving capacity. The seals store a tremendous amount of oxygen in their bodies, bound to hemoglobin in the blood and to myoglobin in the muscles. They conserve this oxygen by reducing their heart rate and their circulation to most organs except the brain during a dive. In addition, after a few initial strokes with the flippers, Weddells relax and let momentum and gravity take over. Essentially, they sink into the depths. ❡ The vast majority of Weddell seal dives last 20 minutes or less. This is no coincidence, as biologists have calculated that 20 minutes is the seal's aerobic dive limit. This simply means that the Weddell seal can function for 20 minutes purely on stored oxygen, without any need to engage in the less efficient anaerobic metabolism that produces lactic acid as a by-product. Anaerobic dives require longer surface intervals to eliminate the built-up lactic acid and recharge oxygen stores and are therefore less efficient.

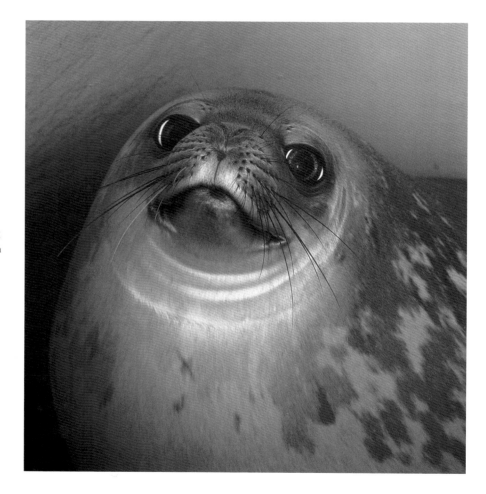

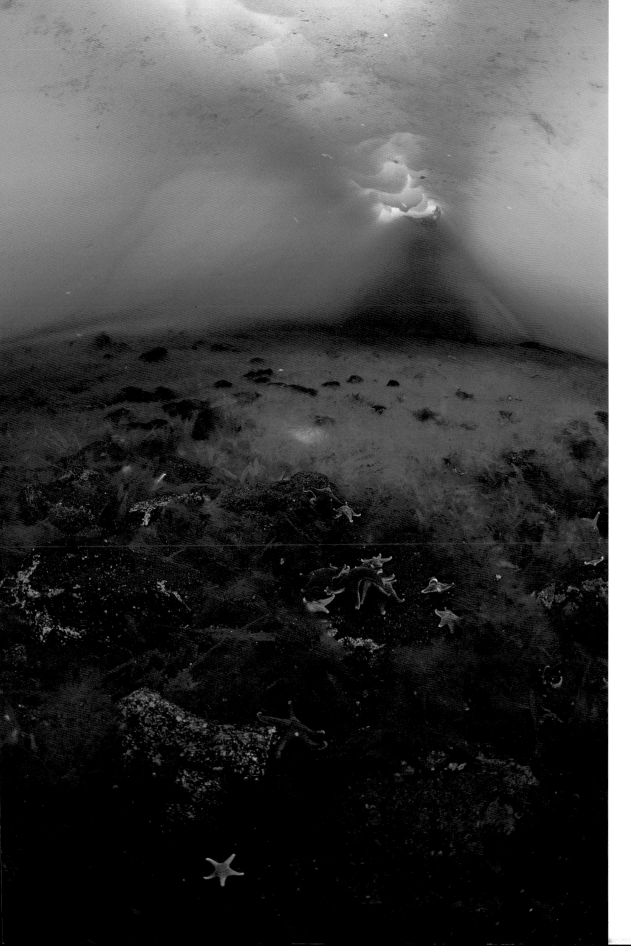

At left is a brightly lit, shallow, underwater ice cave near a seal colony, replete with *Odontaster validus* stars, anchor ice, and seal feces.

The red sea star, *Odontaster validus,* eats almost everything, including sponges, crustaceans, bivalves, and even dead seals. Like a shark drawn to blood, *O. validus* is presumably attracted to chemicals released by decaying matter, or to internal fluids released by prey in the course of an attack. The stars swarm over a food source, creating a conspicuous pile-up on the ocean floor. These pile-ups take place in slow motion and can last for days or weeks. Occasionally, a benthic fish, such as this *Trematomus pennellii,* is drawn into the fray.

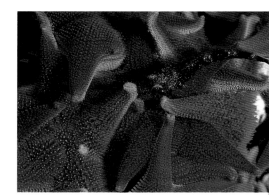

If *Odontaster validus* is drawn to food by a chemical signal, the nemertean worm *Parborlasia corrugatus,* another benthic scavenger, seems to be attracted in the same way. More often than not, these caustic worms, which exude an acidic slime, are found intertwined with the stars. Large feeding clusters, like the one seen here, are impressive, looking like great battle scenes in the eternal struggle between predator and prey. Often, however, they are nothing more exotic than scrambles for Weddell seal feces.

Below, three *Odontaster validus* stars of various sizes are joined by a sea urchin *(Sterechinus neumayeri)* and a spiny polychaete worm *(Flabelligera mundata)* on the dark, volcanic gravel that typifies the sea floor around Ross Island. The worm feeds on detritus and other organic material.

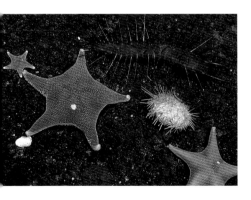

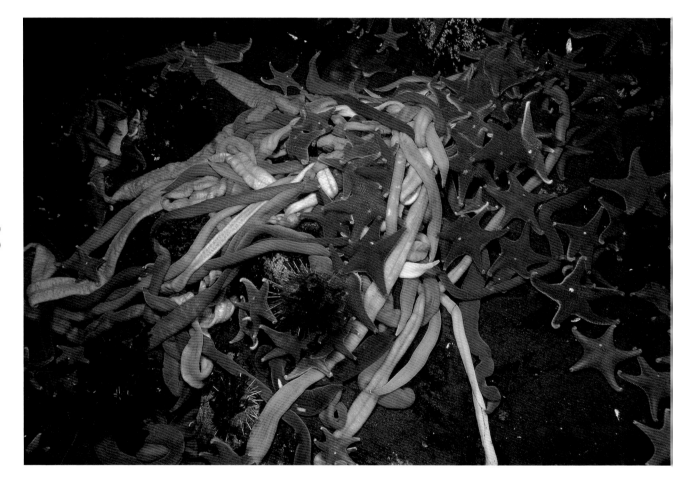

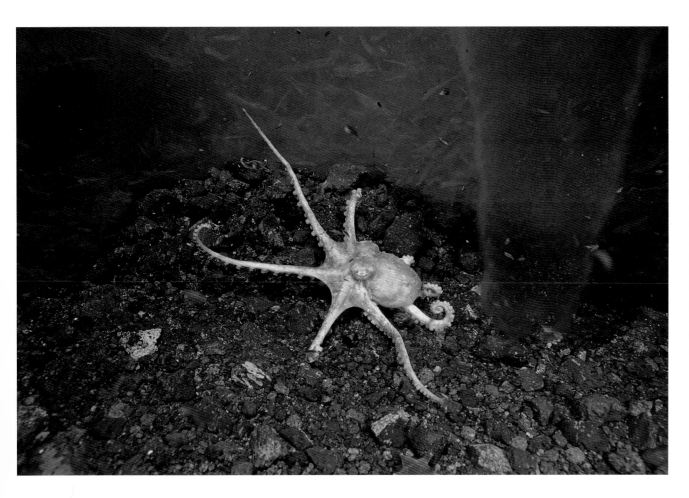

Little is known about the natural history of Antarctic cephalopods. Here a *Pareledone* species—probably *P. polymorpha* or *P. turqueti*— sits on the sea floor near a brine channel. Both species are found throughout Antarctica and the subantarctic, from about 15 to 1,116 meters' depth (50 to 3,660 feet). *Pareledone turqueti* has also been found in deep water near Brazil. Both are small animals, with a mantle size of about 11 centimeters (4.5 inches). Since they are similar in size, morphology, and habitat, it is likely the two species inhabit different niches and consume different prey. *Pareledone polymorpha* has a small, fine-pointed beak, a less muscular body that is prone to abrasion, and a higher number of small suckers, whereas *P. turqueti* sports a more robust beak and body. These differences suggest that *P. polymorpha* may hunt for prey in the water column, while *P. turqueti* probably forages for the bivalves and other benthic prey typically associated with octopuses.

As with any other animal population, there is
a certain level of infant mortality among Weddell
seals. When a pup's carcass remains on the ice,
it is quickly devoured by skuas, voracious gull-like
predators and scavengers. If a carcass falls to the
bottom of the sea it is also devoured, though some-
what more slowly, by the ever-present scavenging
sea star *Odontaster validus,* nemertean worms
(Parborlasia corrugatus), and carnivorous amphi-
pods, including *Orchomenella (Orchomenopsis)
pinguides* and possibly *Hippomedon kergueleni.*

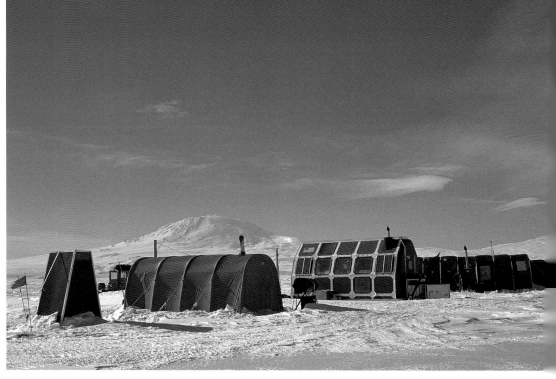

A typical field research camp on the sea ice, with Mount Discovery in the background. The buildings are mobile huts that serve as laboratories and living quarters. The small triangular black hut on the left is an outhouse. It's unheated, but vastly better than the alternative. ⁊ At this camp, researchers are analyzing data from a video camera attached to a Weddell seal. Biologists also use telemetry and satellite tracking to learn about the movements, behavior, and physiology of the seals in the sound. Although considerable hard work is required in the cold and the incessant wind to attach the necessary transmitters and recorders, afterward the scientists can make observations and analyze their data in the relative comfort of a warm hut.

It looks like Robo-Seal in some twisted science fiction movie, but in fact this Weddell seal has been outfitted with an extremely light-sensitive video camera. With images collected by this camera, biologists hope to learn more about how the Weddell seal forages for prey in the lightless depths of McMurdo Sound. A previously unknown behavior has already been revealed: cameras recorded seals exhaling bubbles into the under-ice platelet layer to flush out cryophilic fish, *Pagothenia borchgrevinki* (pages 46–47), which the seals quickly consumed. ⁊ Other instruments record swimming speed, direction, depth, and time. With these, the scientists have determined that Weddell seals conserve energy and oxygen during a dive by allowing themselves to sink under the pull of gravity rather than swimming constantly toward the bottom.

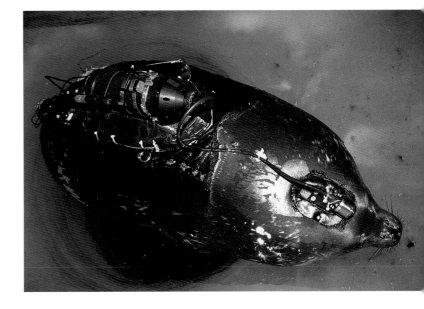

A rocky promontory called Cape Royds, on the west coast of Ross Island, is home to the southern-most Adélie penguin *(Pygoscelis adeliae)* rookery in the world. Male penguins may have to walk over several kilometers of sea ice to reach the rookery in late October or early November. Since 2001, a giant iceberg has blocked access to McMurdo Sound, forcing the penguins to walk much farther than would normally be necessary. Cape Royds penguins survive on a thin margin, and the added distance they must travel to feeding grounds has resulted in breeding failure at the rookery.

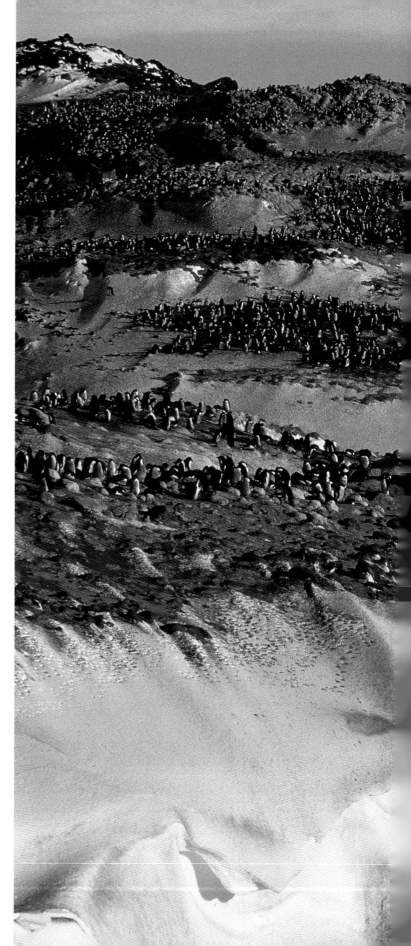

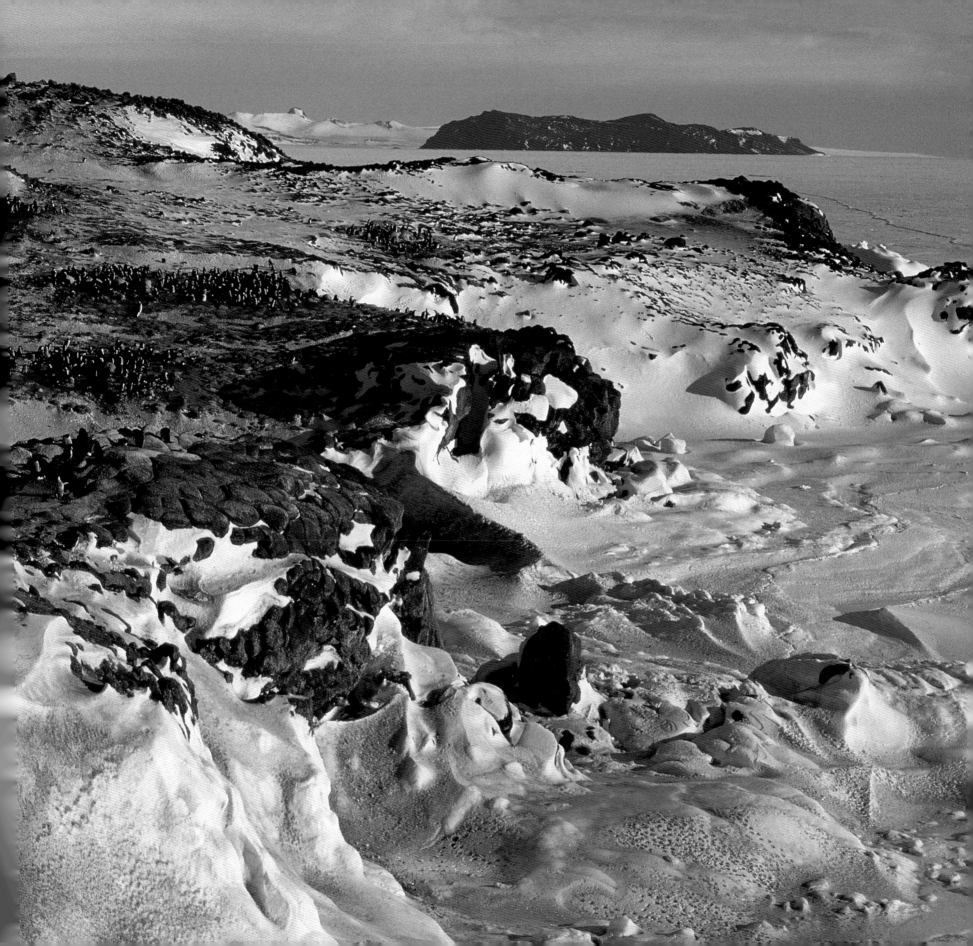

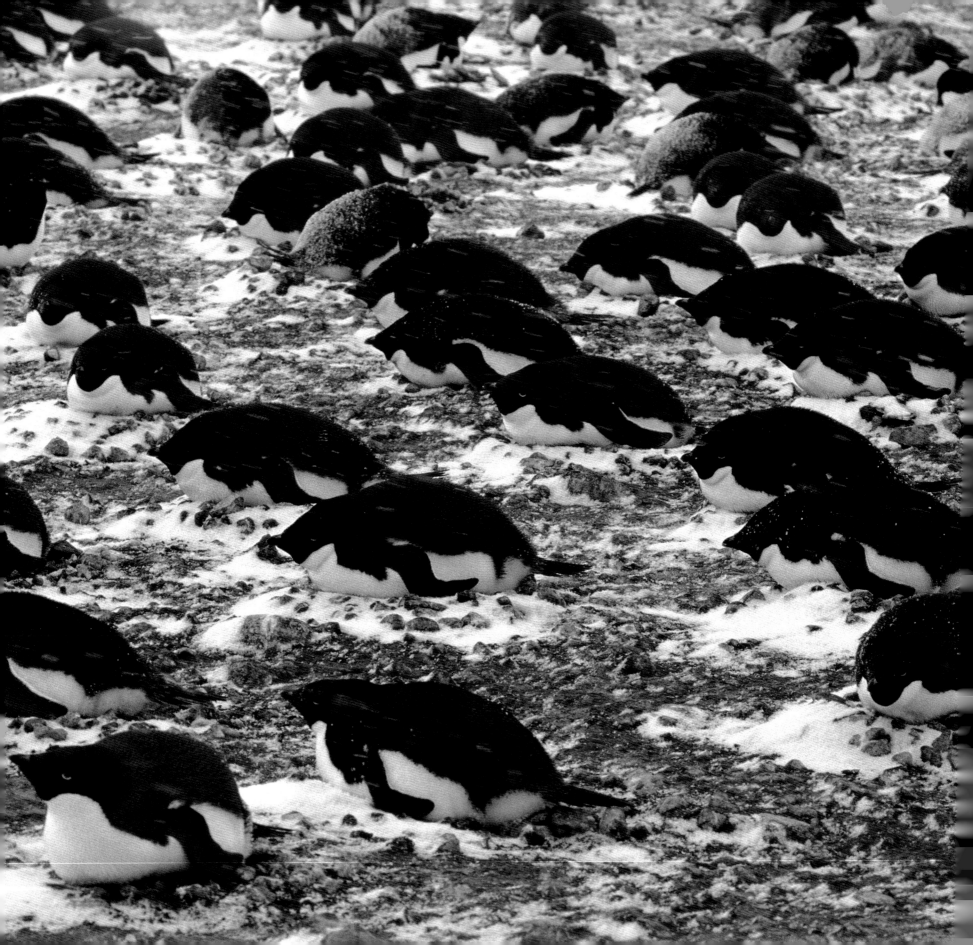

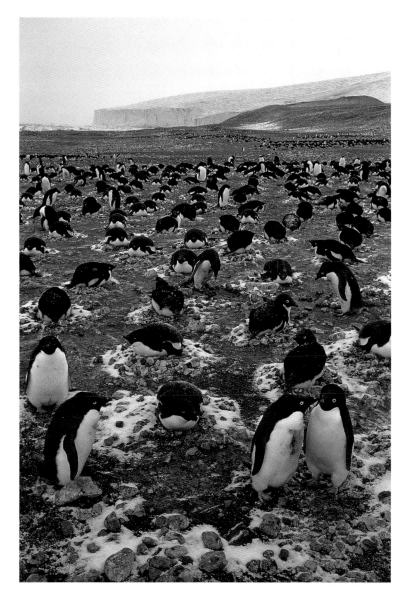

There are three Adélie penguin rookeries on Ross Island: Cape Bird, Cape Crozier (the largest), and Cape Royds. The Cape Bird rookery, shown at far left on a cold and blustery day, is the northernmost and is second in size; the Cape Royds rookery is the southernmost and smallest. To minimize their exposure in stormy weather, nesting penguins lie low and face the wind with their wings tucked in.

The wide, flat, ice-free plain at Cape Bird is prime real estate for mating Adélies. The penguins place their nests just out of pecking distance from one another, but birds traveling to and from their nests are subjected to constant harassment.

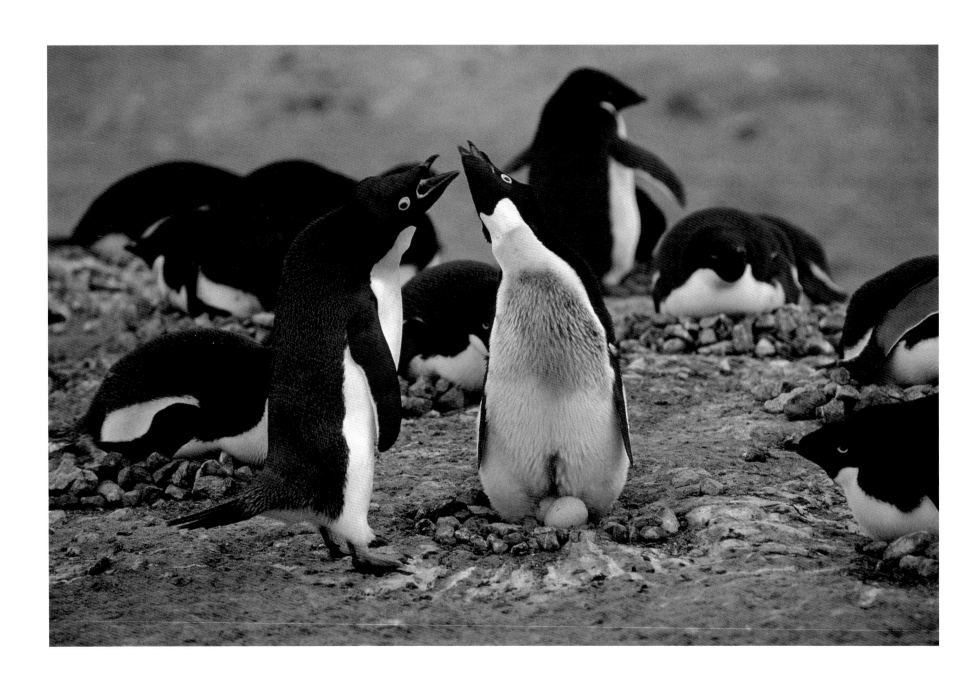

Male penguins arrive at the rookery first to claim territories and build nests, generally using the same site every year. Once the territorial bickering has died down and the nests have been established, the females arrive. Courtship, with its attendant wing flapping, head waving, raucous vocalization, and beak touching, begins immediately. Adélie penguins will pair up with the same mate in succeeding seasons, as long as that mate is available. Pair bonding is not as strong in Adélies as it is in other pygoscelid penguins, however. The breeding season is short in the southern Ross Sea, and time cannot be wasted waiting too long for last year's mate. ¶ In a few days the female lays two eggs, then returns to sea to feed while the male incubates them. When she comes back, the male takes his turn to feed. The two birds continue to alternate incubation duties with foraging trips of up to 100 kilometers (60 miles) that last nine to twenty-five days. Each time a mate returns to the nest, an elaborate greeting ritual ensues, with the nesting bird finally turning over the eggs to its mate. ¶ The eggs hatch in late December, after which each mate takes its turn regurgitating partially digested food into the chicks' mouths while the other mate feeds at sea. These foraging trips grow shorter and shorter as the chicks grow larger and require more food. Adélies forage in McMurdo Sound for the krill (probably *Euphausia*

crystallorophias) and larval fish that are typically abundant in the summer plankton bloom. In good years, both chicks can be raised to fledging. In thin years, only one chick survives, typically by muscling the other chick aside to take most of the food the parents offer. By mid-February the chicks have fledged and the adults have left to find a suitable place to molt.

An Adélie penguin nest consists of piles of loose stones with a central depression. These stones are valuable, and most have long since been gathered up from the surrounding ice-free area. To add to his nest, the male is therefore obliged to steal from others—which he does at every opportunity. Not only is a well-appointed nest with many stones impressive to the female, but it also ensures that the eggs she lays will be held above meltwater.

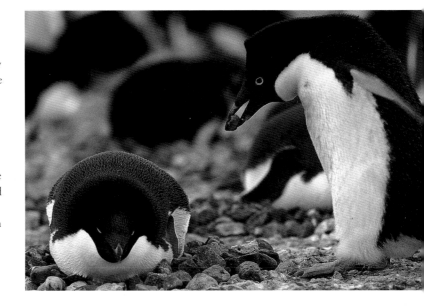

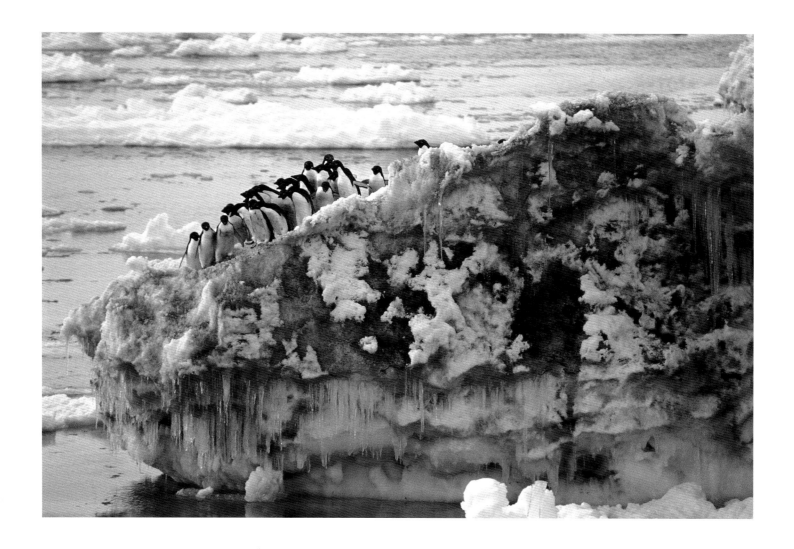

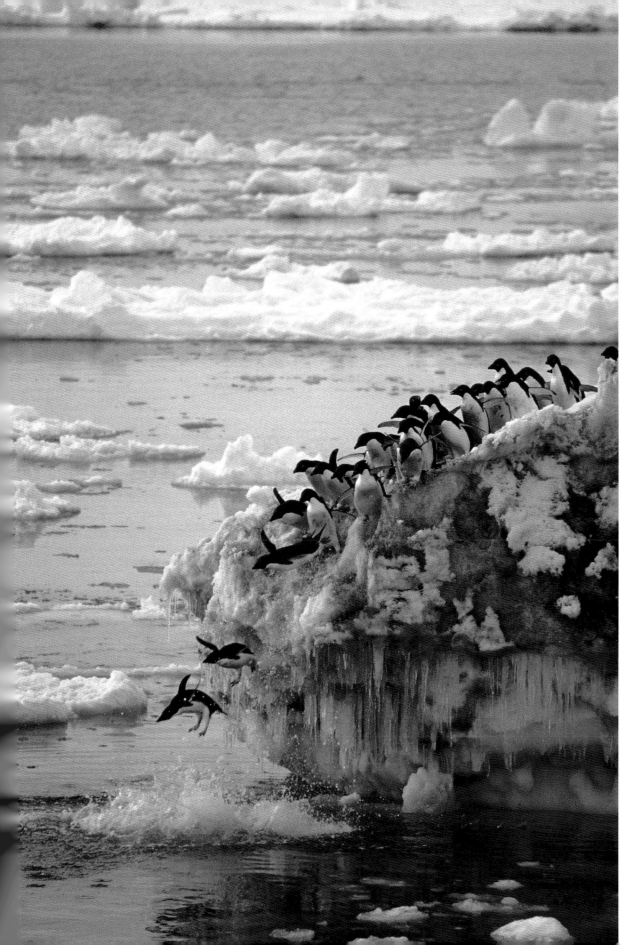

Having been replaced on their nests by their mates, dirty and hungry Adélie penguins make their way to the open water. When the time comes to enter the water, though, these birds are the world's greatest procrastinators. Going to sea to feed is the most dangerous thing they do. Leopard seals *(Hydrurga leptonyx)* lurk just below the ice, ready to pounce on some unlucky bird, and the penguins seem to know it. They'll anxiously scan the water, then decide against that spot and move en masse to another one. "What about here?" they seem to say. "No, I don't like it. What about over here?"

When they finally decide on a spot, the penguins sometimes stand there for hours, looking nervously at the water and jostling each other. No one wants to be the first one in. Finally, as if on some inexplicable group impulse, the birds may suddenly pile into the water, falling all over one another in the process. Other times, one hapless bird ventures too close to the edge and gets pushed in. If that one survives, the rest follow in a mad rush and swim away at high speed.

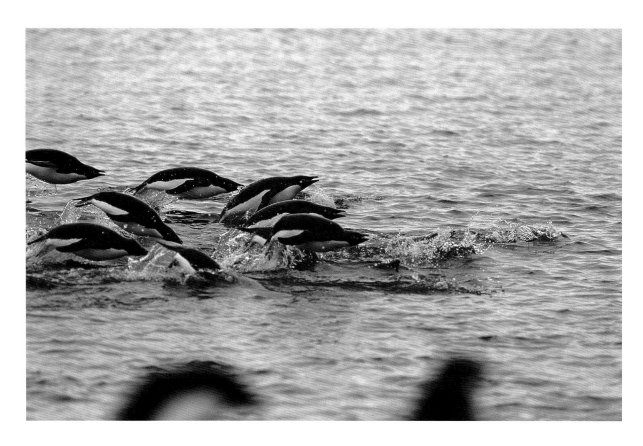

Adélies often travel by leaping out of the water at regular intervals, a process called "porpoising." The behavior may decrease their overall swimming effort by eliminating hydrodynamic drag for at least part of the time they are in rapid motion. More important, it allows them to take breaths without breaking their stride, thus increasing swimming speed and presenting a more difficult target for leopard seals. Other marine animals that swim with their pectoral flippers, such as sea lions, do the same thing.

Sea ice that is fast to the shoreline provides these nesting Adélie penguins temporary safe passage. They are on their way to sea to feed and won't have to worry about lurking leopard seals until they reach the ice edge, which may be several kilometers away. ¶ Adélies lead an existence that would give humans high blood pressure or a nervous breakdown—or both. In the rookery, they are constantly harassed and their eggs and chicks stolen and devoured by McCormick's skuas *(Catharacta maccormicki)*. At sea, especially when entering or exiting the water, they are under the continual threat of predation by leopard seals *(Hydrurga leptonyx)*. The seals grasp penguins in their tyrannosaur-like jaws and shake them so violently that the birds are literally ripped from their skins. When one member of a nesting pair fails to return from a foraging trip, the remaining Adélie must ultimately abandon its eggs or chicks to avoid dying of starvation itself.

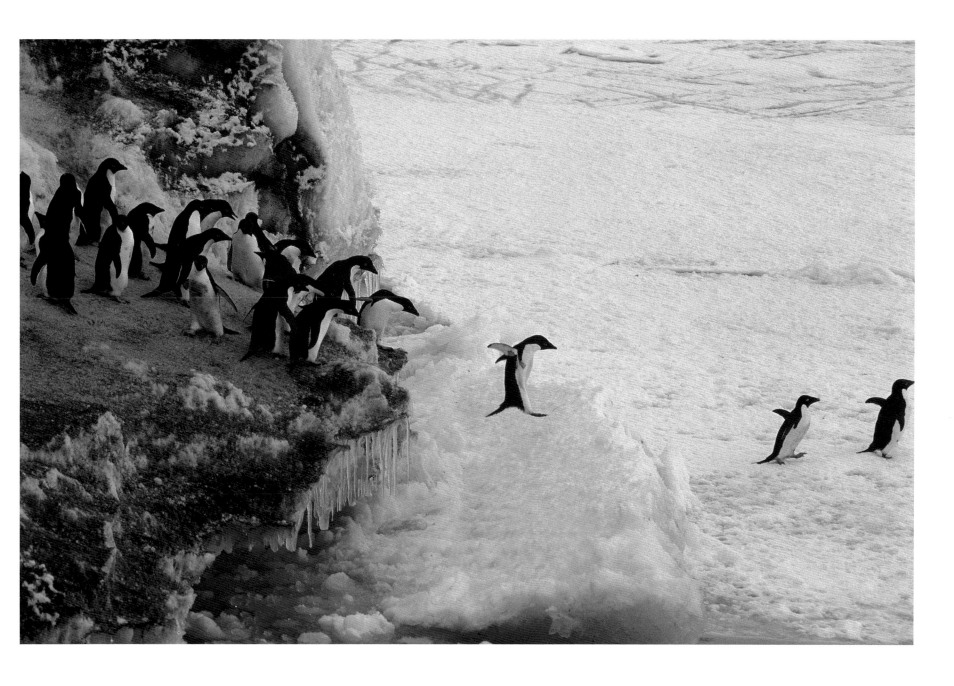

Adélie penguins avoid lingering near the ice edge, since that is where they are most vulnerable to predation by leopard seals. Instead, once the decision has been made to exit the water, the penguins bolt en masse for the shore, flinging themselves like rockets out of the sea and onto the ice or rocks. They can leap 2 to 3 meters (7 to 10 feet) out of the water, and quite often they land on their feet. Emperor penguins, in contrast, always land on their bellies.

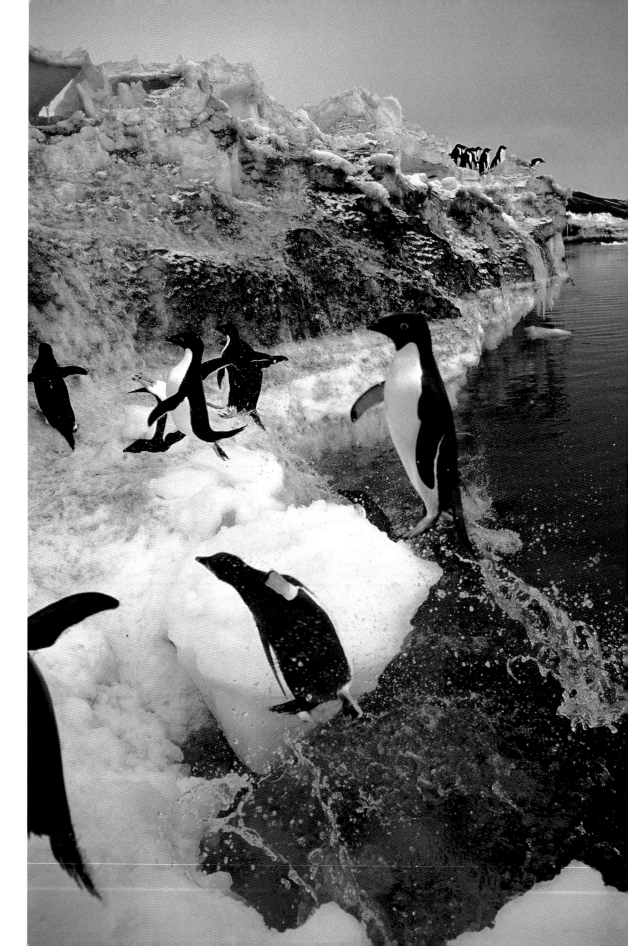

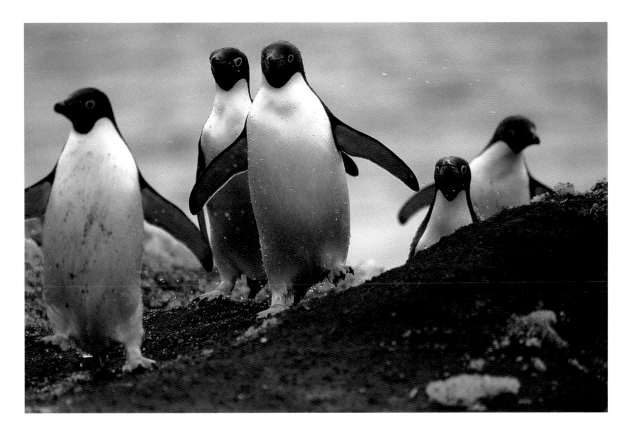

Penguins returning from a foraging trip to sea are easy to spot: unless they've taken a spill into some mud (as the one on the left apparently has), their breasts are shiny and clean. Their mates, in contrast, who have sat on grimy nests for several days, are inevitably filthy.

Far from being an unbroken sheet, the annual fast ice in and around McMurdo Sound is subjected to forces that slowly deform it. The Ross and McMurdo Ice Shelves push at it from the south, while glaciers along both shores apply their own pressure. These forces cause cracks to open in the ice. In some cases the cracks freeze over, only to open up again days or weeks later. In this photograph, the strain on the ice is evident from the numerous parallel cracks radiating out from Couloir Cliffs in Granite Harbor.

In areas where McMurdo's special motorized drill cannot go and where the use of explosives is discouraged, cracks such as this one offer the only practical way for divers (and Weddell seals) to access the water (or air). Even if the crack has frozen over, the ice in the center is typically thin enough during the summer that it can be chipped and broken away to create a dive hole.

At far right is a diver's-eye view of Couloir Cliffs from a crack in the sea ice at Granite Harbor. Over-under photographs like this are difficult to obtain in Antarctica because of the great disparity in light levels above and below the ice.

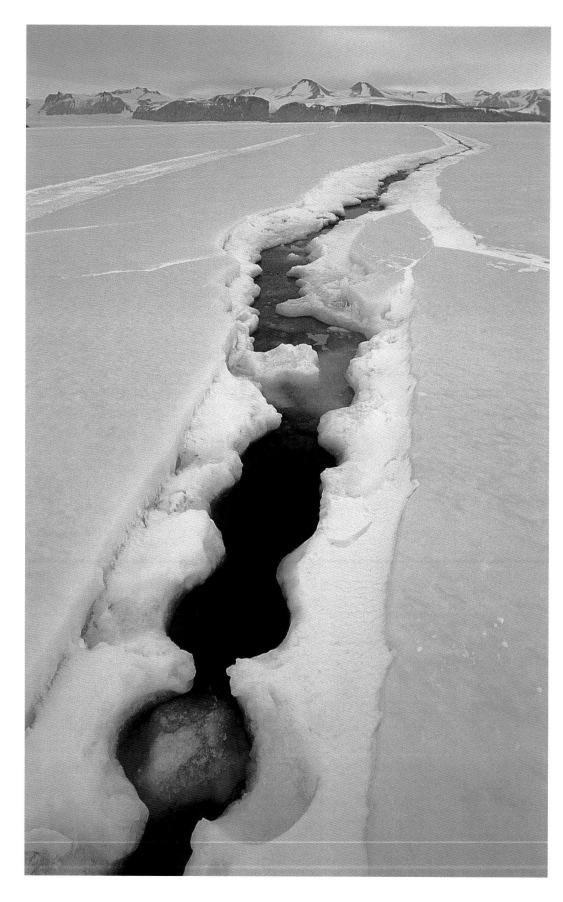

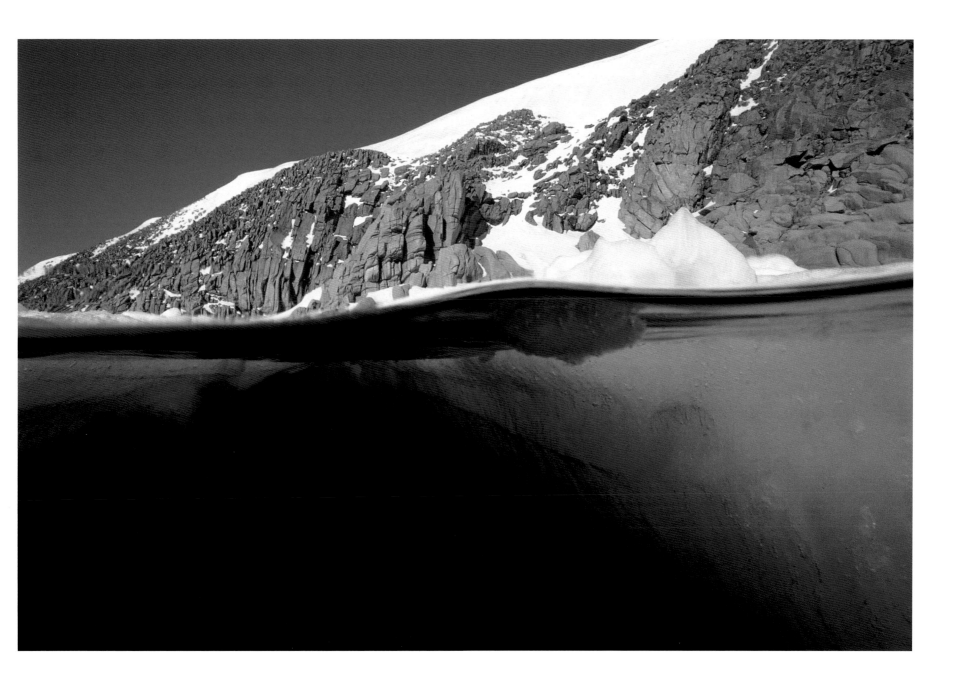

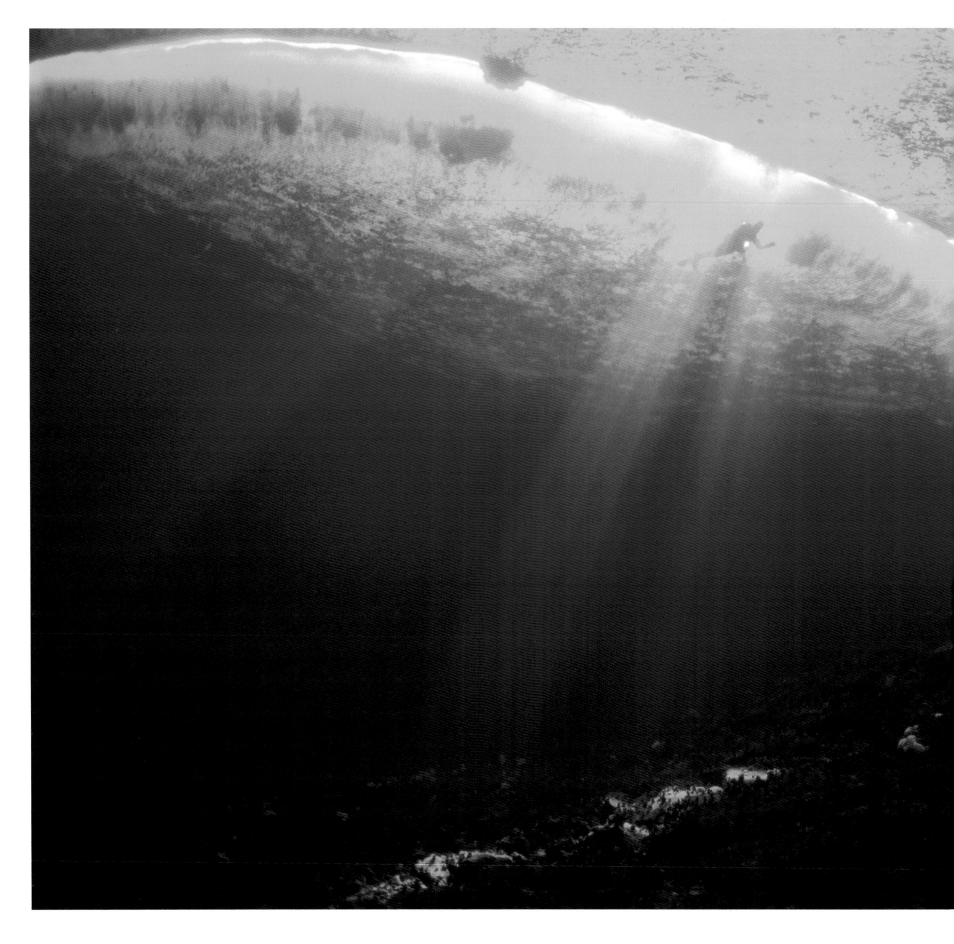

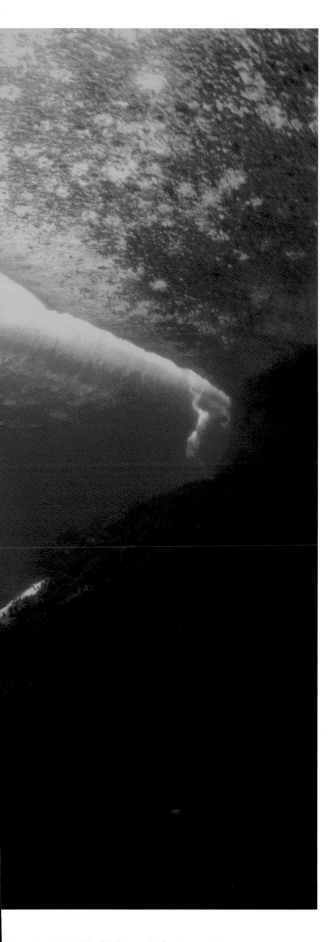

Framed by shafts of sunlight, a diver peers down over the rocky bottom at Granite Harbor. The underwater visibility can be as much as 275 meters (900 feet) during certain times of the year, but even water that clear usually contains enough particles to reflect light. Thus, when the sun is at the right angle, sunshine streaming through an ice crack creates dancing columns of light, a sort of underwater aurora australis. Antarctic divers call this phenomenon the "Jesus effect."

The undersea world in high-latitude Antarctica is full of strange forms, both biological and physical. The deep benthic fauna is a source of endless curiosity and research, but the near-surface region is no less intriguing. Divers sometimes spend hours exploring fractured sea ice, underwater ice caves, anchor ice, and submerged ice walls. At Couloir Cliffs in Granite Harbor, the shallow rocks are encased in ice, as though a waterfall cascading over them was suddenly frozen. Some scientists hypothesize that summer meltwater from the cliffs above, forced downward by hydrostatic pressure, has seeped through the rocks and frozen on contact with the sea.

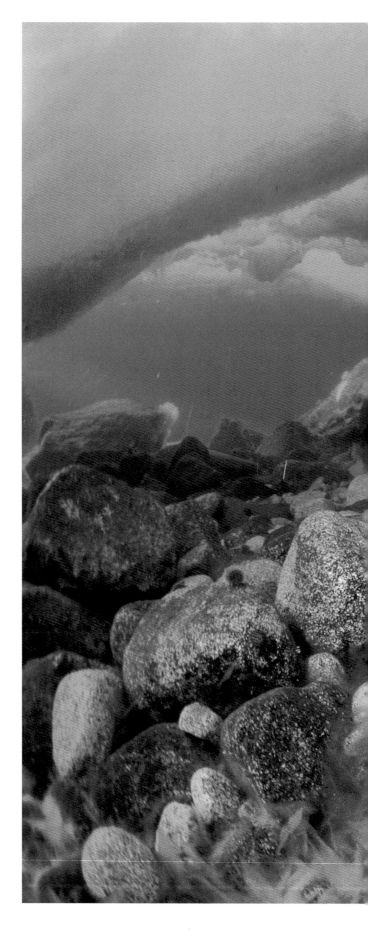

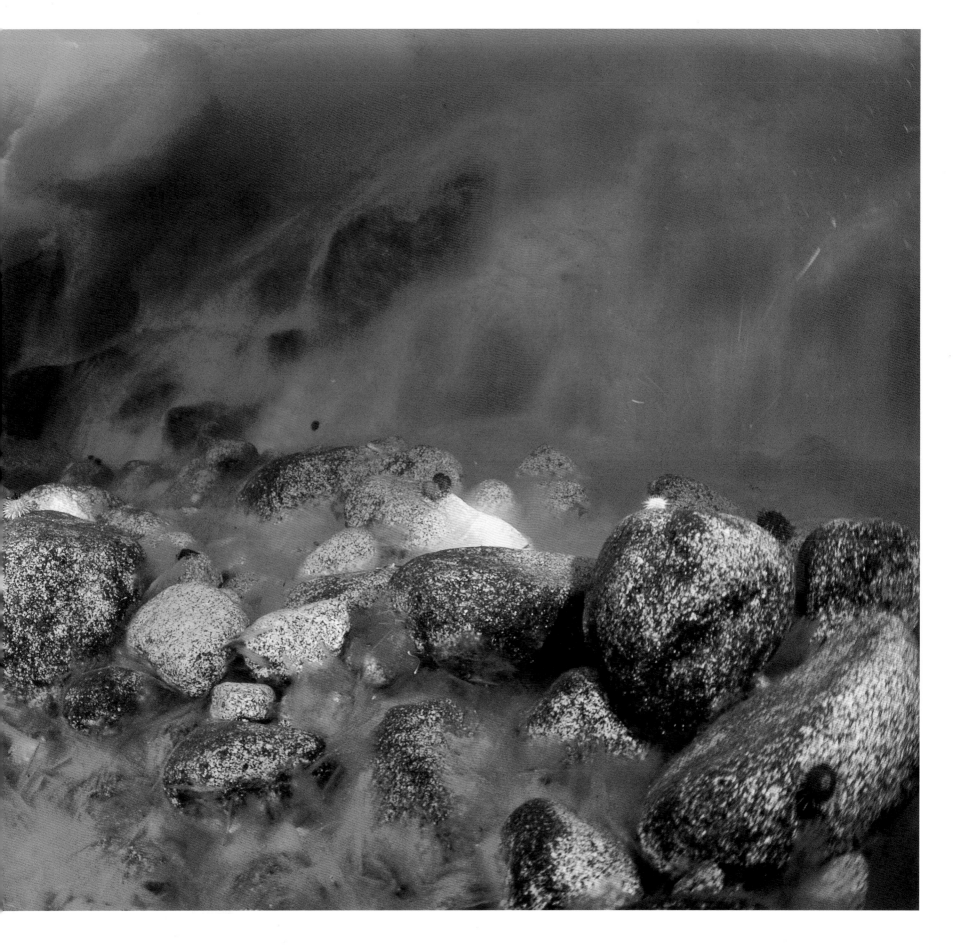

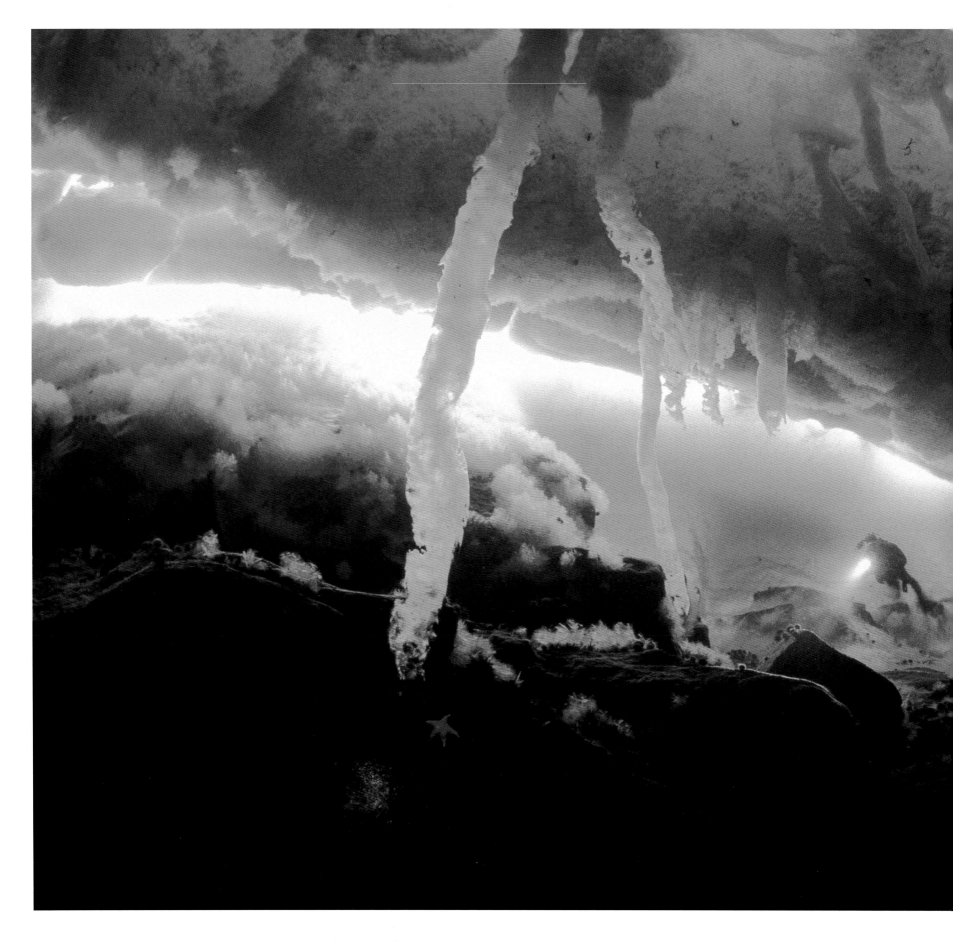

When seawater freezes, it excludes salt, some of which becomes trapped in pockets of brine within the ice. As the topmost layers of sea ice become progressively colder from exposure to ambient air temperatures as low as -50°C (-58°F), more and more water is frozen out of the brine. It becomes increasingly saline and increasingly cold. The brine percolates downward until it seeps out the bottom of the ice and into the water column. There, because it is much denser than the water around it, the brine sinks. As it does so, it freezes the water around it to form brine channels, or "underwater ice stalactites." These hollow, tapering structures are sometimes over 7 meters (23 feet) long, and divers have reported seeing brine gushing out of their tips like water from a fire hose.

Sponges are the kings of the deep Antarctic benthos. Over 300 species of Antarctic sponge have been identified, and more may be waiting to be discovered in the depths of McMurdo Sound. They are the main component of the benthic community below about 30 meters (100 feet), in some places making up as much as 74 percent of the benthic biomass. Sponges provide most of the vertical structure on the sea floor, and they provide food and shelter for many other species. Many of these sponges grow to be quite large. A few white volcano sponges *Anoxycalyx (Scolymastra) joubini*—much older versions of the ones shown here—are big enough for a diver to pass through the osculum and disappear into the central cavity. ¶ In January 1956, a tracked vehicle fell through a crack in the ice off Hut Point and settled onto the bottom in 18 meters (60 feet) of water. What is left of the vehicle is now encrusted with invertebrates, including some small volcano sponges. Careful measurements of their size may provide a good estimate of volcano sponge growth rates—which appear to be very slow. It may be that the largest volcano sponges are hundreds or even thousands of years old.

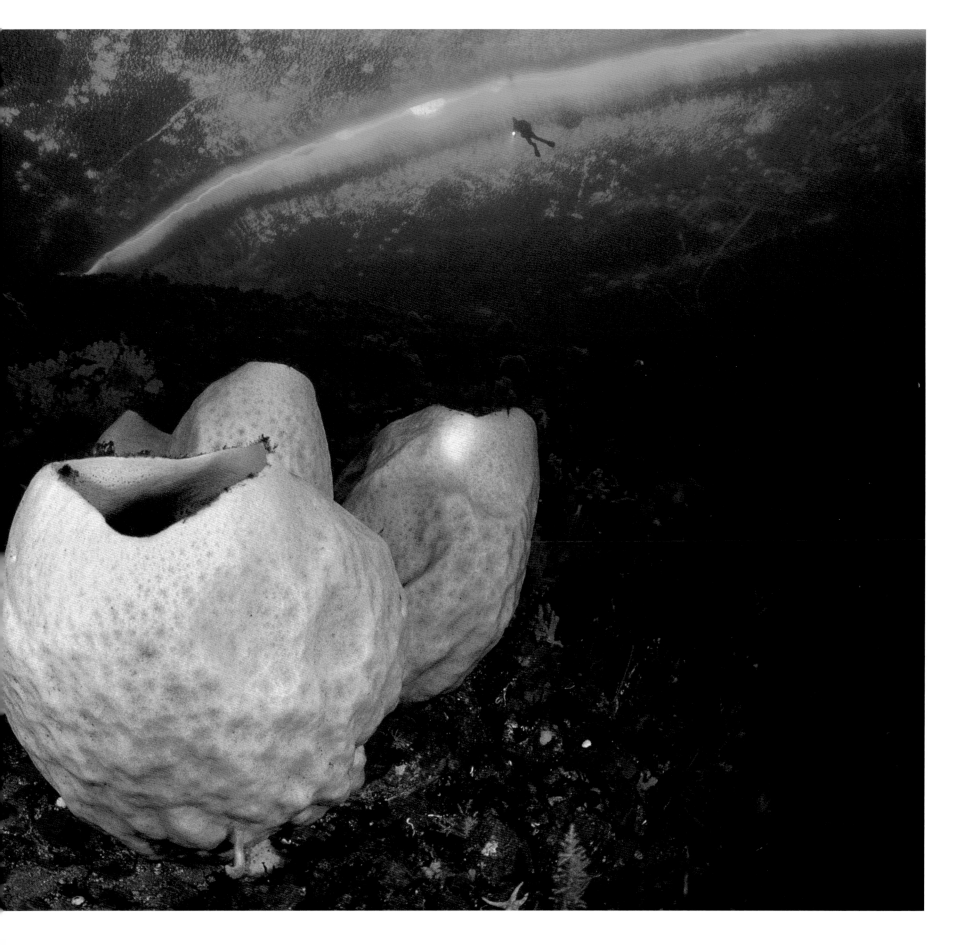

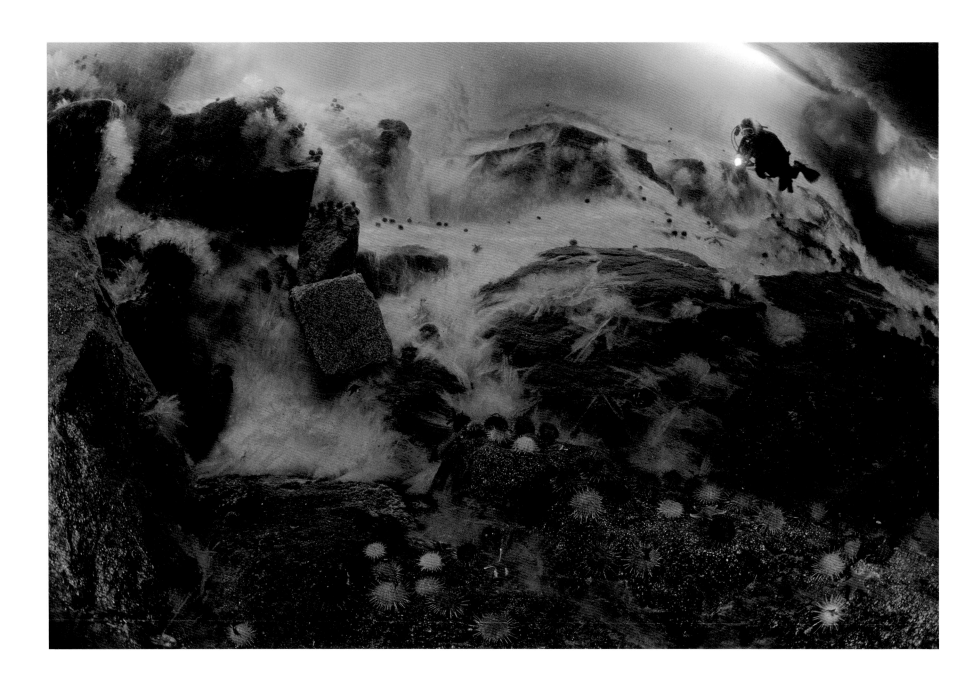

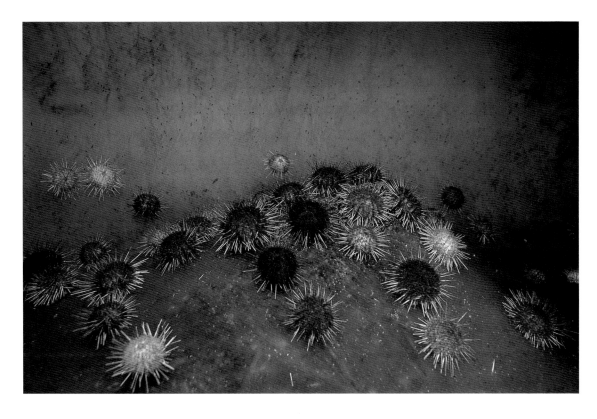

A clutch of sea urchins *(Sterechinus neumayeri)* chows down on a summer feast of diatoms growing on an underwater ice wall at Granite Harbor.

Sea spiders, or pycnogonids, are truly strange creatures. Members of the phylum Arthropoda, subphylum Chelicerata, they are related to both horseshoe crabs and terrestrial arachnids. There are about 1,000 species worldwide, with 251 species in the Antarctic and subantarctic alone. Most temperate and tropical species are tiny (about the size of a fingernail). In the cold waters of the deep sea and Antarctica, pycnogonids exhibit gigantism, with some species attaining tremendous size. Some *Colossendeis,* for example, have leg spans of 50 centimeters (1.6 feet). Pycnogonids also inhabit wide depth ranges. *Colossendeis megalonyx,* the most common of the *Colossendeis* species in Antarctica, has been found as shallow as 3 meters (10 feet) and as deep as 4,900 meters (16,000 feet). ❡ Most Antarctic sea spiders prey on cnidarians, such as soft corals *(Alcyonium antarcticum, Clavularia frankliniana),* hydroids (especially the colonial hydroid *Ophiodes arboreus*), and medusae (like *Diplulmaris antarctica*) that stumble into the benthos. These sea spiders move exceedingly slowly, but with the aid of time-lapse cameras one can see them scamper as their terrestrial cousins do. Here *Colossendeis megalonyx,* which appears to be consuming an unidentified prey item, picks its way across a blanket of anchor ice. The small red creatures are amphipods *(Paramoera walkeri)* grazing on ice algae.

A diver explores a surreal underwater landscape in Granite Harbor. Over thousands of years, boulders have tumbled from the rocky cliffs above to create a chaotic jumble on the shallow sea floor. Ice of unknown origin has covered the rocky confusion like a frozen cascade. Below the ice, sea urchins graze on benthic diatoms.

Sea ice near exposed land is subjected to a constant stream of windblown dust and dirt. The dirt accumulates in piles, absorbs solar radiation, and melts the surface of the ice. This process, along with the uneven distribution of the soil, creates a ragged and tortured surface on the ice that is both difficult and dangerous to traverse. This is especially true in areas where the sea ice has not disintegrated for a number of years. In the scene shown here, at New Harbor, the thick, multiyear ice has been subjected to the same degrading process for several summers, resulting in a minefield of melt pools, disguised potholes, and slippery areas masquerading as safe footing.

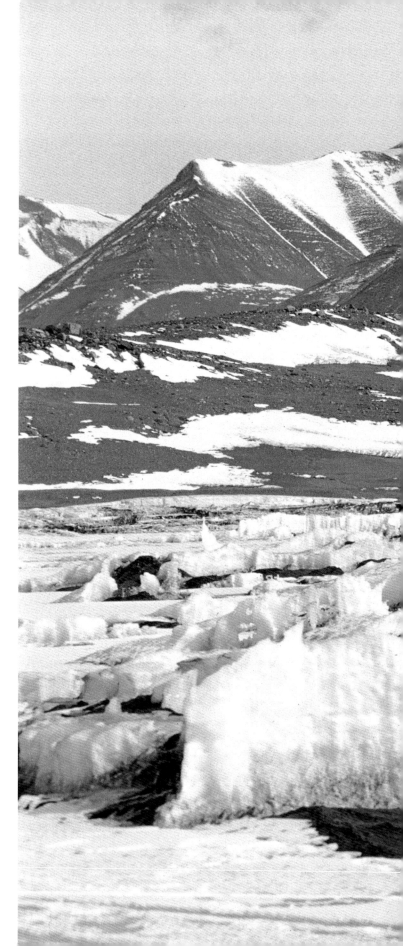

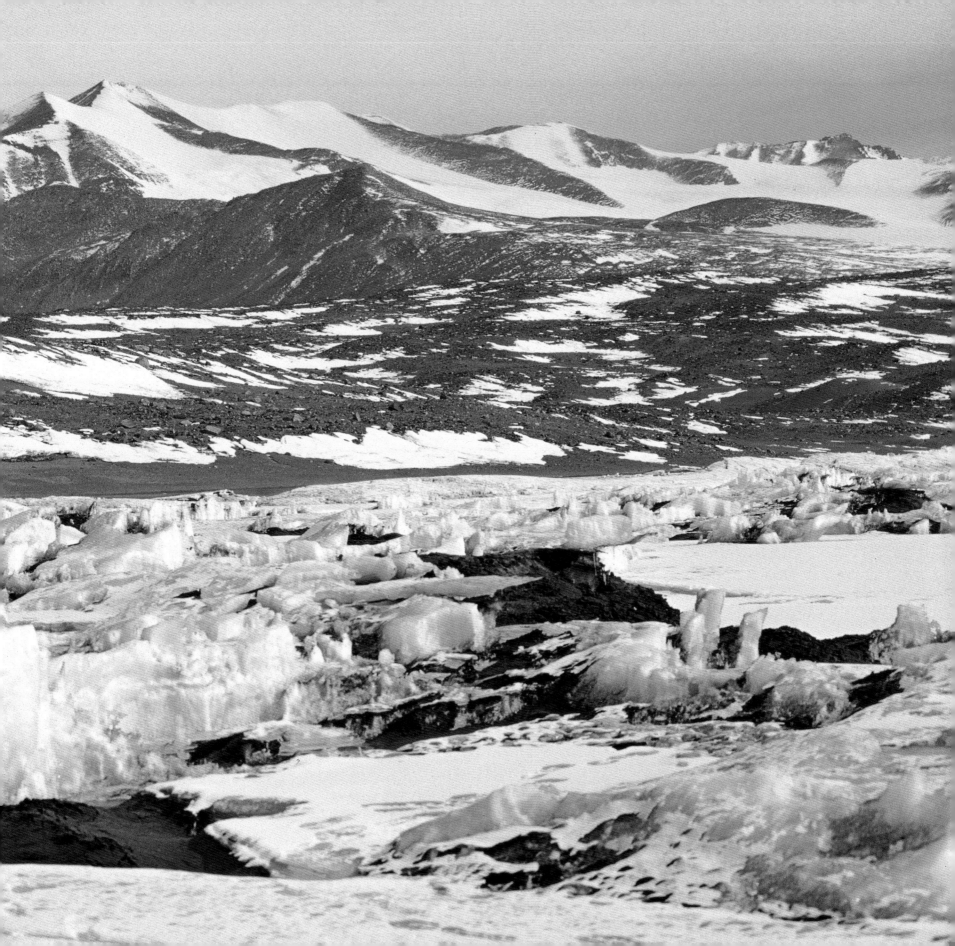

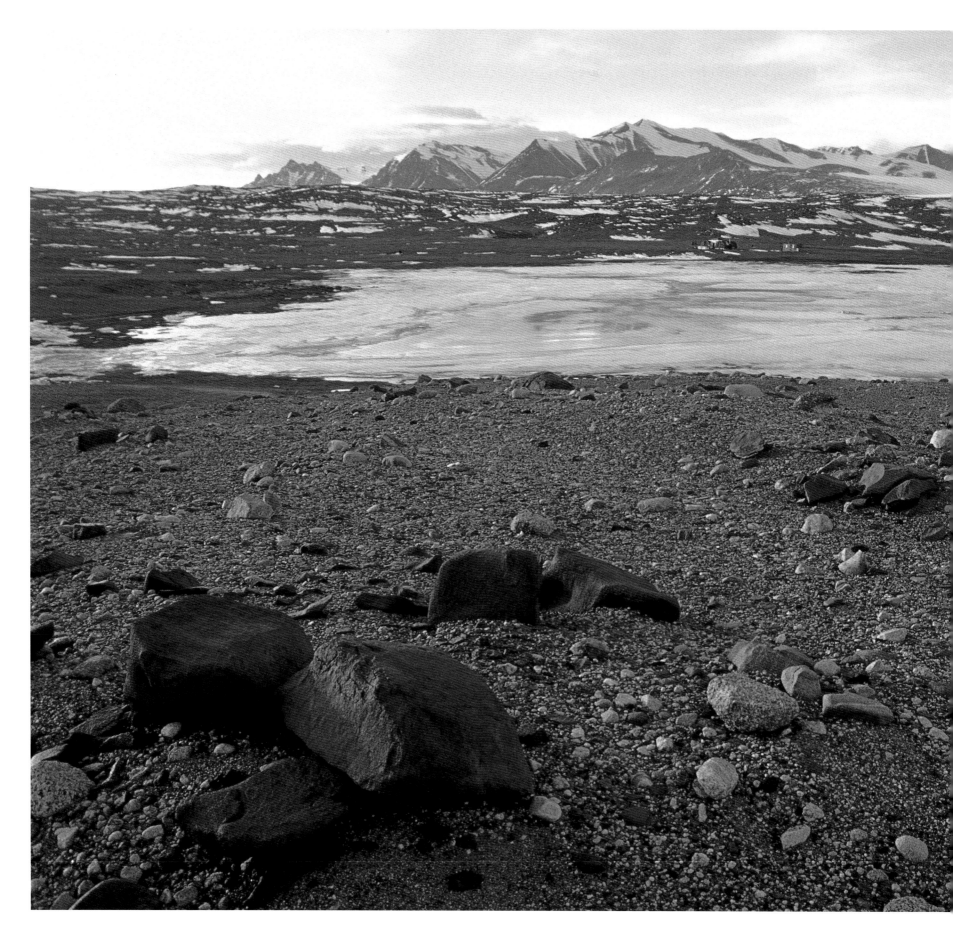

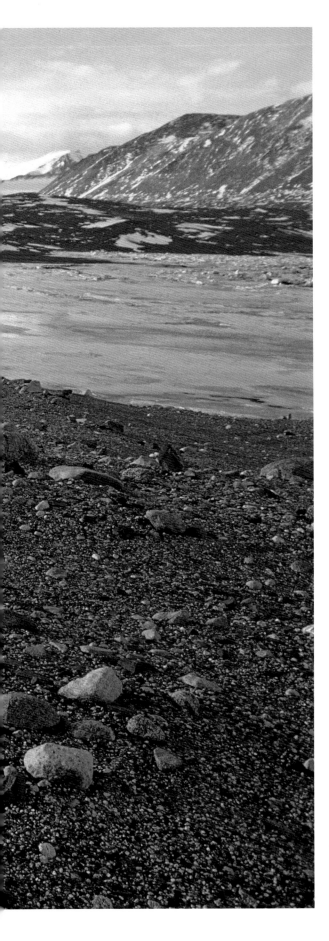

In Explorers Cove, at the windswept mouth of Taylor Valley in the McMurdo Dry Valleys, a semipermanent dive camp sits surrounded by bare earth—a rarity in Antarctica. Only 2 percent of the continent is not covered by ice. Although the cove is only about 80 kilometers (50 miles) from McMurdo Station, its weather is often completely different from that on Ross Island. When McMurdo Station is socked in with wind and blowing snow, Explorers Cove can be windless and balmy, with researchers running around in T-shirts. At other times, the wind can blow down through Taylor Valley at hurricane force for days on end, filling eyes, clothing, and equipment with gritty sand and keeping scientists locked up in their huts.

The soft coral *Gersemia antarctica* is a remarkable creature. Although recently discovered on the rocky substrate south of Cape Evans on Ross Island, most of McMurdo Sound's *Gersemia* are found on the western side, where the sea floor is often composed of sand and silt. Explorers Cove, in New Harbor, is just such an environment, and the *Gersemia* there have evolved a deposit-feeding strategy unique among soft corals. A colony inflates its central stalk with seawater, then bends down to touch the substrate. The polyps sift through the sediment for foraminiferans, diatoms, and particulate organic matter. A series of stalk inflations and deflations allows the coral to forage in a different spot each time, until it has consumed the available food in a circle around itself. Then this colonial animal (with no central brain) moves in a coordinated inchworm pattern, dragging the small rock or scallop shell to which it is attached, to fresh foraging grounds. One colony was found to have moved 7 meters (23 feet) in nine months.

At far right, a brittle star *(Ophionotus victoriae)* approaches a pencil urchin *(Ctenocidaris perrieri)* on the sediment bottom at Explorers Cove. The brittle star is a predator and scavenger that eats sponges, tunicates, polychaete worms, crustaceans, molluscs, foraminiferans, and just about everything else, including sea urchins and other *O. victoriae.* ❡ Because of its oligotrophic nature, sediment bottom, stable low temperature, and consistent low-light levels, Explorers Cove mimics the abyssal ocean environment. This is reflected in the presence of organisms typically found in the deep sea, such as abundant infaunal foraminiferans and the echinoderms shown here. Explorers Cove may be the only place on Earth where scientists can use scuba gear to study a benthic community that is normally the province of the abyssal ocean.

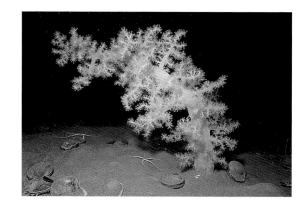

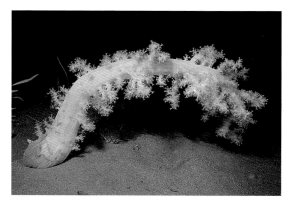

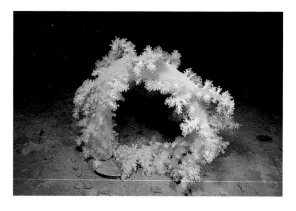

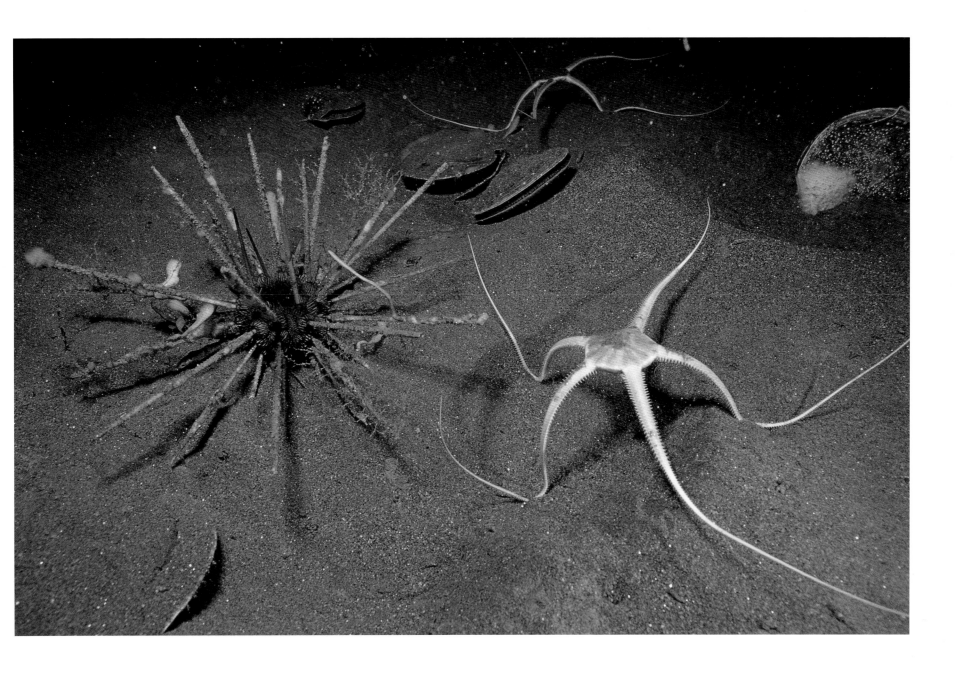

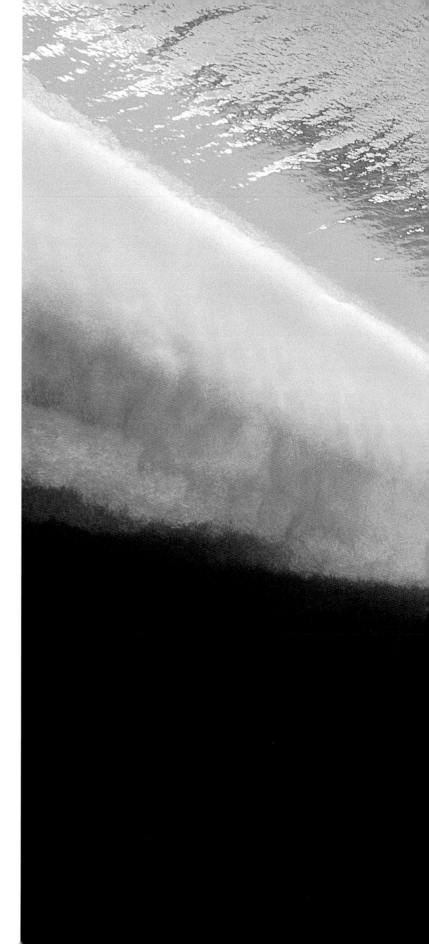

The northern edge of the annual fast ice in McMurdo Sound appears as a clean cut across the world. To the south lies a wide plain of frozen sea, to the north an endless expanse of open water. As a boundary between worlds, the ice edge attracts life. Adélie penguins nesting at Cape Royds must pass here to return to the rookery. Emperor penguins come to the edge to rest on the ice and to dive beneath it in search of food. Leopard seals skulk here, hoping to grab an unwary penguin. Minke and orca whales also cruise the edge, diving into the depths beneath the ice for fish, squid, and other prey.

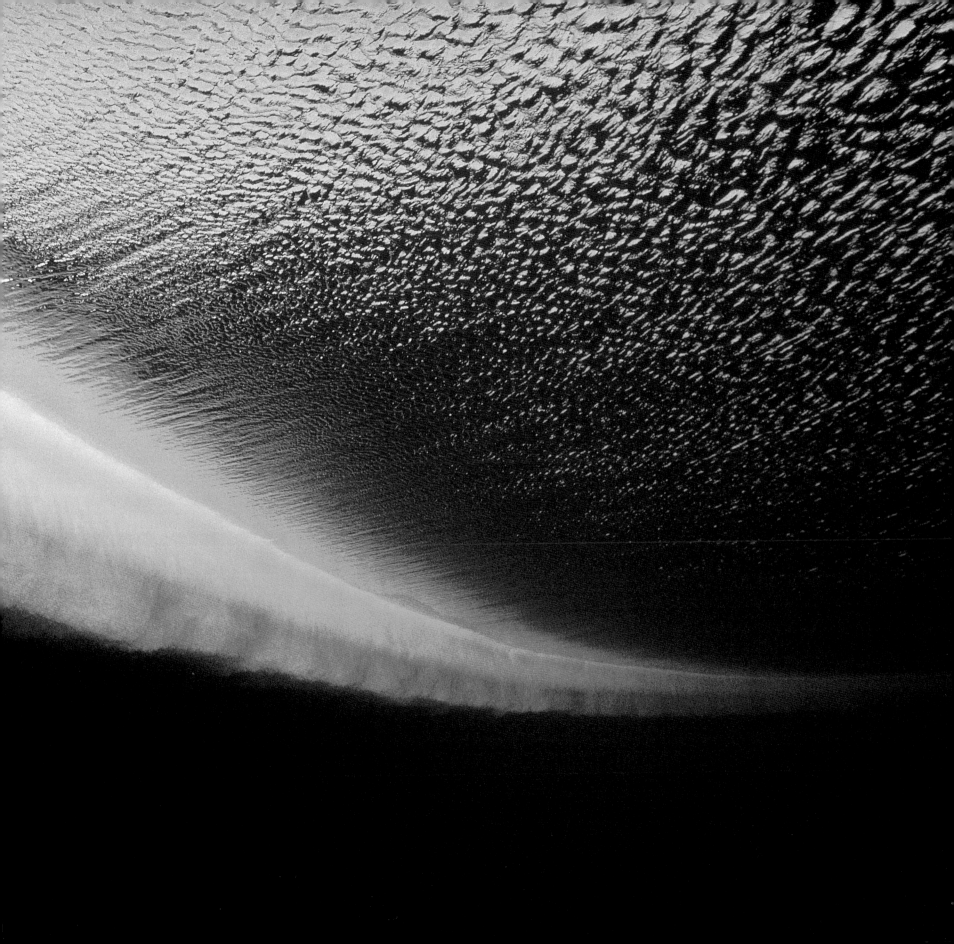

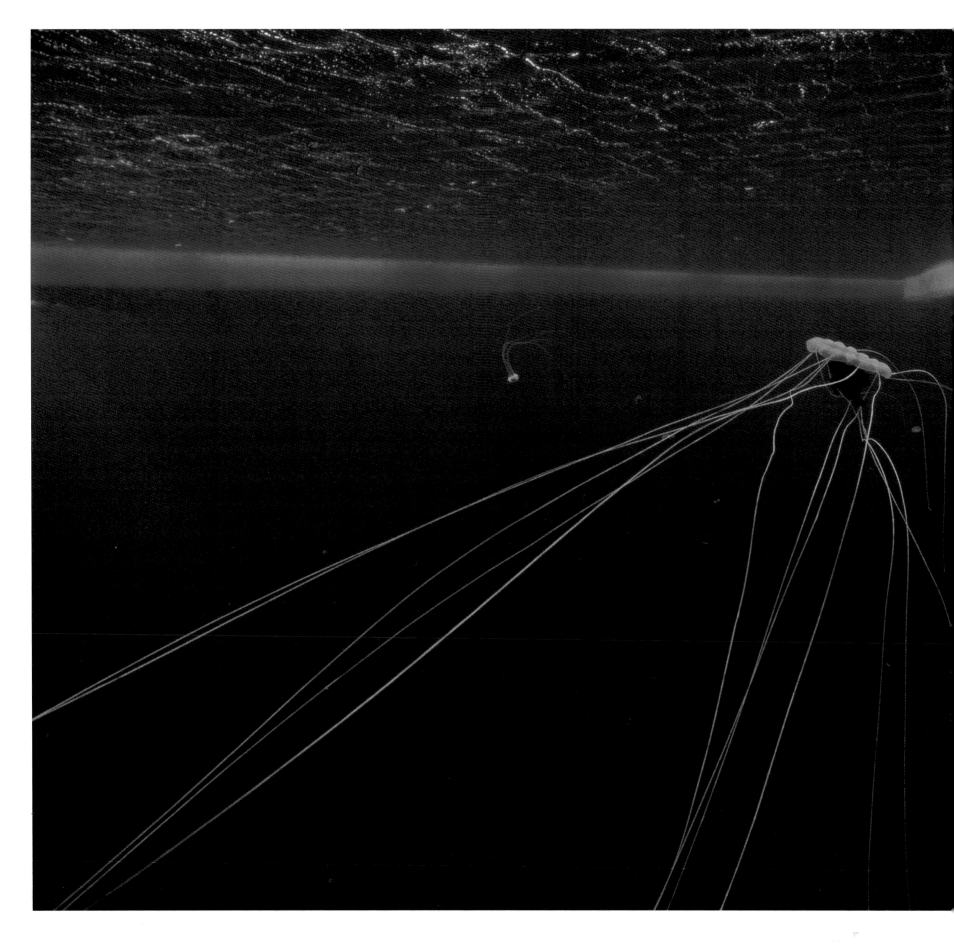

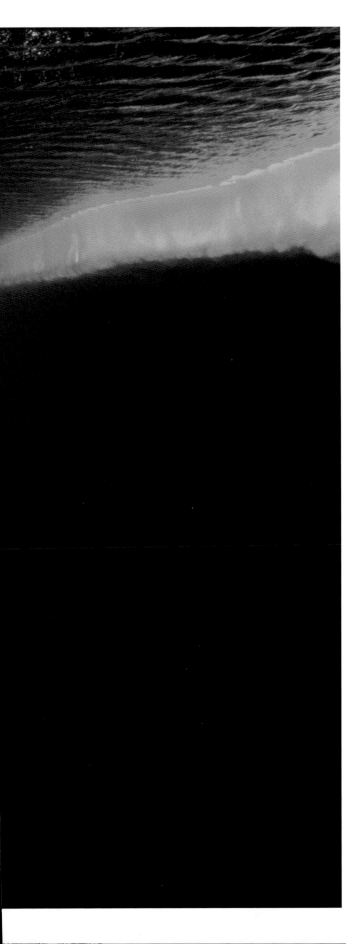

A giant scyphomedusa *(Desmonema glaciale),*
with its tentacles extended to their full 9-meter
(30-foot) length, drifts slowly toward the ice edge
of McMurdo Sound. Once it disappears below
the ice, it will enter a world of relative darkness
from which it may never emerge. If the jelly does
not stumble into the bottom to be captured and
consumed by anemones, currents will sweep it
to the south, past McMurdo Station, and under
the McMurdo Ice Shelf at the very southern end
of the sound.

A group of emperor penguins *(Aptenodytes forsteri)* surveys the water, preparing to take the plunge. Leopard seals *(Hydrurga leptonyx),* the emperor's most significant predator, lurk along the ice edge—where they have a view much like that shown here—and grab unsuspecting birds as they enter the water.

Emperor penguins are superb swimmers and divers. In the water, they are fast, maneuverable, and stupendously graceful. Here, a group of emperors "flies" under a V-shaped notch in the ice edge. ¶ Emperors work the deep waters of the Ross Sea, making frequent repetitive dives as they hunt for fish and squid at depths as great as 536 meters (1,758 feet). Most dives last only about 5 minutes, but emperors are able to hold their breath for as long as 22 minutes, making them the champions of all diving birds.

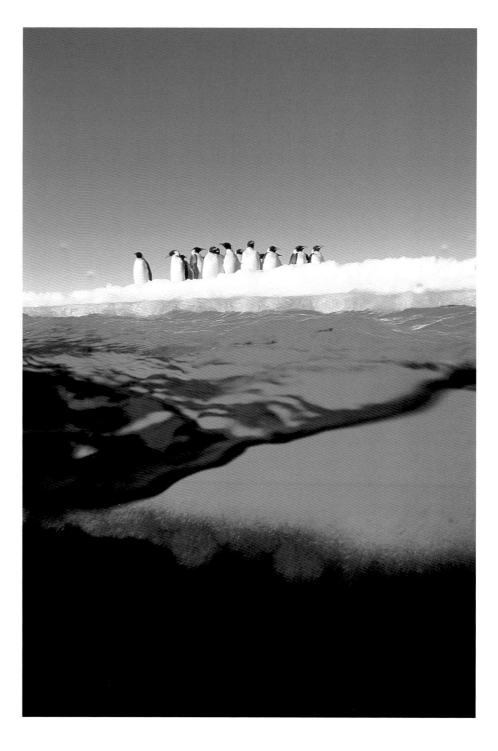

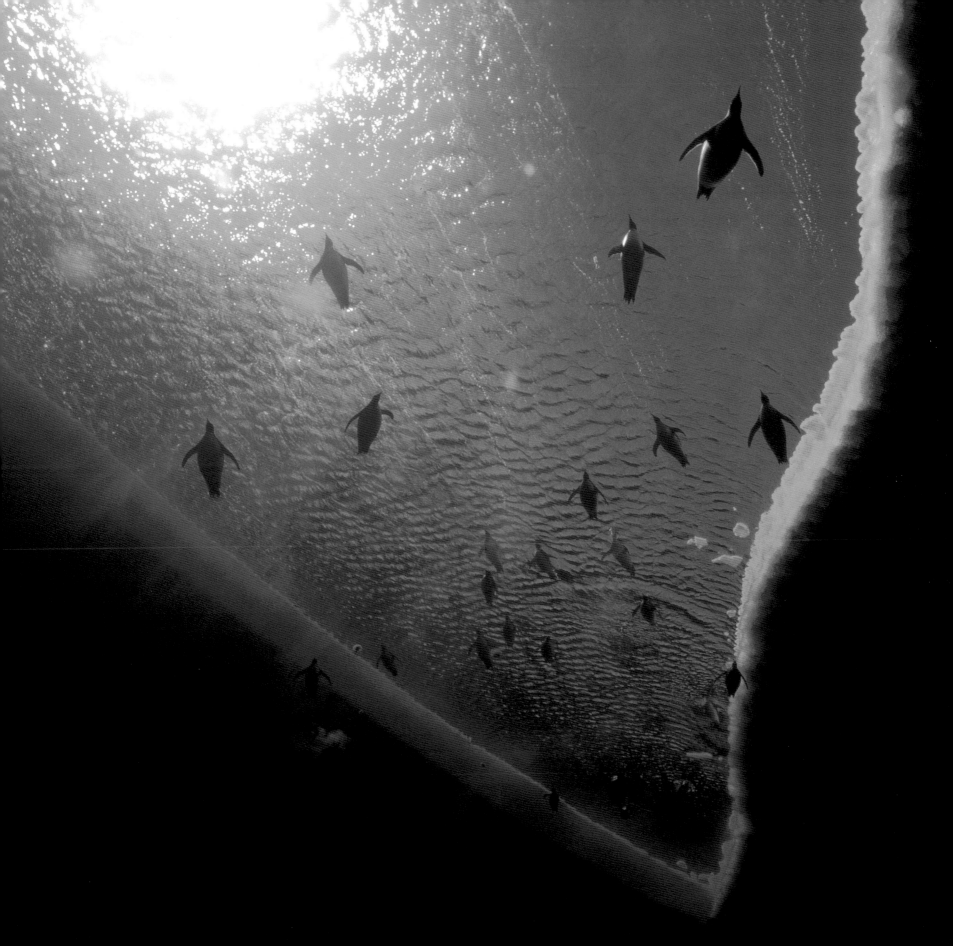

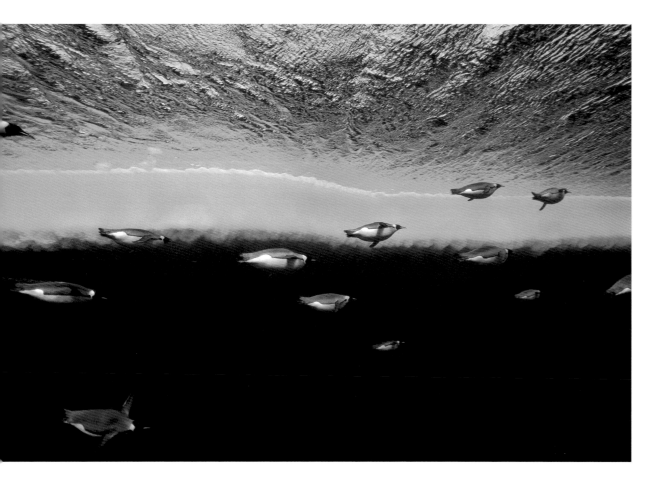

A squadron of emperor penguins glides through the shallows along the ice edge. Despite their diving prowess, emperor penguins are also known to fish in the platelet ice layer directly under the sea ice sheet.

Like torpedoes, emperor penguins shoot through the clear water at the ice edge, leaving contrails of tiny bubbles. The penguin's thick feathers help to insulate it in this frigid water by trapping a layer of air next to the skin, but often some of the air streams out when the bird swims. While other emperors are busy tending chicks at Cape Washington or Cape Crozier, these penguins are using the ice edge as a convenient rest stop between foraging bouts in McMurdo Sound. In their search for food, they've been observed diving below the ice sheet, at times side by side with orca whales.

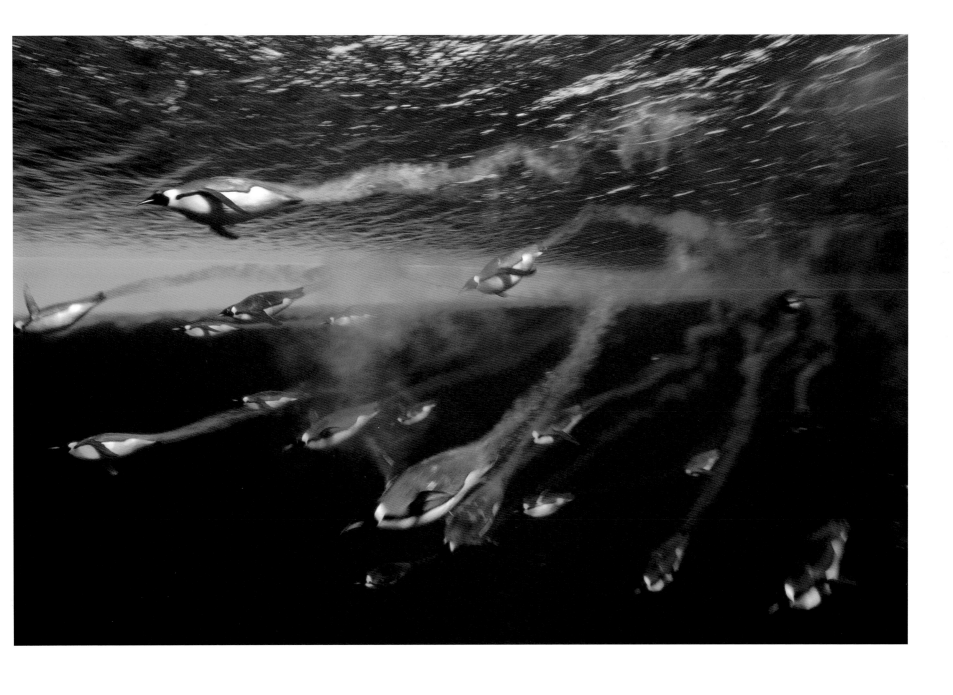

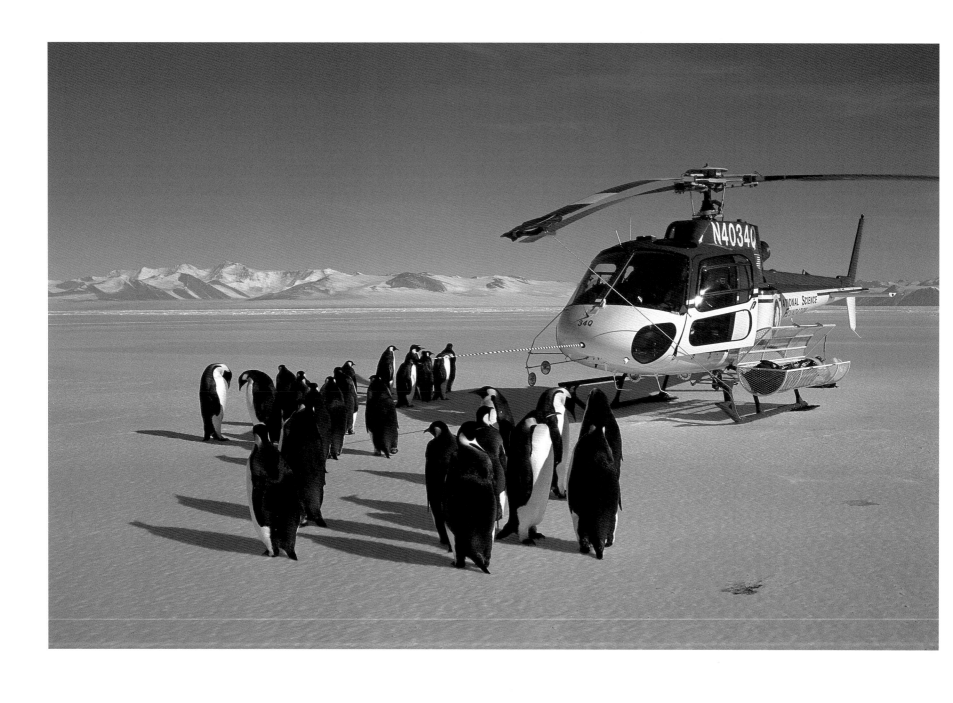

A group of emperor penguins checks out a helicopter near the ice edge. Emperors are irresistibly attracted to objects on the ice, especially people, vehicles, and aircraft. They will walk to within arm's reach, look the person or object over, then stand nearby (nonchalantly, it seems) casting curious glances at what must seem to them a remarkable creature. The birds in this photo are undoubtedly nonbreeders, as emperors with chicks to feed are far too busy for such leisurely pursuits.

Like a guide leading the way, a lone Adélie penguin races ahead of a line of emperors. Emperor penguins may walk 100 kilometers (60 miles) or more to reach their rookery. Sometimes they seem to wander across the ice even when there is no rookery ahead, as though simply exploring. The nearest emperor rookery for these birds is at Cape Crozier, about 90 kilometers (55 miles) away on the other side of Ross Island—but then, these wanderers are almost certainly nonbreeders. ¶ Emperors frequently travel in long trains, with the rest of the penguins dutifully following whoever happens to be in the lead. Adélie penguins also tend to move in groups, but with no clear leader. Apparently, if no other Adélies are available as travel companions, a group of emperors will do.

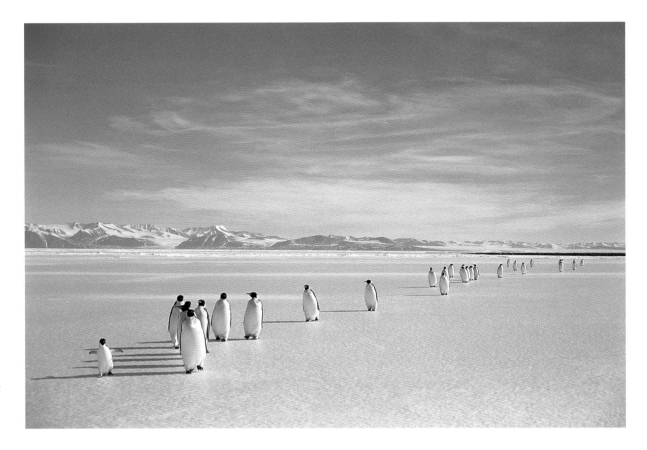

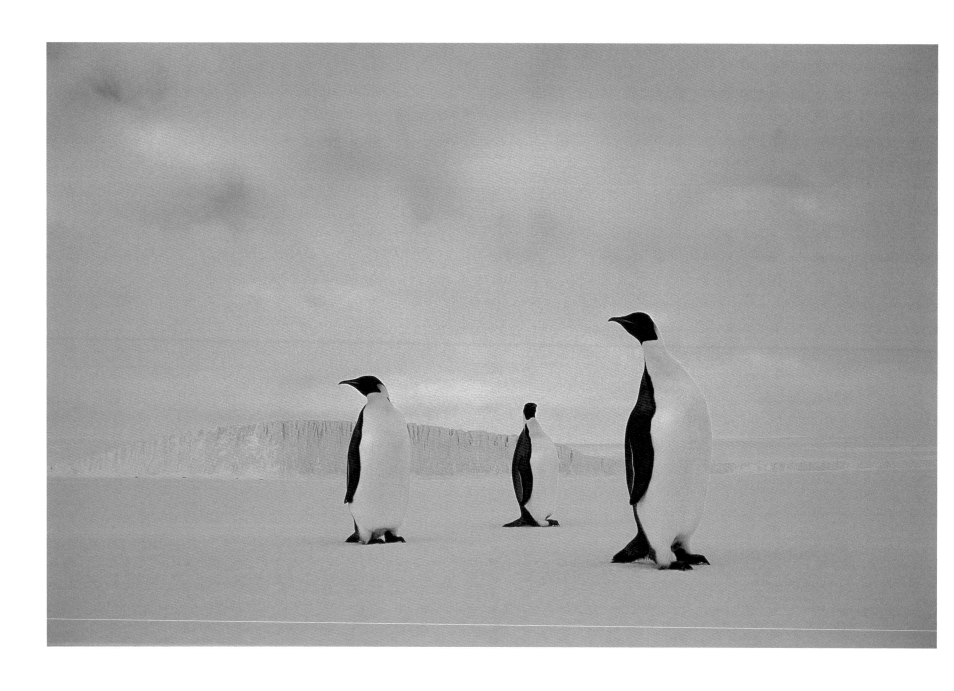

To survive in the coldest, most unforgiving environment imaginable, emperor penguins have evolved a remarkable physiology, one that biologists are only just beginning to understand. When feeding, they are able to convert a tremendous amount of energy into fat stores. The male then uses these stores to endure the fasting required to court his mate and incubate the egg during the bitterly cold and dark winter. For three months he neither drinks nor eats, surviving entirely on stored fat for energy and water. Once the female returns to take over care of the egg (or newly hatched chick), the male needs only about three weeks of foraging to regain enough weight and strength to help feed the fast-growing offspring.

During the late winter and early summer, emperor penguins may wander deep into McMurdo Sound, past McMurdo Station, and even onto the McMurdo Ice Shelf as far south as White Island. They do this with singular purpose, but what drives them to roam so far from the ocean and in directions not remotely associated with breeding areas is completely unknown.

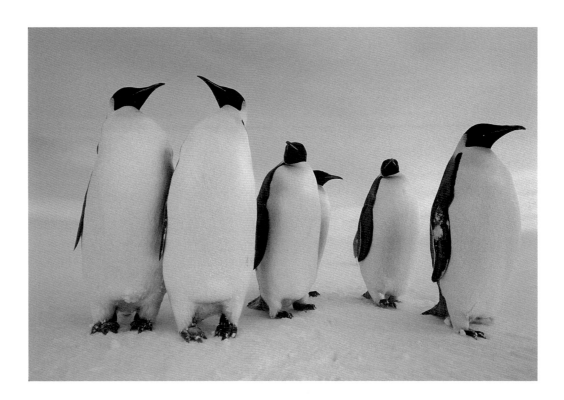

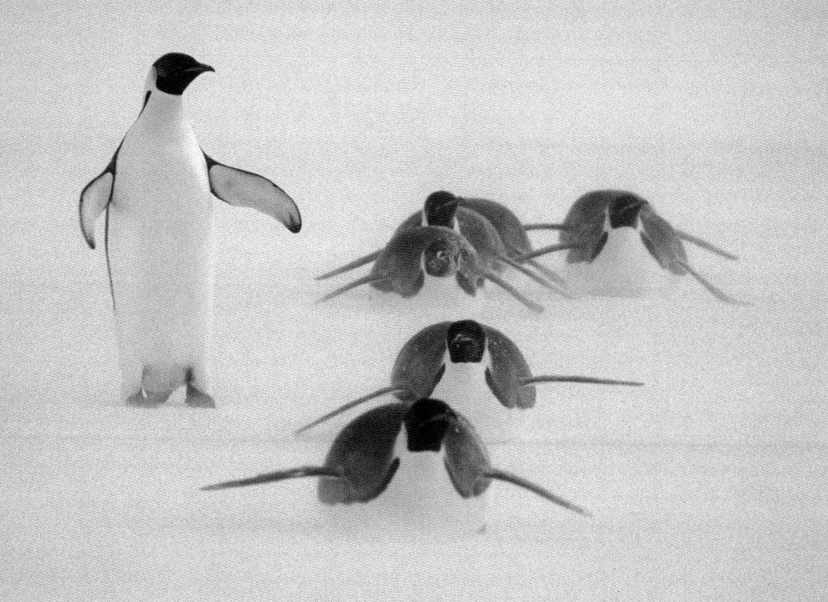

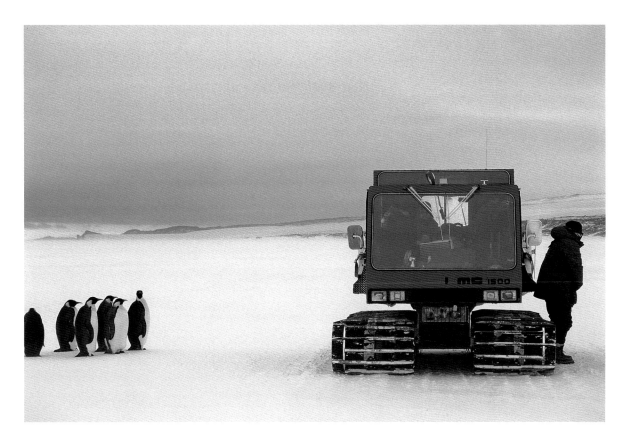

In a behavior that probably allows them to cover more ground with less effort, emperor penguins lie on their bellies and propel themselves forward with their feet, a means of locomotion called "tobogganing."

Curious emperor penguins pause to ponder a tracked vehicle. Scientists working on the ice early in the season often run into these groups of nonbreeding birds, which are conspicuous for being out in the middle of nowhere.

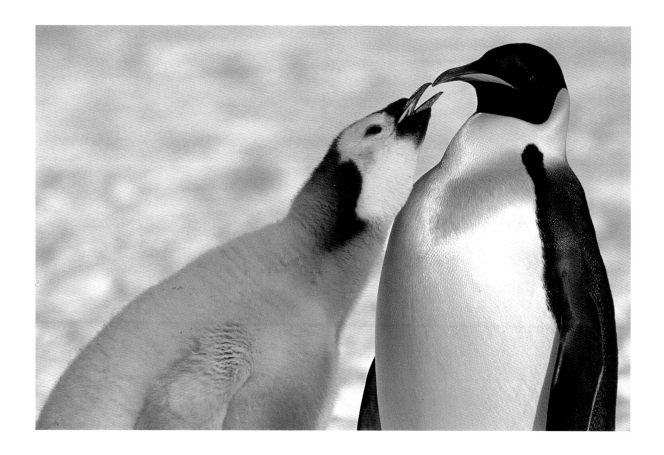

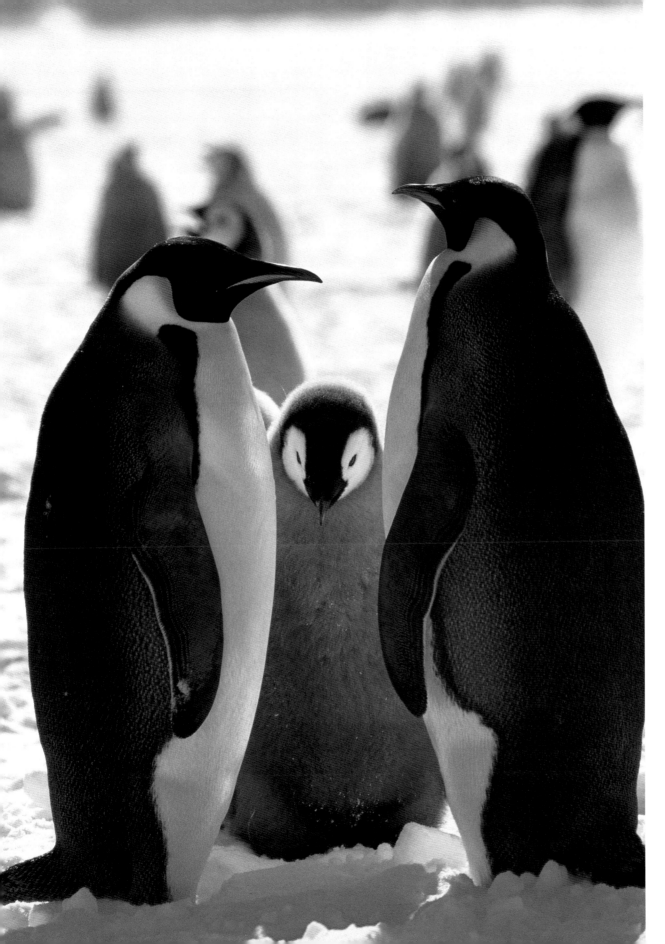

Emperor penguin chicks request food by pecking at the adult's beak (far left). Chicks may request food from any available adult, not just their parents, though they are not always successful. A chick this large is close to fledging and is constantly hungry. Raising a chick to this point involves a tremendous transfer of energy, and both parents must work hard for the chick to survive.

In a successful season, a mated pair of emperor penguins will raise a single chick to fledging. Emperors do not maintain specific nest sites. Instead, the chick (or egg) is carried on an adult's feet, tucked under an abdominal flap to keep it warm. The parents alternate between caring for the chick and going to sea to feed. When the foraging penguin returns, it locates its mate by calling and listening for a reply. Even in a bustling, noisy colony with 25,000 or more mated pairs, it is able to distinguish its partner's call in the din. After a ritual greeting, the chick is carefully transferred to the returning caretaker, who must tuck it into its own warm pouch before the chick freezes. Each adult feeds the chick by regurgitating partially digested fish and squid from its crop.

At about six weeks of age the emperor penguin chicks join the crèche, a sort of penguin day care center, and both parents can leave to forage. This is an important development, because the chick is gaining weight rapidly and has a ravenous hunger. When a parent returns, it trumpets. The chick responds, and the two find each other by homing in on each other's unique voices. In most cases, the chick comes to the adult. ¶ The chicks below, at almost five months old, are nearly ready to fledge. When they do, they will weigh about 12 kilograms (26 pounds), roughly half the adult weight. Soon, the ice will break up and the chicks will head out to sea, where they must fend for themselves. Their greatest danger will be from leopard seals *(Hydrurga leptonyx),* which undoubtedly find fledging and newly fledged chicks to be relatively easy prey compared to the cannier adult penguins.

Cape Crozier is the world's southernmost emperor penguin colony, and the one with the harshest and most unforgiving weather. Penguins begin congregating here as soon as the sea ice is thick enough to bear their weight, usually in late March or early April. The female lays a single egg in late May or early June and passes it to the male. She then heads north to open water to feed. For the next sixty-four days or so, the male incubates the egg by carrying it on his feet, covered with a thick fold of skin. These are the coldest, darkest days of the Antarctic winter. Temperatures can fall to -57°C (-70°F), and winds at Cape Crozier often blow at hurricane force. The males huddle together in groups called scrums, constantly shuffling so that no one has to be on the outside of the group and bear the brunt of the weather for long. ¶ When the chick hatches, the male must feed it. He does this by regurgitating a fat and protein secretion from his crop—even though he has endured three or more months of fast and has lost nearly 50 percent of his body weight. Shortly there-after—at about the time the sun reappears over the horizon—the female returns to take over, and the male heads north. He may have to walk 100 kilometers or more before he reaches open water and can dive for food.

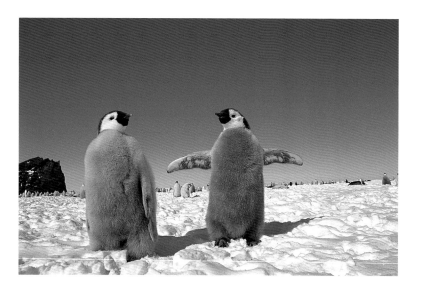

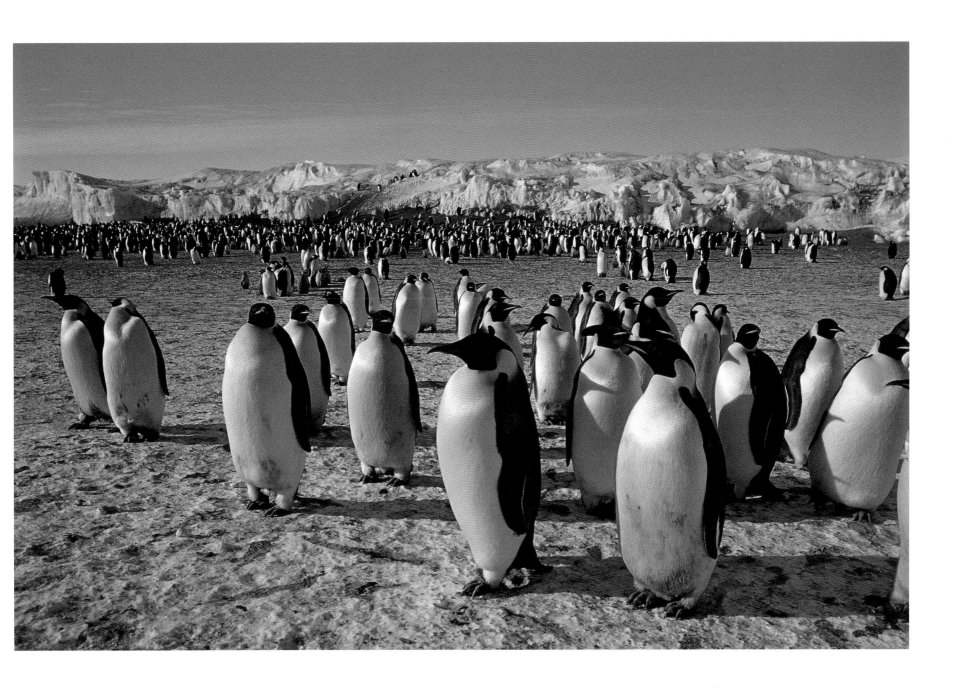

The northern edge of the fast ice divides McMurdo Sound into two domains, one liquid, one frozen. The ice serves as a barrier to predators like orca and minke whales, which are tied to open water. The cetaceans cruise the edge, seeking a way deeper into the sound, where giant Antarctic toothfish (or cod) and schools of Antarctic silverfish lurk in the darkness. In this picture, Mount Erebus, on Ross Island, towers in the background.

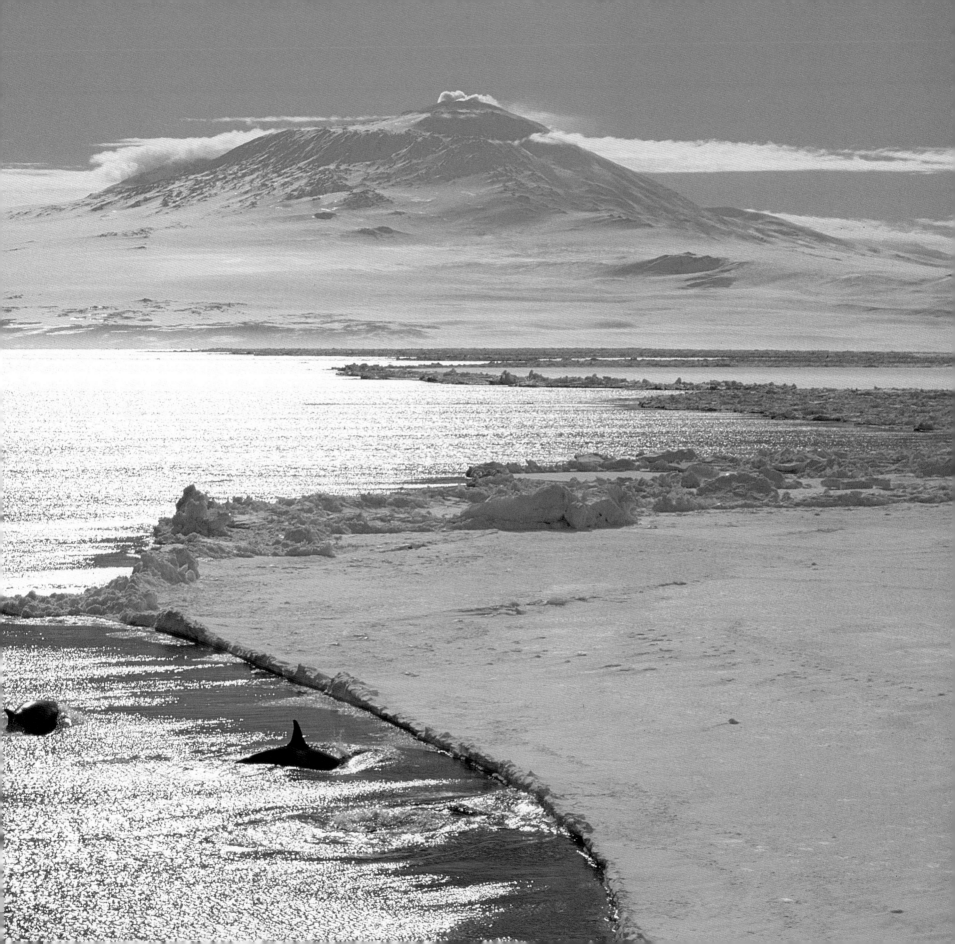

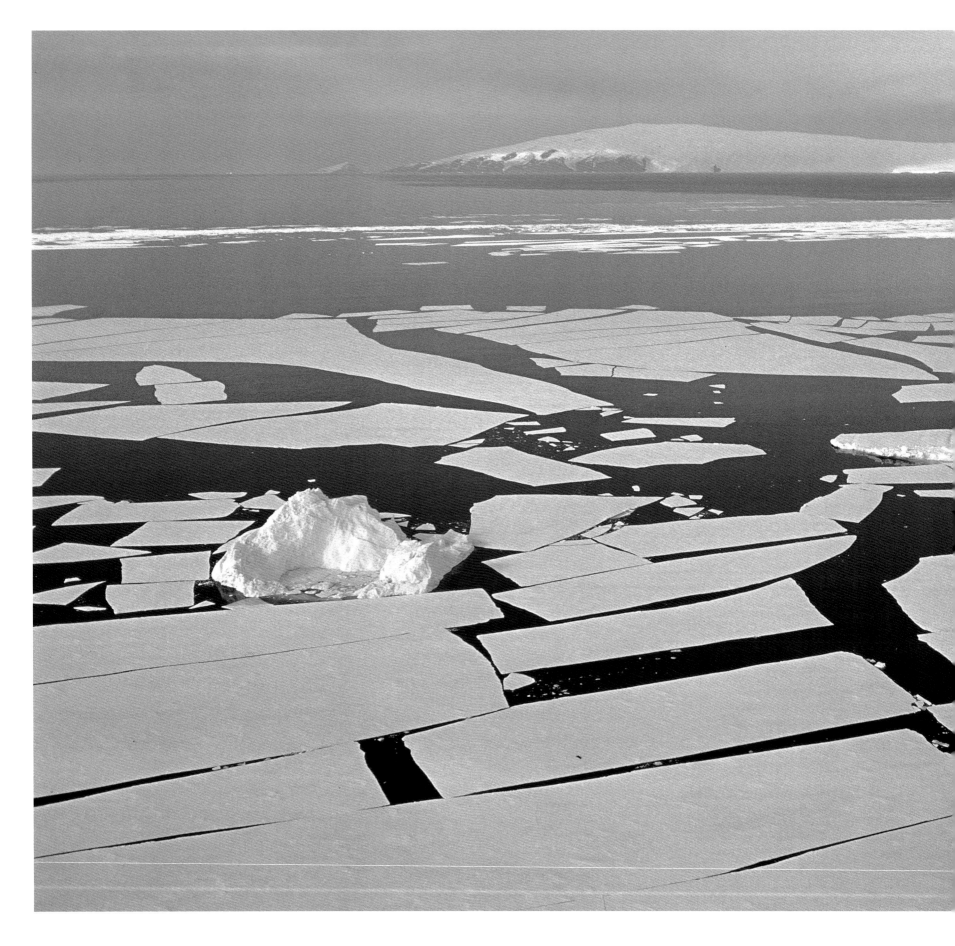

In late summer, the annual fast ice in McMurdo Sound begins breaking up. Large sections split away and are blown north by the prevailing southerly winds. Wind and wave action, as well as collisions between floes, break them into smaller and smaller pieces.

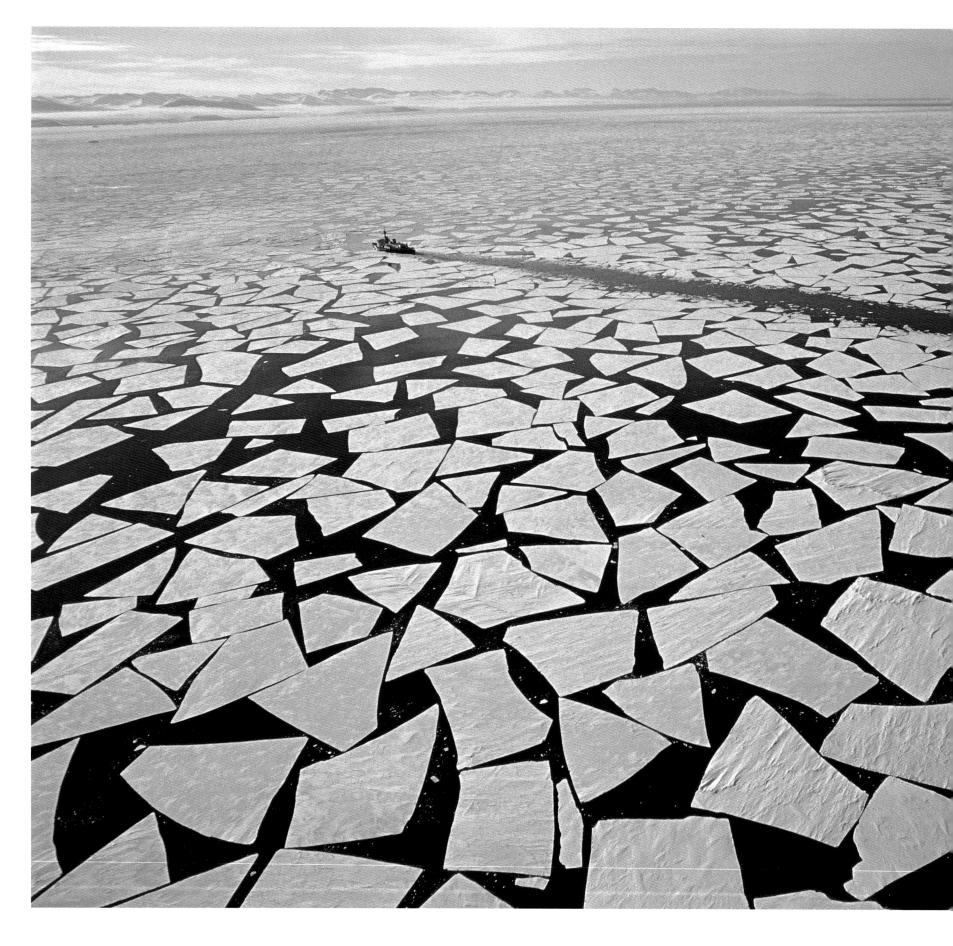

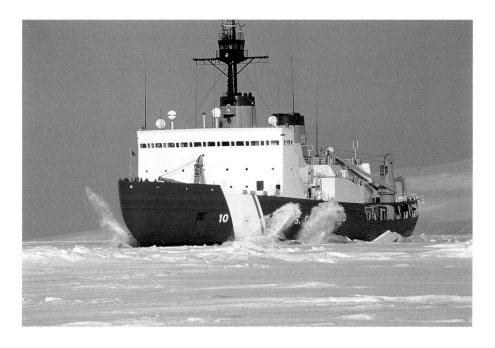

The sea ice breakup in late summer is accelerated by a U.S. Coast Guard icebreaker as it steams to and from McMurdo Station (left).

Above, the U.S. Coast Guard icebreaker *Polar Star* pounds through the sea ice in McMurdo Sound, on its way to McMurdo Station. Each year in late summer, an icebreaker cuts a channel in the ice. This allows a tanker and cargo ship to resupply McMurdo for the coming winter and following summer season.

By late summer, warmer temperatures have taken a toll on the annual fast ice in McMurdo Sound. The breaking-up process begins with the development of a crack. A near-constant southerly wind then pushes the ice apart to create leads that can stretch from the east side of the sound near Ross Island all the way to the Antarctic continent in the west. Whales and penguins use these leads to reach previously inaccessible hunting grounds.

The physics of sea ice formation and destruction are not completely understood, but the shearing forces required to split the ice are tremendous. They can be generated by the horizontal stresses of wind drag at the surface and water drag underneath, or by wind-generated flexural waves caused by turbulent airflow across the surface of the ice. Once the breakup begins, it can proceed quickly (far right, above). Scientists near the ice edge late in the summer season have on occasion found themselves suddenly on a northbound floe and have had to leap over ever-widening open water to reach safe ice.

A group of penguins uses a widening lead as a means of penetrating further into McMurdo Sound (far right, below). Occasionally, the wind pushing the ice apart changes direction, slamming the huge floes back together. When this happens, the penguins are forced to wait until the wind shifts again, or to march north to find open water.

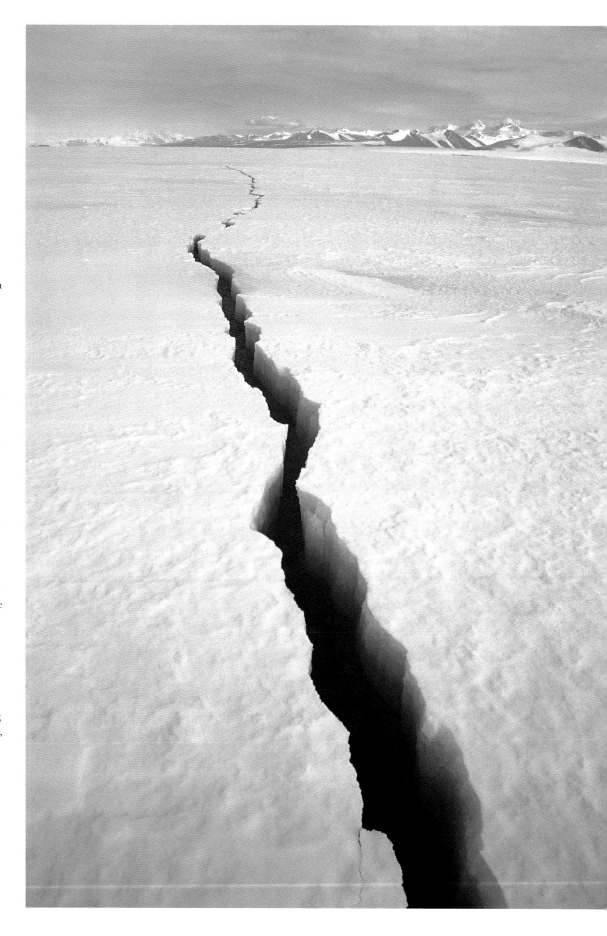

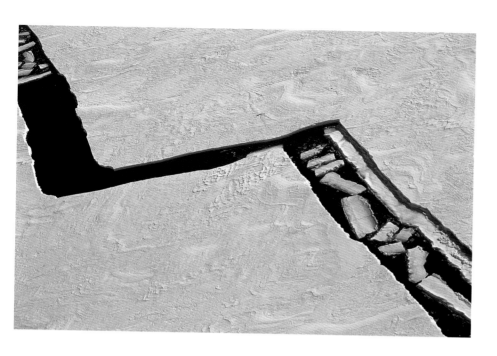

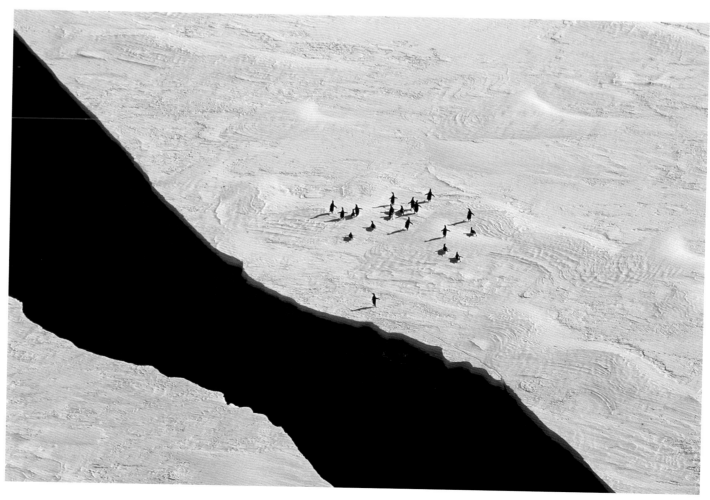

Adélie penguins *(Pygoscelis adeliae)* scramble away as an orca *(Orcinus orca)* surfaces to breathe in a lead. Although this particular whale eats fish and little else, the Adélies don't seem inclined to take any chances.

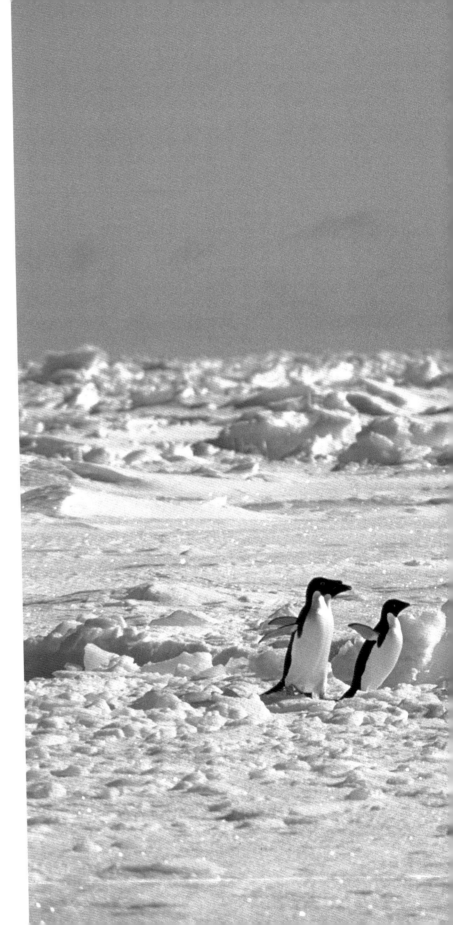

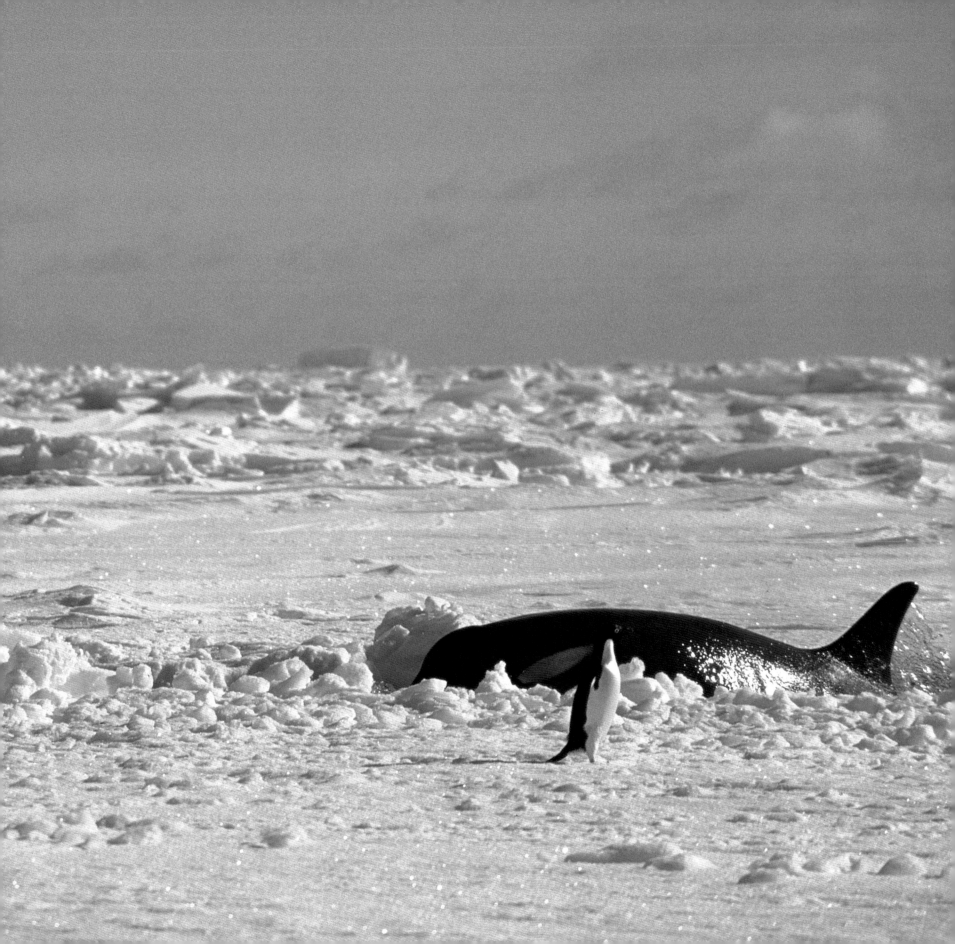

Orcas sprint along a lead that has opened up in the sea ice. The whales use these wide channels of open water to travel deep into McMurdo Sound, where they have access to large Antarctic toothfish *(Dissostichus mawsoni)* that previously enjoyed refuge from predation under the once-solid sheet of ice. This is potentially a dangerous behavior, however, as changing wind conditions can cause the lead to close, cutting off the whales' access to air. The speed at which these whales are moving may indicate that they understand the precariousness of their situation.

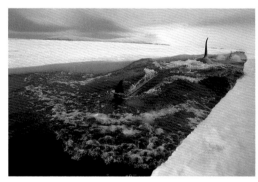

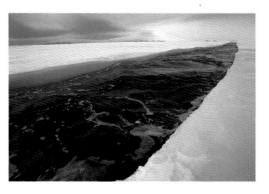

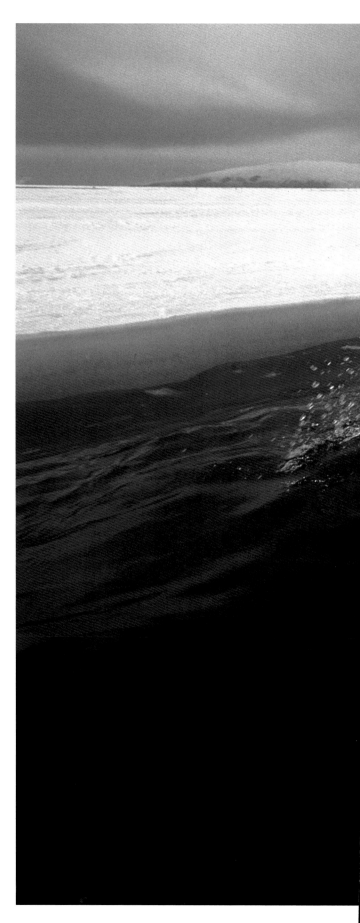

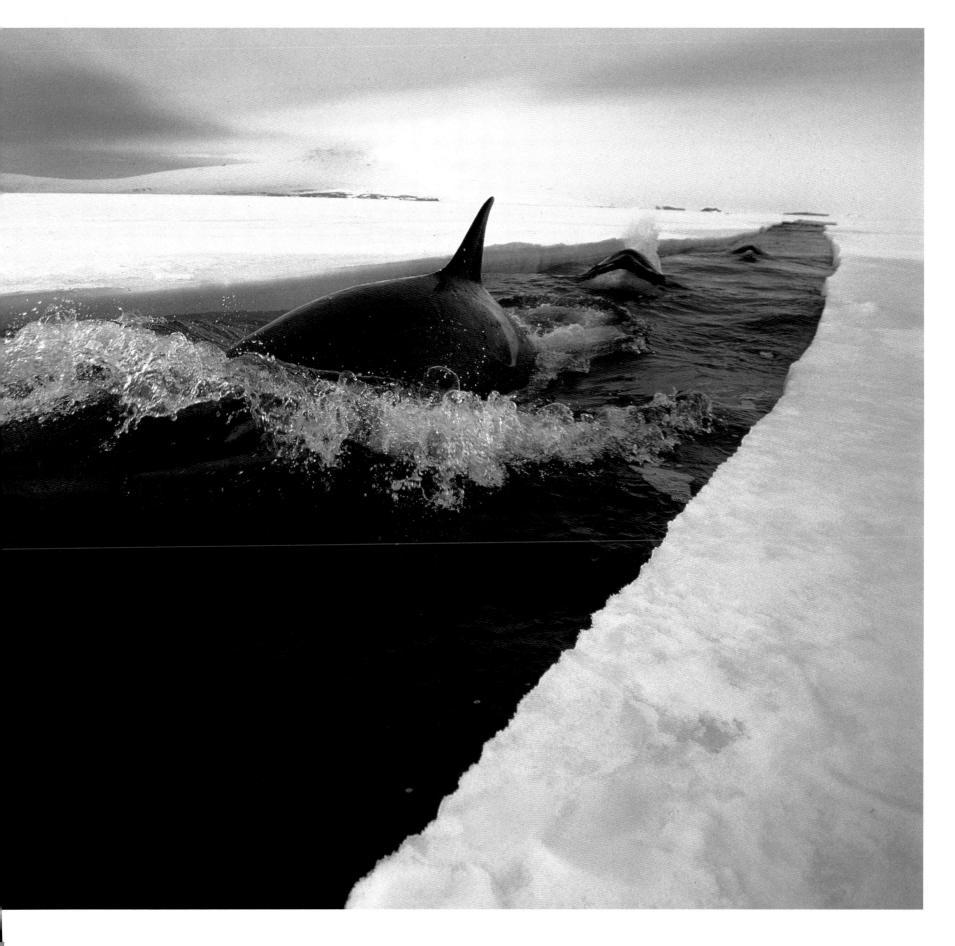

Orca whales often follow the U.S. Coast Guard
icebreaker as it opens a channel to McMurdo Station.
This artificial opening in the ice is deceptive and
potentially dangerous to the whales, however, as it
occurs earlier in the season than would naturally be
the case. Often the channel closes again, trapping
the whales in small pools far from open water.

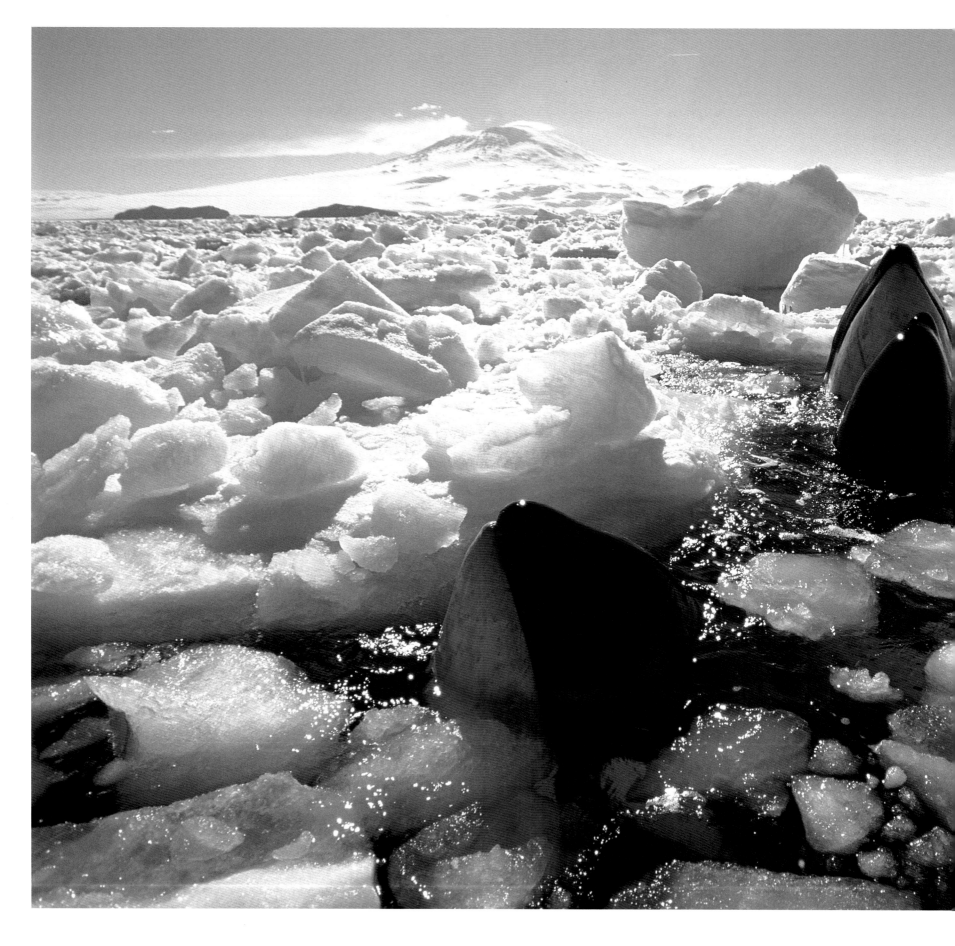

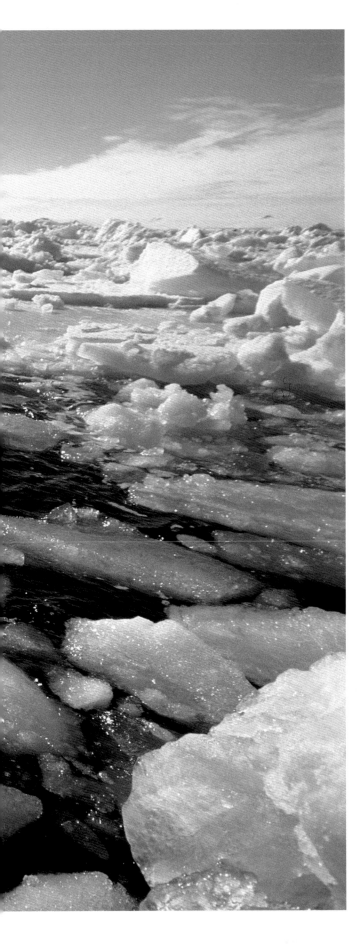

When whales become trapped in the ice, they "spyhop," poking their heads above the surface to look for other open pools and possibly a means of escape. Sometimes they are forced simply to bide their time in ice-locked pools, waiting for conditions to change again and free them.

The orca whales in McMurdo Sound often show curiosity toward people by spyhopping to get a better look at someone on the ice, or by hovering in the water next to a diver. To date, these particular whales have not been aggressive toward humans. The yellow tint on their skin, caused by diatomaceous algae, identifies these whales as fish eaters. Why algae grow on the skin of this piscivorous population of whales and not on a second population that eats almost exclusively marine mammals is not known.

Some of the distinguishing features of the piscivorous orca whales that work the ice edge in McMurdo Sound are their tendency to travel in large pods (150 to 200 individuals), remaining in fairly close proximity to one another; their relatively small size; and their yellow, algae-tinted skin. Indeed, in these regards they are quite distinct from a population of larger, untinted whales that travels in groups of 10 to 15 widely spaced individuals and eats marine mammals almost exclusively. Russian scientists have proposed renaming the fish-eating population *Orcinus glacialis,* based on clear morphometric differences between the two groups and the complete absence of mingling between the populations. In 2002, however, a scientist named Robert Pitman, working with DNA samples from skin and tissue, concluded that they were one and the same species: *Orcinus orca.*

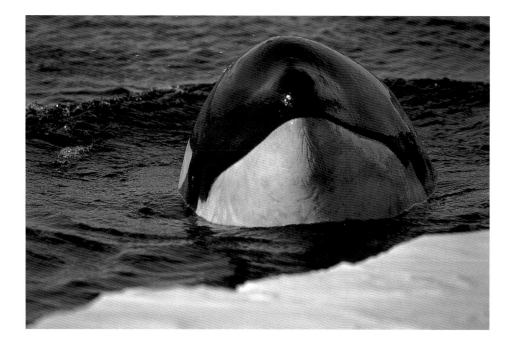

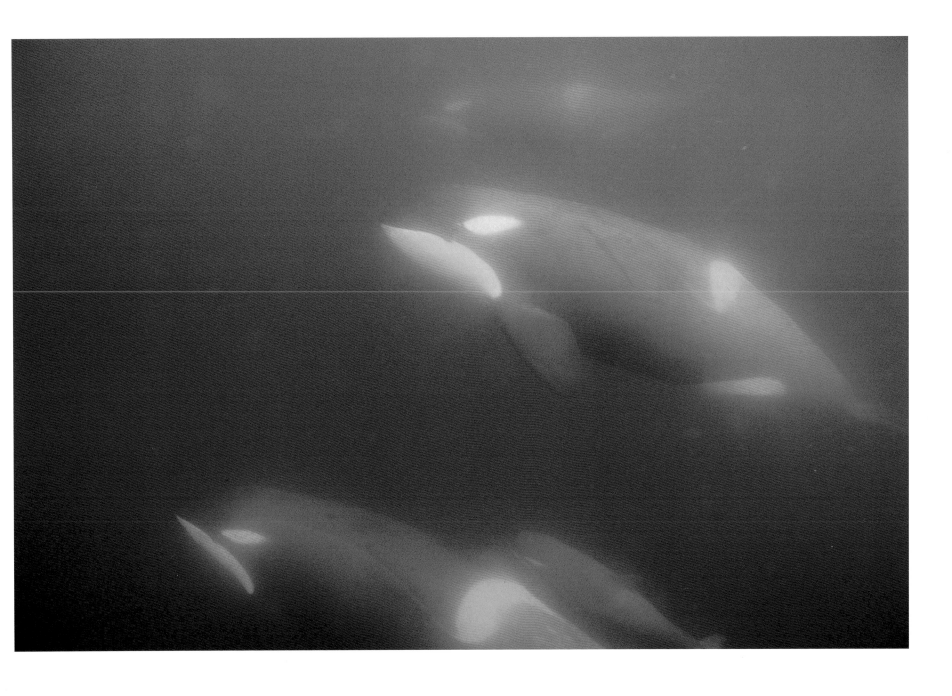

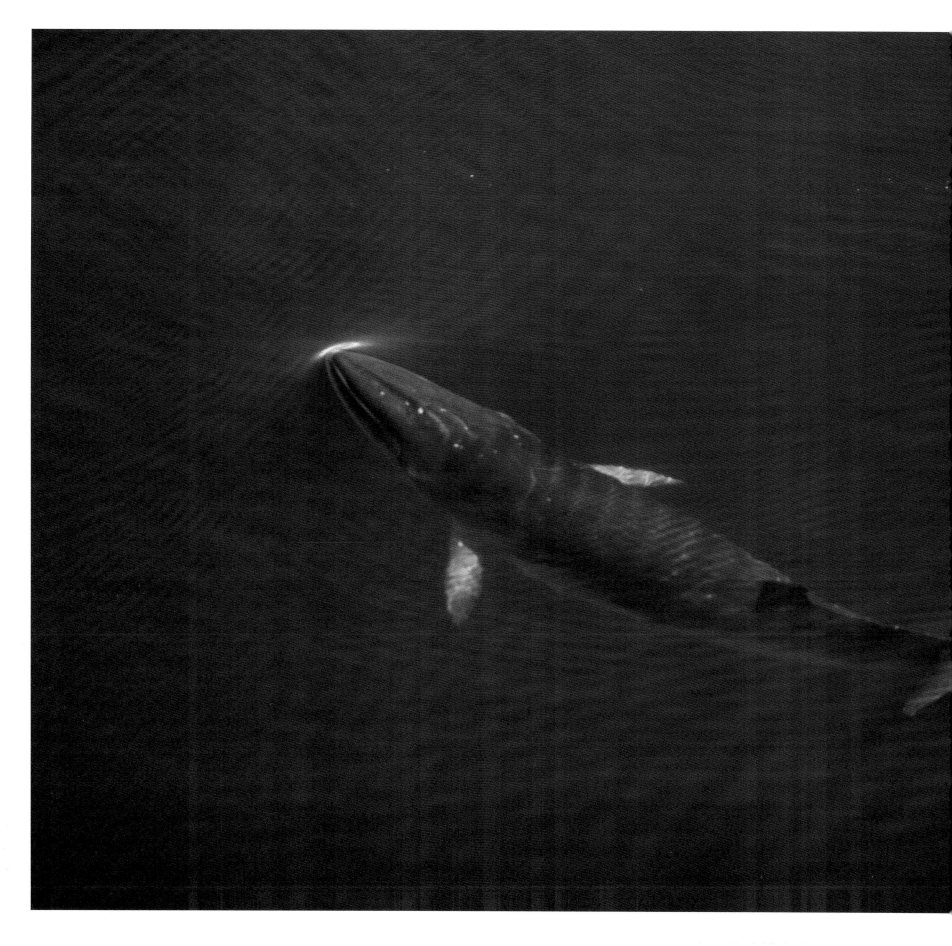

Like orcas, Antarctic minke whales *(Balaenoptera bonaerensis)* cruise the ice edge and dive beneath the ice in search of prey. In late summer, if the annual sea ice has completely broken out of McMurdo Sound, these animals forage as far south as the McMurdo Ice Shelf. Antarctic minkes (a species distinct from the northern variety, *B. acutorostrata*) are the smallest baleen whales in the Southern Ocean, and they are known to feed on the Antarctic krill species *Euphausia superba*. Since *E. superba* is generally not found in McMurdo Sound, however, the whales here must be feeding on other organisms. Potential prey may include the closely related krill *Euphausia crystallorophias* and the Antarctic silverfish, *Pleuragramma antarcticum.*

Two Antarctic minke whales forage near an iceberg at the ice edge in McMurdo Sound. These marine mammals often travel and forage in pairs.

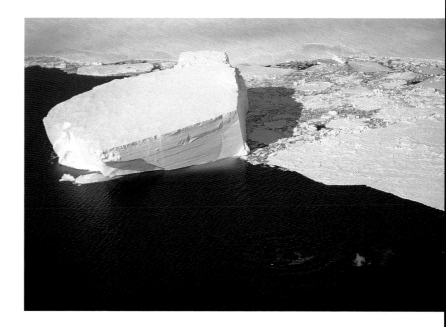

Like the orca whales, Antarctic minke whales *(Balaenoptera bonaerensis)* seek their prey under the ice, pushing as far south as possible while still maintaining access to open water. Sometimes, though, these whales also overreach and become trapped in small pools when the ice closes in around them. Once that happens, they have little choice but to wait until ice and wind conditions change and their access to the open sea is restored.

These three Antarctic minke whales (right) are temporarily confined to an ice-locked pool near the ice edge.

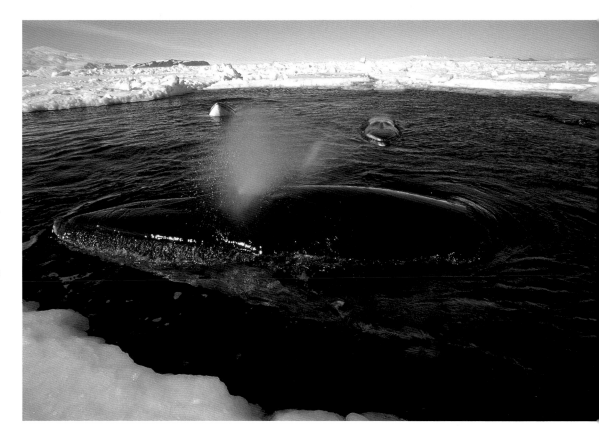

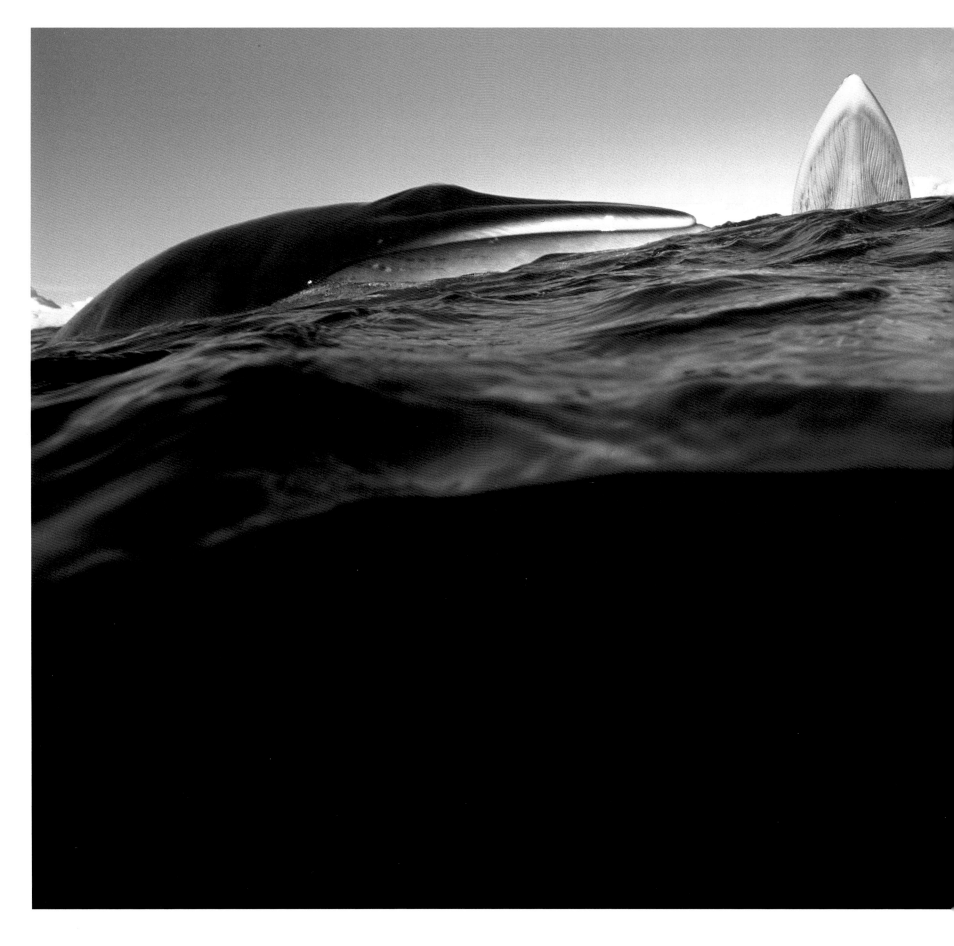

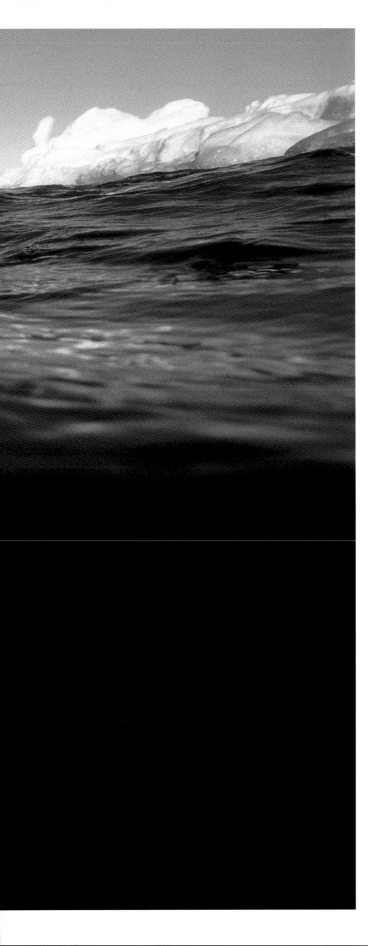

Much like orcas, Antarctic minke whales that become trapped in the ice spyhop to search for a way out of their predicament. Because underwater visibility is so poor during the late-summer plankton bloom, it may be easier to see areas of open water from the surface than from below.

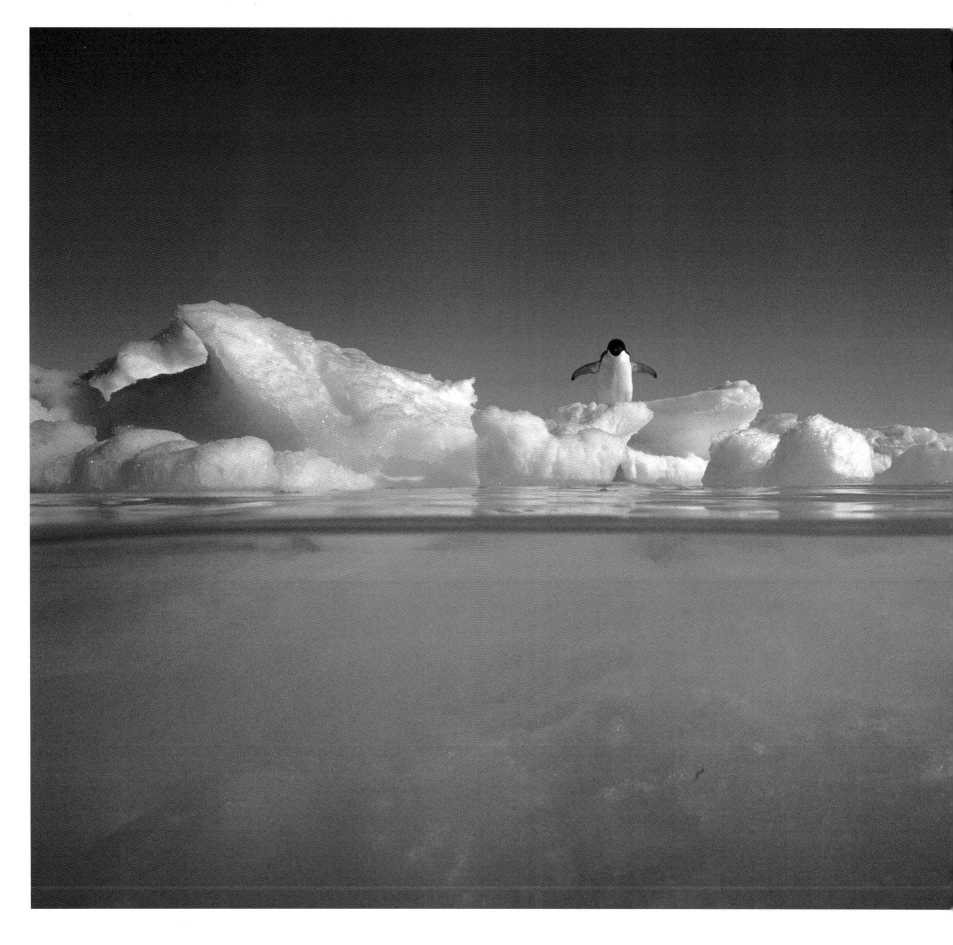

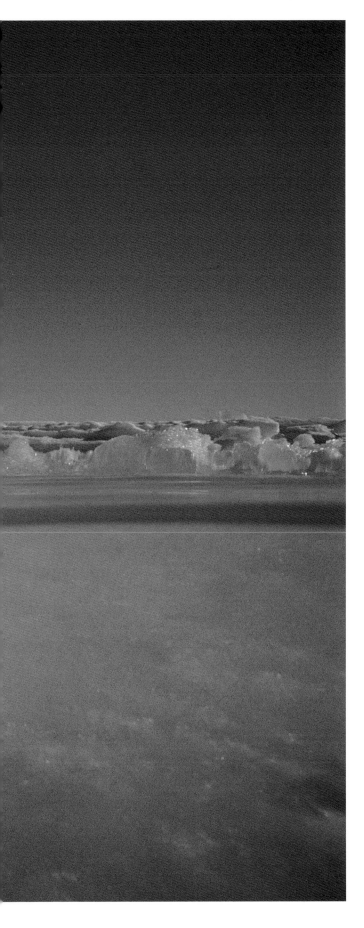

A whale's-eye view of an Adélie penguin
(Pygoscelis adeliae) standing near the edge
of the ice.

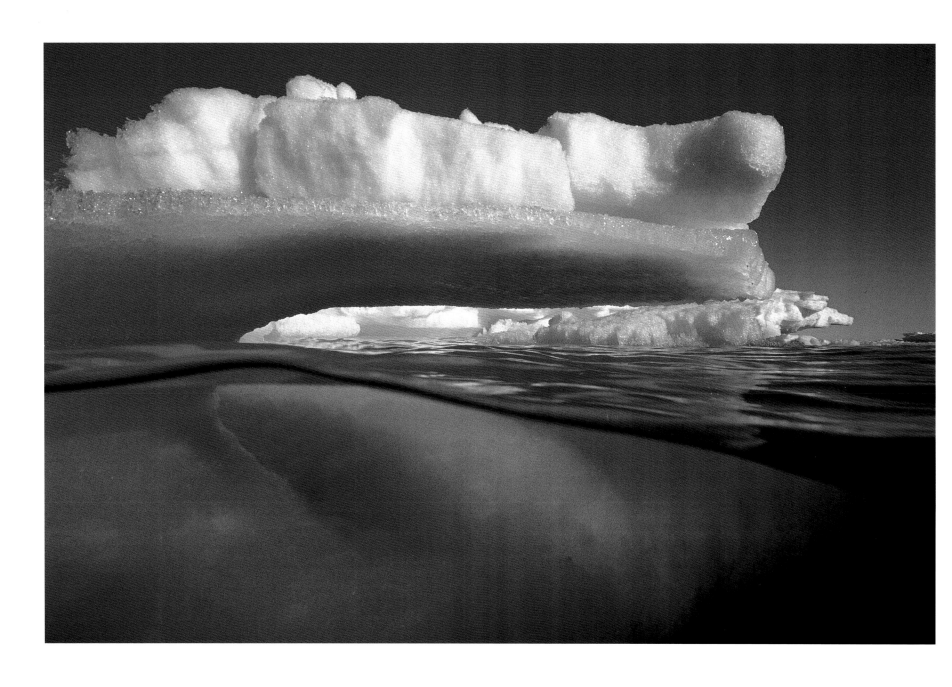

Because wave action can erode the ice at the edge in unpredictable ways, scientists working here must be exceptionally careful where they walk. Leopard seals *(Hydrurga leptonyx)* pose another—though uncommon—risk. In a typical hunting pattern, the seals lurk out of sight just under the edge, hoping to catch an unsuspecting penguin standing too close to the water. In 1989, a researcher was collecting water samples at the ice edge when a leopard seal lunged out of the water and grabbed her knee. Fortunately, human beings are not standard leopard seal fare, so the animal promptly let go and disappeared back into the water. It had probably mistaken the kneeling human for an oversized penguin. In fact, in the brief moment its mouth was around her leg, the seal appeared to the researcher to be as surprised as she was.

An orca whale *(Orcinus orca),* cruising past with the carcass of an Antarctic toothfish *(Dissostichus mawsoni)* in its mouth, verifies what scientists had long suspected: that the smaller, deep-diving McMurdo Sound orcas prey mainly on these fish. In fact, a substantial population of toothfish is known to exist in the sound during the austral summer, which likely explains the whale's apparent eagerness to get past the sea ice and deeper into the sound. The largest of the notothenioids, *D. mawsoni* can reach a length of 2 meters (6.5 feet) and a weight of 100 kilograms (220 pounds), and because it is rich in oil it maintains near-neutral buoyancy. The fish represents a good-size chunk of high-calorie food to an orca whale.

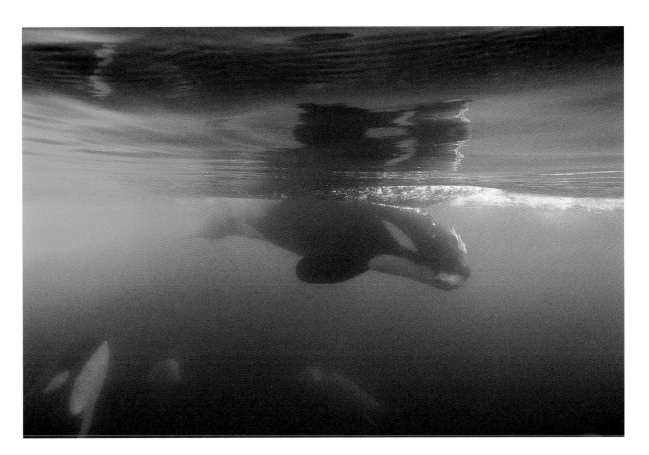

As summer comes to an end, temperatures plummet and open water begins to freeze. Here at the ice edge, a thin layer of "grease ice" is forming. If temperatures remain low, the grease ice will thicken to a mushy "frazil ice," and then to a harder "congelation ice." Typically, though, wind and wave action break up new ice before it becomes very thick. The fast ice in McMurdo Sound often doesn't form and remain in place until sometime in the winter.

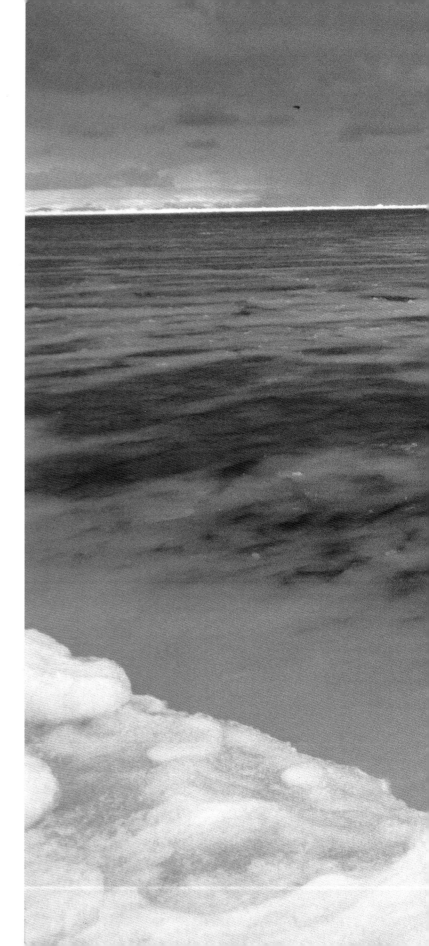

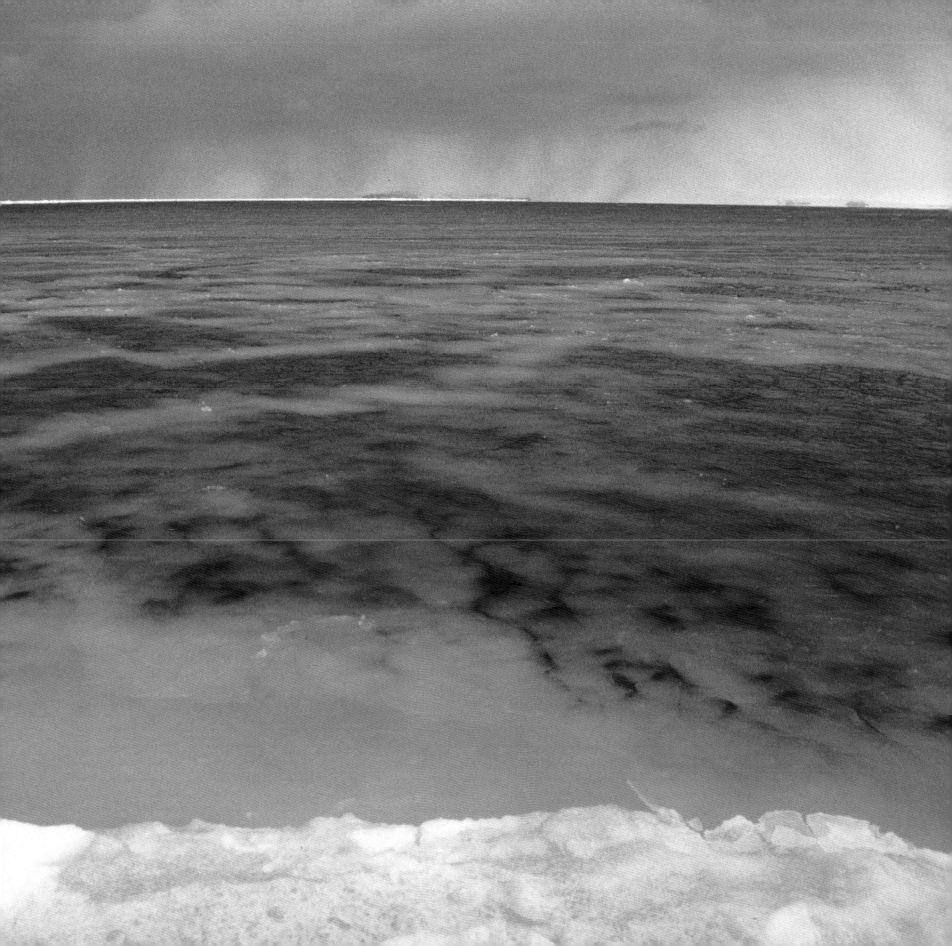

"Ice is the beginning and ice is the end of Antarctica," writes historian Stephen Pyne. Antarctica—The Ice—is the most remote, the coldest, the windiest, the most inaccessible, and the most inhospitable land area on Earth. Ice dominates and shapes the environment, and it is the overwhelming physical presence everywhere in Antarctica—including underwater. All life revolves around The Ice.

There's something special about peering beneath the bottom of the world. When Antarctica's diving season begins in late September, the sun has been below the horizon for months, and the water, free of plankton, has become clearer than any in the world. Visibility can be measured not in feet but in football fields. Prevented from freezing by its salt, the water is as intensely cold as it is clear, and diving in this ice-roofed world feels like floating in space. Yet it's never a place to relax: your regulator can freeze up if you breathe too fast or work too hard, and you need to keep sight of the dive hole, your only exit to the outside world.

The pristine beauty of this continent invariably takes my breath away. With my first step off the plane I fell in love with the vastness and purity of the place. I fell in love with the cold and clarity of the underwater realm and marveled at the way animals had adapted to this harsh environment. I grew to love the crooning calls of the emperor penguins, the cacophony of the Adélie penguins, and the eerie symphonies of the Weddell seals. I fell in love with the people at McMurdo base—self-reliant individuals with a sense of humor and adventure and a spirit of cooperation. I loved the surprises that Antarctica sprang upon me. It is a place that made me feel happy to be alive. I'm always thrilled to get there—and always glad to leave.

Around the islands the water is incredibly clear—180 meters (600 feet) of visibility is common early in the season. There is a rich bottom community of fishes, soft corals, and sponges. Until recently scientists thought that Antarctica's waters, like the Arctic's, had a relatively low diversity of life; it now appears that Antarctic biodiversity is richer than they had imagined. But you'd never guess it from the surface. Marine ecologist Dale Stokes comments about our dives: "There's this large, active, colorful community under the ice, and then you come up through a hole into a raging blizzard."

On the surface, this is the coldest, windiest, most inhospitable place on Earth, but under the ice it is another world. The water is warmer than the air above, staying fairly constant year-round and varying little with depth, but it is still a chilling -1.86°C (28.6°F)—below the freezing point of fresh water.

Photographing on land here involves two main obstacles. First, the photographer must compensate for the snow and ice, which fool camera meters into underexposing images. I usually solved this problem by having my camera overexpose by $^2/_3$ stop from its meter readings and bracketing around this exposure automatically by $^1/_3$-stop increments. Second, the bitter cold can damage equipment. I found, however, that only my batteries were affected, and I got around this by switching from alkaline to nickel-cadmium batteries. Even in -40 degree (Celsius or Fahrenheit) temperatures, my Canon and Nikon cameras and my film performed just fine.

Photographing underwater presents an entirely different set of obstacles. Because of ice and snow cover, Antarctic waters are very dark, necessitating long shutter speeds. The cold wreaked havoc on my underwater equipment. I brought a dozen camera bodies, seven underwater housings, and a dozen underwater flash units. By the end of my stay, only three housings and strobes were working properly.

I rarely log technical details about my photographs like aperture and shutter speed, so I have not included this information. Underwater, I used Nikon N90s (F90X) cameras in Subal and Sea and Sea underwater housings, Ikelite Substrobe 200 underwater flash units, Nikon F4s cameras in Aquatica housings, Nikonos V amphibious cameras, and, in later seasons, Ikelite's superb underwater digital light meter. On land, I used Nikon N90s and Canon EOS-1 cameras. I used color transparency film ranging from Kodak's Kodachrome 64 and 200 to Fujichrome Velvia and Provia. All in all, I shot 500 rolls of film.

For more information (and more photographs), please refer to our team's website at http://scilib.ucsd.edu/sio/nsf. This website has been created by the Scripps Institution of Oceanography Library to aid in disseminating information about Antarctic marine life. The website contains a catalog of Antarctic species to access and to use for reference as well as detailed information on the biology of the subjects in these photographs. Team members' journals are included, along with a section on diving equipment and techniques.

Nearly all the images in this book were published using enlarged 70mm duplicates from the original transparencies. They have not been manipulated in any analog or digital manner, other than standard color correction in the printing process.

This southern sea proved to be full of surprises. It was undoubtedly the most difficult place I have ever worked, but it is rich in extraordinary life. I was captivated by the magic of this pristine place. I hope this book brings some of that magic to you.

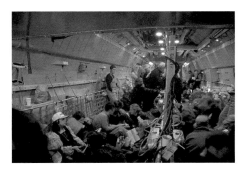

▲ page 3 C-141 MILITARY TRANSPORT BOUND FOR MCMURDO STATION

To get to McMurdo, you fly to Christchurch, New Zealand. It is a charming little city to spend time in, which is a good thing, because weather conditions in McMurdo can leave hundreds of people stranded in Christchurch for weeks. My record for being stuck in Christchurch was seven days. I heard of one scientist who flew in to Christchurch, could not get to McMurdo for three weeks, and then had to turn around and go home because the window for her project had come and gone.

When you first arrive in Christchurch, you report to the U.S. Antarctic Program's Clothing Distribution Center (CDC). You are issued your Antarctic clothing at this monstrous warehouse, which is packed full of parkas, rubber "bunny boots" that insulate your feet by holding air in the rubber, and other, more standard winter clothing. It is a busy, confusing ordeal.

The next day involves getting up at 4 A.M., trudging in all your gear to the CDC, then waiting to board the C-141 military cargo plane for the flight to McMurdo. If you are lucky, your flight will leave as scheduled and you will see McMurdo six to eight hours later. If you are not so lucky, you must repeat the process for several days in a row before finally landing in McMurdo. It's here that a sense of humor helps; and indeed, the McMurdo community's sense of humor—combined with not just a little sarcasm—is a prevalent part of the Antarctic experience.

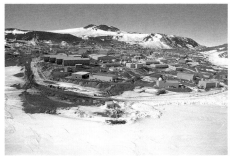

▲ page 3 AERIAL VIEW OF MCMURDO STATION

The U.S. National Science Foundation (NSF) maintains three year-round research stations in Antarctica. The largest is McMurdo Station, on Ross Island, in the southernmost ocean in the world. I worked out of McMurdo Station in 1997, in 1999–2000, and again in 2000–2001 under the NSF's Antarctic Artists and Writers Program (part of the science-based USAP) to document the underwater world of Antarctica in still photographs and for a high-definition television (HDTV) documentary for WNET/Thirteen New York's *Nature* series, which airs on PBS stations.

I am a slow learner. It took me three seasons and the task of writing a film script to understand how special McMurdo Station is, both physically and historically. It is situated on the peninsula of an island, with the Ross Ice Shelf, the world's largest confluence of glaciers, next to it. Sweeping under this huge mass of ice are ocean currents carrying deepwater animals past McMurdo Station. The sound itself is a vast, deep bay that boasts large populations of Antarctic silverfish and giant Antarctic cod, food for Weddell seals and orcas. Both Ernest Shackleton and Robert Scott established expedition camps here, which are still standing. Winter Quarters Bay, in McMurdo Sound, is the world's southernmost port, making McMurdo the obvious choice for early Antarctic explorers' bases. No other place in Antarctica has as much history—or, quite possibly, is as interesting or diverse—as McMurdo Sound.

Antarctica is much larger than the United States. The Antarctic continent covers 14 million square kilometers (5.4 million square miles), while the United States, including Alaska and Hawaii and inland waters, is 9.8 million square kilometers (3.8 mil-

lion square miles). Most tourists visit the Antarctic Peninsula, a long finger of the continent that reaches close to South America. McMurdo Station is on the opposite side of the continent and 10 degrees farther south. High-latitude Antarctica is a much harsher environment than the Antarctic Peninsula and subantarctic islands. Only two species of penguins, the Adélie and emperor, and two species of seals, the Weddell and leopard, make their home in these difficult conditions.

Although one or two tourist ships visit McMurdo Sound each summer, most of the people actually living and working here are affiliated with the science that goes on at the station, either as investigators or as support staff. Of course, the United States underwrites the science here in order to keep an eye on, and a stake in, the Antarctic continent. Some say that science is only a flimsy excuse for maintaining a physical—and geopolitical—presence in Antarctica. If one takes that view, and looks at the long record of research produced by U.S. scientists in Antarctica, it would seem our quest for scientific knowledge is being very well served by politics.

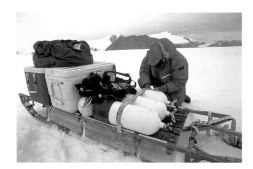

▲ page 4 CREW PREPARING DIVING AND CAMERA GEAR, GRANITE HARBOR

The Antarctic diving season begins in late September or October, early in the Antarctic summer, when the sun has been largely absent for six months and the water is virtually free of phytoplankton and thus strikingly clear. In fact, visibility was limited not by particles in the seawater, as is usual when diving, but by the availability of light filtering through the sea ice. In three months we made sixty-eight scuba dives—typically lasting an hour, sometimes longer if our hands could stand the cold—and various field trips.

Diving in freezing water is tricky. Our team had surprisingly few problems, however, thanks largely to the well-stocked diving locker at McMurdo and the expertise of Rob Robbins, the diving safety officer. Diving from the sea ice of McMurdo Sound was heaven for me, since I hate boats. Most of the time we simply loaded up our Spryte tracked vehicles and snowmobiles with gear, drove up to 32 kilometers (20 miles) over the sea ice to a heated hut placed over a hole in the ice, and jumped in the water. No seasickness and no time spent on a boat, which Samuel Johnson likened to "a prison with the possibility of being drowned." Not only that, but the huts were equipped with diesel fuel heaters, Coleman stoves to heat up soup, and survival food like unwholesome meat sticks and chocolate, making the time spent out of water quite cozy.

We generally dived near land masses, since islands and coastal areas present a bottom shallow enough to see. Farther out in the sound, the water is thousands of feet deep (maximum depth in McMurdo Sound is a bit over 1,000 meters, or 3,280 feet)—much too deep to touch bottom, and with little marine life to see.

We were able to dive up to three times a day, with dive times averaging about 40 minutes. My personal record was 90 minutes underwater. Dry suits and thermal underwear mostly worked very well in keeping us dry and warm, but my feet, hands, and lips were numb all the time (divers' lips are exposed to the water), and an area around my neck, near the latex seal of my dry suit, actually got frostbitten. Putting a neoprene collar around my neck solved this problem. For some reason, my lips never did get frostbite.

Our infrequent problems always involved little things: dry-suit inflator valves that got plugged with a bit of ice; dry suit gloves that flooded because of improperly installed sealing rings; torn hoods. If even the smallest detail wasn't attended to, a diver would have to grapple with it throughout the dive.

Equipment must be rugged to withstand Antarctic conditions. In tests of several regulators, the U.S. Antarctic Diving Program found that an older, simpler model of Sherwood regulator, the Maximus, had the lowest failure rate. Ironically, the Maximus

regulator, unlike most of the other models tested, was not designed specifically for polar conditions. The Sherwood Maximus regulators we used had been further modified with a brass plate, which allowed our breath to warm up the regulator second stage and thus inhibit ice formation inside it. We always dived with tanks that had a Y-valve, to which two regulators were attached. If one regulator failed, we could turn off the air to that one and carry on with our second regulator.

In my three seasons of diving in Antarctica, logging over 150 dives, I did not have a single serious regulator failure. These photographs, then, are a tribute to safe and advanced diving technology.

Diving in Antarctica requires not only some special equipment, but a certain presence of mind as well. If you exert yourself too much underwater, you will breathe faster and drain your tank faster. In the end, it is all about not working too hard.

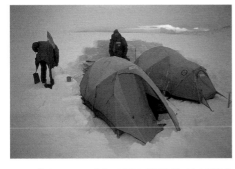

▲ page 4 SNOWCRAFT SURVIVAL SCHOOL, MCMURDO STATION

The day after I arrived in McMurdo I was whisked away to spend two days in the base's mandatory two-day snowcraft survival course—otherwise known as Happy Camper School. In addition to learning essential survival techniques, we became thoroughly acquainted with the survival bags that all field parties must carry, containing such essentials as sleeping bags, a stove, fuel, matches, and comic books. I had never camped in temperatures below about -7 degrees Celsius (20 degrees Fahrenheit), much less in snow. Here, though, I learned that, properly equipped, I could indeed survive in any kind of weather. (The day after I finished Happy Camper School, however, I came down with McMurdo Crud, a variety of flu that afflicts

a great percentage of the McMurdo population each season.)

One thing you don't learn about in Happy Camper School is how cold affects camera gear. As an underwater photographer, I used to carry my topside cameras in plastic coolers rather than camera bags, which allowed both quick access to my equipment and protection from splashes. I quickly learned that more conventional Lowepro Cordura camera bags were more appropriate to Antarctic conditions: after photographing our camp in -30 degree Celsius temperatures, I shut my cooler, and the top shattered. The cold continued to wreak havoc, as my flash unit's vinyl reflector shattered also. And my alkaline batteries lasted exactly two shots before they stopped working. That's two *shots,* not two rolls. I switched to nicad and lithium batteries, and my cameras went the rest of the night with no problem.

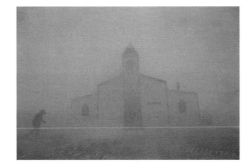

▲ page 5 CHAPEL, CONDITION 2, MCMURDO STATION

McMurdo Station is like a small Alaskan mining town. Everyone lives in dorms, two to a room. It's almost like being in college, except there are no supervisory resident advisers, and no one is studying. The station has its own chapel, a library, a communal galley where meals are served, two bars, a coffeehouse, a greenhouse, and even a store that offers snacks, T-shirts, and a video library.

The village atmosphere does not conceal the serious nature of McMurdo, though. The entire station exists to support research. Because the austral summer is brief and spaces for researchers are limited, time is short. People are always in a hurry, and the twenty-four-hour sunlight only adds to this sense of urgency.

▲ page 5 FLAGGED ROUTE, CONDITION I, MCMURDO
STATION

Ultimately, weather dictates the work around the
station, with three "conditions" holding sway. The
most severe, condition 1, means blizzard condi-
tions, with winds in excess of 102 kilometers per
hour (55 knots), wind chill temperatures below -73
degrees Celsius (-100 degrees Fahrenheit), and/or
visibility less than about 30 meters (100 feet). A con-
dition 1 means no sea ice travel, and of course no
diving. Perhaps a third of our dive days in 1997 were
canceled because of bad weather. Even travel be-
tween buildings in McMurdo Town is restricted
during a condition 1. I have bad hearing, and I am
known for being absentminded, so one day I was
unaware that a condition 1 was in effect. I left the
dorm, trudged to the lab, and walked in. My crew
looked at me in amazement and asked what I was
doing there.

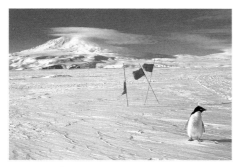

▲ page 6 ADÉLIE PENGUIN IN FRONT OF MOUNT
EREBUS AND FLAGGED ROUTE

We often encountered lone Adélie penguins *(Pygoscelis
adeliae)* wandering around the sea ice near McMurdo
Station. These little critters really get around. In
1997, an Adélie penguin wandered into the Dry
Valleys; after much debate among the powers-that-
be at NSF, it was eventually airlifted out by heli-
copter. When I included this story in a children's
book on Antarctica, the editors asked me to take it
out, sure that I had made it up.

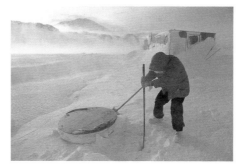

▲ page 7 DALE STOKES READYING A DIVE HOLE
AFTER A BLIZZARD, CAPE EVANS

I have fond memories of the situation depicted in
this photograph. I had arrived at McMurdo Station
for the first time about two weeks earlier. I had gone
through Happy Camper School and promptly
come down with the McMurdo Crud; then a storm
blew in for four days, confining everyone to the
base. After eleven long days of waiting, I had finally
done my first dive in Antarctica near the McMurdo
Pier—and immediately had camera problems
caused by the cold water. The team was eager to do
some real diving.

Cape Evans is a long 19 kilometers (12 miles) away
from McMurdo Station—an interminable, rough,
two-hour drive—and near the logistical limit for
diving from McMurdo Station. This sea ice hut had
been placed at Cape Evans by a research group sev-
eral days prior, and it was scheduled to be moved
the next day. We therefore loaded all of our gear
into a Spryte, and I had my first Antarctic experi-
ence.

Dale, a Canadian, loves to shovel snow. (Well, at
least he doesn't complain about it.) He was also the
only member of our team who had been to The Ice
before. He promptly jumped out of the Spryte,
grabbed a shovel, and began digging away in the
howling wind and snow to free the styrofoam plug
from the safety hole. I was shocked by the fierce-
ness of the wind, cold, and blowing snow. I grabbed
a topside camera and began photographing Dale
at work.

Unbeknownst to us, the wind had been so strong
in the days previous that it had moved the 13.5-kilo-
gram (30-pound) styrofoam plug several feet toward
the hut. While taking this photograph, I was one
step away from falling right into the safety hole.
Eventually Dale realized that he was trying to chip
away at 2 meters of sea ice. We then found the safety
hole right behind me.

Little did I know that most Antarctic summers are
sunny and warm, nothing at all like the howling,
cold summer of my first season in Antarctica. The
1997 season saw the worst weather that McMurdo
Station had experienced in thirty years. I look back
now on those short twelve weeks of work, and I
am astonished I got anything done at all.

Diving huts (also called fish huts, being regularly
used by scientific research groups studying fish) can
be very comfortable, with lounge chairs, a stove,
and a diesel room heater. They can provide a warm
environment out of the wind for the hours that it
takes to suit up and get ready for a dive. The diesel
heaters, however, are instruments of the devil.
Sometimes, having (we thought) turned down the
heater when we left for the day, we would return
the next day only to discover that the heater had
turned itself on full blast, melting plastic chairs,
cookies, chocolate, meat sticks, chicken soup pack-
ets, and plastic food wrappers into one solid mess.
During blizzards, when you really needed the
warmth of the heater, the wind would blow back
into the exhaust, chilling the air and cloying it with
fumes and soot.

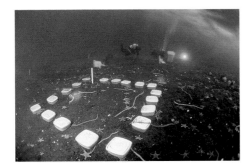

▲ page 8 RESEARCH DIVERS CONDUCTING LONG-TERM EXPERIMENT

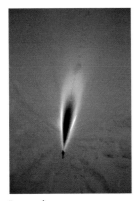

◄ page 9
ANDY DAY
IN A CREVASSE,
ROSS ISLAND

Large, dangerous crevasses such as this one require ropes and guides—people who really know what they're doing. On this trip, Ted Dettmar from the snowcraft survival crew guided me and three friends to this cathedral of ice. The crevasse was made famous in an IMAX film about Antarctica.

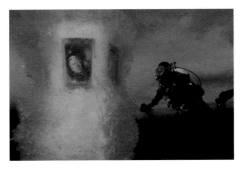

▲ page 24 OBSERVATION TUBE AND DIVER, JETTY, MCMURDO STATION

I took this photograph on my first dive in Antarctic waters, at the Jetty, in front of McMurdo Station. The observation tube is basically a large pipe that pokes down about 7.5 meters into the ocean. The windows of the tube are often encrusted with ice, so divers are needed to clean them. Here, Stacy Kim of Moss Landing Marine Laboratories comes face to face with Guy Guthridge of the National Science Foundation's Office of Polar Programs.

Observers have no problem staying warm, since the temperature in the tube is nearly the same as the surrounding seawater—near zero degrees Celsius—and usually much warmer than the cold and wind chill on top of the ice. I've often been asked how the cold affected my cameras. The truth is that cameras encased in housings in this coldest of water are not nearly as cold as topside cameras being used in -30 degree Celsius conditions. I had almost no problems related to the cold water—with one exception.

I usually put my cameras in their housings and then dump them in a freshwater tank to check for leaks. This habit, a good idea anywhere else, caused problems in Antarctica. For the first week of diving, I performed this test immediately before heading off to the dive site. After hours and hours of preparation, packing, driving, and suiting up, I would finally find myself underwater, focusing on a subject. Everything seemed to be working fine, but when I squeezed the shutter, the underwater flash would not go off! (Underwater photography requires the use of flash units to bring back the colors and light that are lost underwater.)

After several sleepless nights troubleshooting my equipment, I finally discovered the cause of the problem. My habit of rinsing the camera housings in fresh water immediately before a dive resulted in a small amount of water remaining in the electrical ports connecting the underwater flash units to the camera housing. When the housing hit the cold ocean water, the fresh water immediately froze and expanded, allowing a small amount of seawater into the electrical connections.

Once I realized what was wrong, I simply gave my cameras plenty of time to dry out before going into salt water. This solved the problem. Other than one make of flash units that refused to work in the freezing water, I had nothing more than the usual underwater photography problems (which, needless to say, can be considerable).

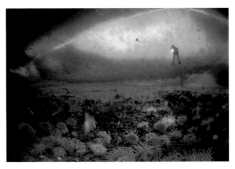

▲ page 25 FIELD OF ANEMONES AND DIVER, ARRIVAL HEIGHTS

Only a 15-minute drive from McMurdo Station, Arrival Heights was one of my favorite dive sites, featuring a steep slope of volcanic rock that tumbles to a depth of 27 meters (90 feet). Because of the thick snow cover at Arrival Heights, the water was extremely dark. This photograph was taken with a shutter speed of 4 seconds; Dale Stokes, the diver, is performing a preternatural feat of endurance by hovering motionless throughout the long exposure. A large crack in the sea ice is visible behind him.

As an underwater photographer, I often confront the problem of showing scale in this otherworldly environment. The solution is to put a diver, a dolphin, a school of fish, or something else recognizable in the frame. Having a diver who can obey your directions on the spot is often the best solution, and it's a method I used in Antarctica with great success.

An underwater model must be adept at obeying hand signals, and Dale was one of the best underwater models I have ever used. He invariably swam quickly to the place that I signaled him to, something few other divers ever managed to do. Years later I learned that Dale could not even see me signaling in the darkness of Antarctic waters: he had simply guessed at the best place to position himself! As an underwater photographer himself, Dale had the experience to know what I was shooting for, and I am still amazed at his abilities.

The other members of my dive team all served as

models for my photos as well, but they were less able to read my mind—and in the dark, they couldn't begin to interpret my hand signals. Instead, they only wound up highly amused at my increasing agitation as I tried desperately to wave them to and fro, like a traffic cop to whom no one pays attention.

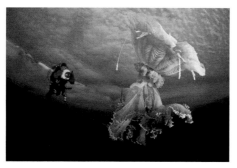

▲ pages 26-27 GIANT ANTARCTIC JELLY, TURTLE ROCK
Jellies, or medusae, were among the most prominent midwater organisms that I saw under the ice at McMurdo. I constantly encountered jellies drifting along with the prevailing current, but the larger ones—such as *Desmonema glaciale,* which occurs near the surface—are active swimmers. Here, Dale Stokes captures one on video. This jelly has had its 9-meter-long (30-foot-long) tentacles stripped away by contact with the seafloor and the numerous predators there. I call this an "unhappy jelly," for it has wandered away from its usual habitat of bottomless seas and encountered the rocks and predators of the coast. By contrast, a "happy jelly," its long tentacles intact, can be seen floating in thousands of feet of water on page 98. Could these jellies sting us? We were so thoroughly encased in our diving gear, we never had to find out.

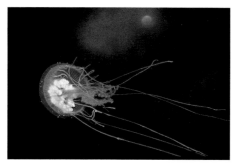

▲ page 28 COMMON ANTARCTIC MEDUSA

When diving in closed environments such as a cave, divers must usually wear tethers connecting them to the exit. The world under the Antarctic ice, however, though still enclosed, is different from a cave. The visibility is phenomenal, often as great as 180 meters (600 feet). As Paul Dayton of the Scripps Institution of Oceanography told me before I went to The Ice, "You will learn very quickly to keep track of your exit hole." He was right—and fortunately, thanks to that extraordinary visibility, it is easy to do. Daylight shining through the safety hole serves as an ever-present beacon to guide divers back to the surface. Using a tether in such conditions is unnecessary.

A diver's path to safety, the hole is always in one's consciousness while under the ice, and it feels reassuring just to glance at it now and again—or to place it in the frame of a photograph.

To create the dive holes, a large drill, mounted on a truck, bores two holes in the sea ice, each 1.2 meters (4 feet) in diameter. The sea ice hut, basically a small wooden shack on skis, is pulled over one hole. The second hole serves as the safety hole, used for exit from the water in case the primary dive hole is blocked by a Weddell seal—or, as the Antarctic diving manual states, to be used in case the dive hut is on fire upon return from a dive. As the manual helpfully puts it, "If divers recognize during the dive that the dive hut is burning, they should terminate the dive and ascend to a safety hole. If no safety hole exists, the divers should ascend to the undersurface of the ice next to the hole (but not below it) in order to conserve air. Divers who have followed proper air management procedures will likely have enough air to wait out a rapidly burning hut. Complete destruction of the hut may take only 15 or 20 minutes."

As absurd as this sounds, a hut has burned down on at least one occasion, and it could easily happen again. Antarctica is the driest continent in the world (most of the snow in a blizzard is just old snow being blown around). Consequently, buildings like sea ice huts are dry as tinder and can go up in flames quickly.

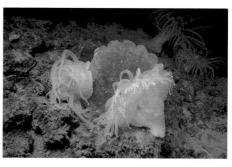

▲ page 29 TWO SEA ANEMONES FEEDING ON A JELLY, ARRIVAL HEIGHTS
The current that sweeps under the Ross Ice Shelf brings all manner of jellies to dive sites around the McMurdo Peninsula. Once the jellies come close to the bottom, anemones snag them, and the feasting begins. I found these two anemones, *Isotealia antarctica* and *Urticinopsis antarctica,* feeding on many kinds of marine life, including jellies, sea urchins, and sea stars.

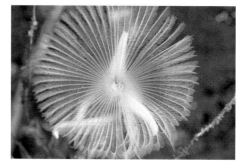

▲ page 30 SEA STAR & TUBEWORM, ARRIVAL HEIGHTS

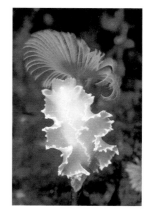

◀ page 31
NUDIBRANCH
CLIMBING
UP STALK OF
FAN WORM,
CAPE ARMITAGE

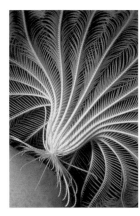

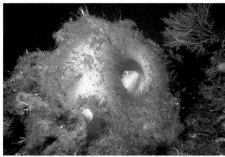

◀ **page 32**

CRINOID,
COULOIR CLIFFS,
GRANITE HARBOR

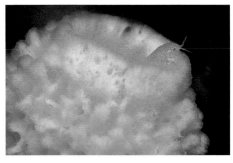

▲ **page 33** ISOPOD IN SPONGE, CAPE ARMITAGE

The sea floor at this site is dominated by sponges and is covered with a mat of sponge spicules laid down by many generations of sponges such as the one shown in this photograph, probably *Haliclona dancoi*. With no plant life on land here, the marine sediment consists primarily of sponge spicules, rather than the organic sediments found everywhere else in the world.

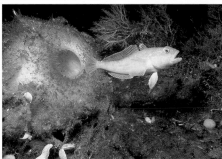

▲ **page 33** EMERALD NOTOTHEN IN SPONGE

Small notothens—a type of fish—hopped around on the bottom everywhere during our dives. They were often attracted to our lights. I remember one incident where a member of my team, Peter Brueggeman, watched in delight as a fish hovered in front of his dive mask, inspecting him closely. Peter's epic nature experience was then deflated, however, as the fish darted in and nipped his lip. Neither colorful nor uncommon, these fish nevertheless had their own distinctive personalities.

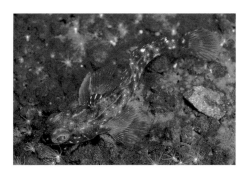

▲ **page 34** SHARP-SPINED NOTOTHEN

▲ **page 35** ANCHOR ICE COMMUNITY, LITTLE RAZORBACK ISLAND

Anchor ice, which forms in water less than 30 meters (100 feet) deep, provides habitat for motile animals such as sea stars, sea urchins, and nemertean worms. Here, at a depth of 4.5 meters (15 feet), the the anchor ice community is clearly visible. I remember my reactions on this dive: The visibility is phenomenal. I can see sponges and anemones on the steep volcanic slope, 46 meters (150 feet) down. The cold and the clarity of the water have heightened my senses. I've been in the water for over an hour, and my hands have gone from numb to painful; yet this dive has been exhilarating. I swim out of the room (a tunnel formed by the sea ice rising in a pressure ridge), squeeze through the shallow ledge formed by Little Razorback Island and the sea ice, and make my way to the diving safety line, which guides me to the exit hole.

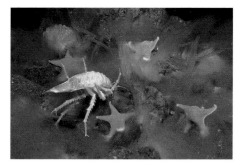

▲ **page 36** GIANT ANTARCTIC ISOPOD IN ANCHOR ICE, LITTLE RAZORBACK ISLAND

I'm used to seeing isopods in other waters, where they are usually so small I can barely make them

out. These giant Antarctic isopods, by comparison, are huge, up to the 20 centimeters (8 inches) long. While making our film *Under Antarctic Ice,* my team put an isopod in an aquarium with other animals and filmed the collection over a period of three weeks with a time-lapse camera. The sea stars moved around almost continuously, as sea stars do. The giant isopods usually sat in the position you see here. Every few days, however, the isopod would move, ultimately settling on one of its neighbors for a feast.

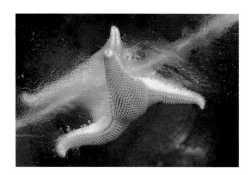

▲ page 36 SEA STAR ATTACKING A BUSHY SPONGE, CAPE ARMITAGE

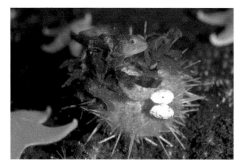

▲ page 37 SEA URCHIN COVERED WITH ALGAE, CORAL, AND SHELLS

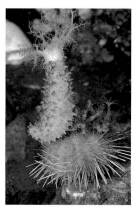

◄ page 38
SEA URCHIN AND
SEA CUCUMBER

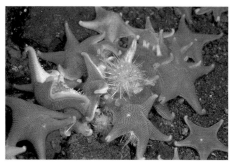

▲ page 38 SEA STARS ATTACKING A SEA URCHIN

I'm always amused to see sea urchins covering themselves with other animals and debris to protect or camouflage themselves. This defense often does not work, however, for I often see sea stars attacking urchins. While making our film, we watched sea stars pick out one urchin as their victim; it was quickly (in a relative sense) surrounded, subdued, and eaten, while other urchins around it went completely unnoticed. There's no telling just why that particular urchin became the unfortunate center of their attention.

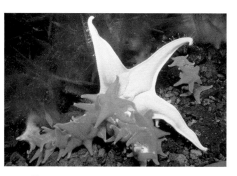

▲ page 39 SEA STARS ATTACK A LARGER SEA STAR, LITTLE RAZORBACK ISLAND

Much that happens in the cold water of Antarctica happens extremely slowly. In this case I watched for three weeks as, in an ice cave below a seal hole, a group of red sea stars *(Odontaster validus)* attacked and fed on a larger sea star, *Acodontaster conspicuus.* By the end of that period, the attack was still raging, with little visible difference relative to the beginning. In warmer waters, an attack like this would have taken just a few hours from start to finish.

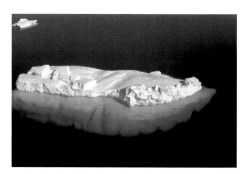

▲ page 40 ICEBERG, MCMURDO SOUND. The iceberg shown in this aerial view is tiny compared to the giants that calve from the ice shelves ringing the Antarctic continent. In the 2000–2001 austral summer scientists followed the movements of the largest icebergs seen in recorded history, calved from the Ross Ice Shelf, the world's largest gathering of glaciers over the past few years. The biggest of these icebergs, named B-15, was 300 by 65 kilometers (186 by 40 miles)—larger than the state of Delaware. It contained an estimated 2,500 cubic kilometers of fresh water, equivalent to four years of Mississippi River flow or four years of total domestic water use in the United States.

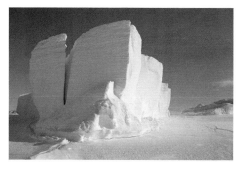

▲ page 41 GROUNDED ICEBERG, TOPSIDE VIEW, NEAR CAPE EVANS

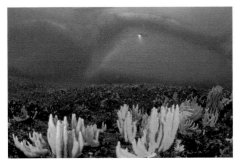

▲ pages 42-43 POLYCHAETE SPONGES
AND GROUNDED ICEBERG, NEAR CAPE EVANS
Calved from the fronts of glaciers and pushed along by wind and the prevailing current, icebergs can become grounded in shallow coastal water when they plow into the sea floor, leaving huge troughs behind them. When the ocean freezes over in winter, these grounded icebergs are locked in by surrounding sea ice. They then become a gathering place for marine life.

This iceberg ran aground near Cape Evans on Ross Island. It was about 18 meters (60 feet) tall, resting in 25 meters (82 feet) of water, and glowed in the dark water as if lit from within. A huge polychaete sponge colony grew around the iceberg. Within the cracks and dimples of the iceberg, hundreds of icefish (*Pagothenia borchgrevinki,* known as "borchs") had gathered for shelter and to build nests.

In this photograph, the safety line with its checkered flag and "pony" bottle (a miniature scuba tank filled with compressed air as an emergency air source) are clearly visible, about 30 meters (100 feet) away. However, I also wanted to take a photograph of the iceberg without the safety line (or "down line") being apparent. We worked out a plan with our assistants, who remained topside in the sea ice hut. We would start our dive without the safety line in the water; after 40 minutes—the time of a typical dive—the assistants would drop the line down, enabling us to locate the exit hole easily.

The problem was, the iceberg was absolutely fascinating to look at, even from the dive hut. With the windows shuttered, the hut would go dark, and we could see the iceberg clearly through the dive hole, glowing like a giant fluorescent-blue ice

cube. On the day of our safety-line-free dive, as we swam around beneath the ice, our assistants became so enthralled with looking at the iceberg that they forgot the job they were supposed to do. With the windows of the hut blacked out, moreover, no beacon of sunlight came through the dive hole. Fortunately, we knew the area so well by that time that we found the hole and our way out without difficulty. Sunlight through the secondary safety hole also eased what could have been a dangerous situation.

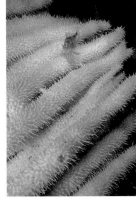

◄ page 43
EMERALD
NOTOTHEN ON
POLYCHAETE
SPONGE, NEAR
CAPE EVANS
This fish is sitting on the sponges shown in the previous photo.

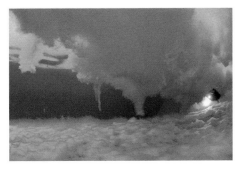

▲ page 44 SHELF OF GROUNDED ICEBERG, NEAR
CAPE EVANS
Icebergs often possess underwater spurs and ledges that extend a considerable distance from their visible topside portions. Here, a diver explores the shallower reaches of the Cape Evans grounded iceberg, which has a shelf of ice that sticks out at about the

6-meter (20-foot) level. The dimpled surface of the iceberg is at the bottom of this image, and the sea ice ceiling is at the top. The shelf is covered in ice algae and loaded with bright red amphipods grazing for food. These amphipods in turn have attracted a large number of fish that are feeding on them. Larval fish by the thousands rise and fall among the shimmering crystals of anchor ice.

▲ page 45 BALD NOTOTHENS IN ICEBERG CRACK,
NEAR CAPE EVANS
Fish had settled into the iceberg's cracks and holes by the hundreds.

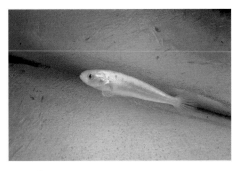

▲ page 46 BALD NOTOTHEN IN ICEBERG CRACK,
NEAR CAPE EVANS

▲ page 47 BALD NOTOTHEN LIVING ON GROUNDED ICEBERG, NEAR CAPE EVANS

▲ page 48 BALD NOTOTHEN EGGS IN ICEBERG, NEAR CAPE EVANS

In a hole at the top of the iceberg I discovered a mass of fish eggs, close to hatching, the eyes of the tiny fish clearly visible. A parent guarding the nest disappeared deeper into the hole as I approached. Scientists were excited by this discovery, and I am not sure if eggs of these fish have been found since.

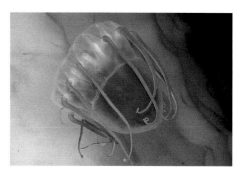

▲ page 49 HELMET JELLY, NEAR CAPE EVANS

This jelly, *Periphylla periphylla*—here foregrounded against the dimpled surface of the iceberg—is common in deep water worldwide. In most parts of the world it is found near the surface only at night, but diving in Antarctica is equivalent to diving at night. In McMurdo Sound, divers often find helmet jellies on the bottom, captured by anemones and in the throes of being consumed. Sometimes two or more anemones will fight over the bounty, with a *Periphylla* stretched between them being slowly torn apart.

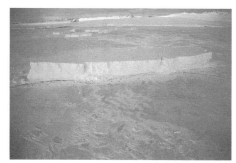

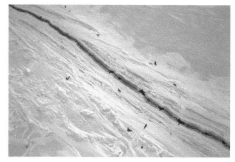

▲ pages 50–51 WEDDELL SEALS GATHERED AROUND CRACKS IN SEA ICE

Weddell seals *(Leptonychotes weddellii)* are bound to cracks in the sea ice. Around islands and icebergs, the sea ice cracks and buckles in pressure ridges, creating long passageways and ice caves underwater. Weddell seals rely on these cracks to enter the water.

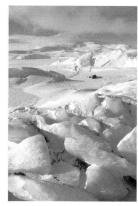

◀ page 52
WEDDELL SEAL
MOTHER AND PUP,
LITTLE RAZORBACK
ISLAND

Little Razorback Island, a tiny volcanic island, was one of my favorite dive sites in McMurdo Sound. The landscape around it, both on the ice and underwater, changed drastically from year to year, and even from week to week, during the three seasons I spent in Antarctica. In 1997, my first season, the pressure ridges around the island were huge, the result of huge forces buckling the sea ice the previous winter. The diving under these ridges was correspondingly interesting, and we saw many seals in the water on every dive. In 1999, my second season, the pressure ridges around the island were far smaller, and only a couple of seals made an appearance the entire season.

Here a mother and pup Weddell seal bask in the sunlight, in the midst of ice boulders the size of buses. Behind the sleeping couple looms Mount Erebus, sulfurous gases streaming from its tip. The air is so clear in Antarctica that this huge mountain seems close enough to touch, although it is about 22 kilometers (14 miles) away.

▲ page 53 WEDDELL SEAL MOTHER AND PUP
This pup is only a few hours old, the stains of its afterbirth clearly evident on the ice.

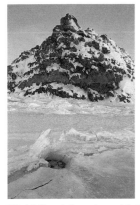

◄ page 54
WEDDELL SEAL
BREATHING HOLE,
LITTLE RAZORBACK
ISLAND

Weddell seals have kept this hole free from ice throughout the long winter. It is located in a crack in the sea ice, formed as forces push the ice against immovable Little Razorback Island. The path taken by seals away from the hole shows up clearly as a track in the ice.

Seals also use the sea ice holes that humans make. Although in three seasons of diving I never found my exit hole blocked by a seal, I often passed them during their forays under the ice and saw them taking advantage of our dive holes to catch a quick breath. On one occasion, a seal came up for air while we were in the hut: it took several breaths, tried to come out of the hole, then created an enormous splash when it realized it had company.

▲ page 55 LIFE BENEATH SEAL BREATHING HOLE,
LITTLE RAZORBACK ISLAND
Dale Stokes examines the invertebrates that have gathered beneath a seal's breathing hole at Little Razorback Island. Sea stars gather beneath seal holes to feed on feces and other debris, in what Dale humorously calls the "fecosystem." In the barren shallows, where ice crystals form on anything that doesn't move, animals can't afford to be picky.

Here is what I wrote in my logbook after a dive at Little Razorback Island: "I am swimming through a room of blue ice. Ice crystals cover the bottom. As I move over them, some become detached and slowly float up. Light fills the room, spilling through a hole in the ice ceiling. On the bottom lie hundreds of red and orange sea stars, looking like rose petals lying in shattered crystal chandeliers. A Weddell seal, cautious, huge, and benign, rises to the air hole, takes a few breaths, then leaves the room. The eerie whistles, trills, and chirps of the seals fills my ears. I am underwater, in the middle of a Weddell seal's living room in deep Antarctica. It is a very cool place."

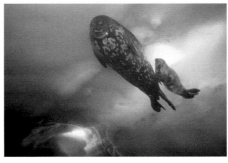

▲ page 56 WEDDELL SEAL MOTHER AND PUP,
TURTLE ROCK
Safe from open-sea predators, this mother and pup showed no fear of divers as they floated in shallow water beneath their breathing hole.

I had plenty of opportunity to observe these intelligent animals. The pups were, like many young animals, curious, and I often paused to enjoy their energetic flailings as they investigated me and my cameras. One diver on my team was nuzzled repeatedly on his hood-covered forehead by a baby seal, apparently drawn by the air bubbles rising up my friend's face. The mothers always hung back, watching carefully but seemingly aware that divers posed no harm to their youngsters. Whenever a male seal came by, however, the mothers immediately became protective and chased the intruder away.

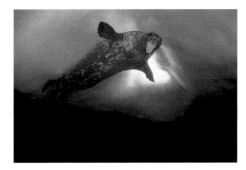

▲ page 57 YOUNG MALE WEDDELL SEAL FEIGNING
AGGRESSION, TURTLE ROCK
This young male was following the mother and pup. Female Weddell seals enter estrus immediately after giving birth, but are rarely "in the mood" while tending to their pups. This male took out his frustration on us. I never felt threatened, but the sight of this 450-kilogram (1,000-pound) animal

speeding toward me with its mouth wide open was certainly unnerving. The mother was unconcerned with the males' territorial problems. She had laid claim to an air hole, and no one bothered her as she kept a watchful eye on her pup.

One team member was trying to make sense of the various sounds that seals make underwater. Watching us as we swam along revealed the meaning of one particular sound, a deep thump-thump-thump. It turned out male Weddell seals were following closely behind us as we moved through their defended territories. Because of our very limited peripheral vision, we usually did not know they were there, directing their aggressive territorial warnings at our tender and undefended backsides. None of us was attacked, but once you heard that particular sound, you watched your backside diligently.

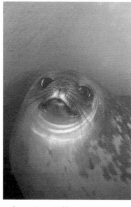

◄ page 58
WEDDELL SEAL,
LITTLE RAZOR-
BACK ISLAND

I found it difficult to photograph seals underwater, as they had a personal space of about 4.5 meters (15 feet), and the physics of underwater photography requires the subject to be within 2 meters (6.5 feet)—ideally closer—for the best results. This seal was an exception. I found it resting in a cave, and it fascinated me for hours with its captivating expression. In my three seasons in Antarctica, this was the only seal that allowed me to get so close for so long a period. I was able to photograph it on one dive, then change cameras in the sea ice hut before returning to photograph it with a different camera and lens.

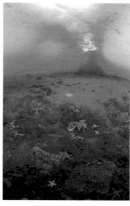

◄ page 59
ICE CAVE BELOW
WEDDELL SEAL
BREATHING HOLE,
LITTLE RAZORBACK
ISLAND

At Little Razorback Island our dive team explored passageways of ice formed by pressure ridges, which seals likewise used to move from breathing hole to breathing hole. The floors of these "living rooms" were filled with invertebrate life.

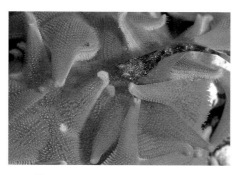

▲ page 59 FISH ON SEA STARS, LITTLE RAZORBACK ISLAND

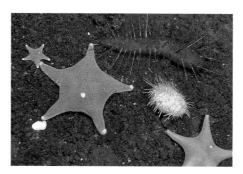

▲ page 60 SEA STARS, SEA URCHIN, AND POLYCHAETE WORMS, TURTLE ROCK

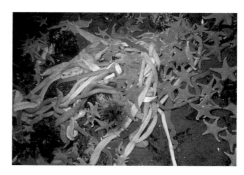

▲ page 60 MASS OF NEMERTEAN WORMS, LITTLE RAZORBACK ISLAND

Common occupants of the shallow zone include nemertean worms *(Parborlasia corrugatus)* and red sea stars *(Odontaster validus)*. We came across these feeding on seal feces beneath a Weddell seal's breathing hole. The nemertean worms are little more than tubular stomachs crawling along the bottom in search of a meal.

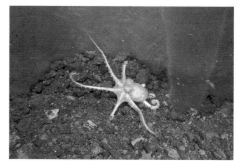

▲ page 61 OCTOPUS, LITTLE RAZORBACK ISLAND

We found this small octopus *(Pareledone* sp.) in the seal "living rooms" of Little Razorback Island. Little is known about these octopuses. This one may well hunt for fish and crustaceans, such as the giant Antarctic isopod *(Glyptonotus antarcticus),* as well as sea urchins *(Sterechinus neumayeri).* It, in turn, is probably hunted by Weddell seals.

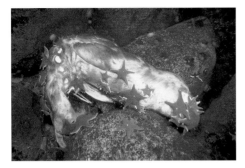

▲ page 62 DEAD WEDDELL SEAL PUP BEING EATEN BY SEA STARS, GRANITE HARBOR

We often discovered the carcasses of baby seals underwater. In the water a pup can tire quickly, and a major problem for the young animal is getting back out. I often saw mothers pushing their babies up, trying to help them clamber out of the hole. If the baby is unable to do so, it will die.

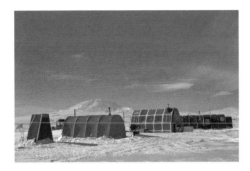

▲ page 62 RESEARCH CAMP FOR SCIENTISTS STUDYING WEDDELL SEALS

▲ page 63 WEDDELL SEAL WITH VIDEO CAMERA AND TELEMETRIC DEVICES

A scientific team headed by Randall Davis has conducted groundbreaking research on the diving physiology and behavior of Weddell seals. The images captured by his research team, at a camp in the middle of the sea ice, reveal science at its most glamorous. Because Weddell seals depend on a hole in the ice for their air supply, they return to the same hole if no other one is available. Every season when he returns to Antarctica, Davis must find an area of sea ice in the middle of frozen McMurdo Sound that has no air holes or cracks for miles around—no small feat. After finding a suitable site, the team sets up a field camp. Davis then captures seals, mounts telemetric equipment and video cameras to the seals' backs, and releases them into a hole he has drilled, surrounded by a Jamesway tent filled with scientific apparatus. The seal returns from each dive to that same hole, where the data from the telemetric equipment are uploaded for analysis.

The research team occasionally loses track of a seal, along with its $20,000 payload—a tribute to these animals' diving capability. The delinquent seal is usually found far from camp, having managed to find its way to the only other source of air for miles around.

In the summer of 2001 a physiologist named Paul Ponganis traveled well into the interior of the sea ice, close to the Ross Ice Shelf, to establish a site for a study of emperor penguins that became known to researchers as the Penguin Ranch. His team dug into the ice to make a pool about 13 meters (15 yards) square, with a bottom about 30 centimeters (1 foot) thick, for penguins to swim in. Within a week, Weddell seals had penetrated the bottom of the pool, which soon was filled with as many as sixteen seals, all using this magnificent air hole for forays into deep water. They must have had a purpose to venture so deep into the sea ice, and that purpose soon became evident. Almost every day a seal showed up with the carcass of a giant Antarctic cod *(Dissostichus mawsoni),* a close relative of Chilean sea bass (also known as Patagonian toothfish) that can reach 100 kilograms (220 pounds) in size.

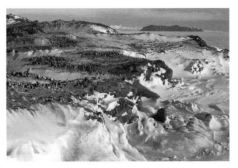

▲ pages 64–65 ADÉLIE PENGUIN ROOKERY, CAPE ROYDS

Around McMurdo Sound are three of the world's southernmost penguin colonies, at Cape Royds, Cape Crozier (on the far side of Ross Island), and Cape Bird. Cape Royds is the smallest, with about 5,000 breeding pairs. Early in the season we traveled to this colony by snowmobile every few weeks. On my second trip there, the wind was blowing steadily and strongly, and we hiked to the cliff edge downwind from the penguin colony. I took several rolls of pictures with a long lens, the wind blowing in my face all the while. We could see penguins gathering at the ice edge, about a mile away, but the weather did not allow us to get there. On the four-hour ride back to the base, I marveled at the serenity and quiet of the place, commenting on its purity. My companions all agreed. We got back to McMurdo, and an hour later a condition-1 blizzard roared in. The next morning I woke up with an infected right eye. Evidently, as I was riding back to the base and marveling at the pristine white landscape of Antarctica, a large piece of penguin guano had been festering in my eye.

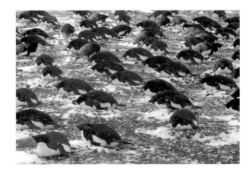

▲ page 66 ADÉLIE PENGUIN ROOKERY, CAPE BIRD

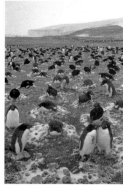

◀ page 67
ADÉLIE PENGUIN
ROOKERY,
CAPE BIRD

Cape Bird, in the deep Antarctic, is a barren spot of land—the only land around for miles that is not covered with snow and ice. Home to a rookery of 50,000 Adélie penguins, it is not a peaceful place.

The penguins here have been sitting on their eggs for up to three weeks, and they are hungry, dirty, and irritable. They have hardly been able to sleep, and they cannot move from their nests, lest voracious skuas (which look like overgrown seagulls) waiting nearby snatch their untended eggs.

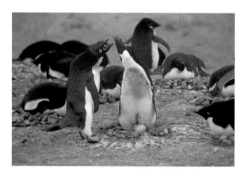

▲ page 68 ADÉLIE PENGUINS DISPLAYING,
CAPE BIRD

Safely ashore, a returning penguin moves through the landscape of ice and black volcanic sand at Cape Bird, then makes her way up the slope to the rookery, passing by pair after pair of penguins brooding their eggs. She knows this area well, as Adélie penguins return to the same nest site each year.

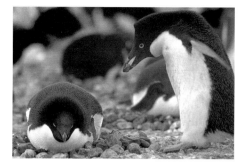

▲ page 69 ADÉLIE PENGUINS IN NEST-BUILDING
RITUAL, CAPE BIRD

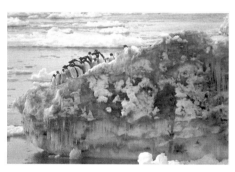

▲ page 70 ADÉLIE PENGUINS WAITING TO JUMP,
CAPE BIRD

Leopard seals are dramatic predators of penguins, and much of the birds' behavior near and in the water is influenced by awareness of their proximity. Penguin chicks, awkward in the water, are easily taken; adult penguins are caught in pursuit or after missing a leap out of the water and falling back in. The leopard seal peels away the penguin skin by holding the bird between its incisor teeth and whipping it back and forth. At Cape Crozier, scientists reported that six leopard seals killed an average of eight adult Adélie penguins each per day during a hundred-day breeding season, and four seals killed fifteen chicks each per day during a two-week period of departure from the rookery.

Leopard seals are, without a doubt, the bad boys of the Antarctic. Stories of their viciousness abound: they routinely attack inflatable boats, even moving ones, in Antarctic Peninsula waters; they often attack and kill 450-kilogram (1,000-pound) Weddell

seals; and, according to McMurdo legend, a seal once leaped onto the ice edge, seized a scientist by the leg, and dragged her toward the water, not letting go even when other researchers started beating it on the head with their ice axes. This last bit, admittedly, is an example of how a story grows larger in the telling; Jim Mastro's account of this incident (page 141) is undoubtedly closer to the truth. However, during the winter of 1986, a starving leopard seal did grab a man by the foot and drag him toward the water, refusing to let go even as his two companions beat the seal about the head with ice axes.

Although other divers and photographers had dived with leopard seals in the water, I was uncertain whether I wanted to. I have dived unprotected with sharks, orcas, and other large predatory animals, and in almost all cases I felt like such a loud, alien presence that I was convinced the animal did not see me as a prey item. I had seen some footage of leopard seals by Doug Allen, a renowned polar cameraman who does much work for the BBC. I wrote Doug and asked his opinion, and he replied that it would probably be fine to get in the water with leopard seals. I now wonder whether Doug wasn't trying to get rid of the Antarctic filmmaking competition!

We knew there were leopard seals at Cape Bird, though, as the resident Kiwi researchers warned us, "They are definitely out there, but you won't see them." Two of my crew, Dale Stokes and Peter Brueggeman, took on the job of scouting for them. On our third day they wandered out on a finger of compacted ice adjacent to deeper water to take a look. Immediately, a leopard seal that had been lurking beneath the ice shelf popped up right next to them, taking a close look. The seal had probably been underneath Dale and Peter the entire time, following their footsteps as they moved across the ice.

I saw leopard seals perhaps three times in my week at Cape Bird. Every time, I felt like lunch as it sized me up, apparently judging the distance between us and deciding whether it was worth the effort to run me down. It was disconcerting, to say the least. I ultimately decided not to risk diving with the seals.

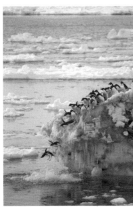

◄ page 71
ADÉLIE
PENGUINS DIVING,
CAPE BIRD

Team member Peter Brueggeman, writing in his journal, gives a wonderful description of Adélie penguin behavior as they teeter onshore waiting for the perfect moment to leap: "I spent considerable time sitting still at a point regularly used by penguins to jump in the water. If you sit still, the Adélie penguins don't mind that you are there; fifty to eighty penguins would crowd around in front of me waiting to jump in. So what does it take for them to jump in? They watch the water, and when a large group of penguins comes swimming into their immediate area, the Adélie penguins start getting very vocal. They start jostling, jockeying for position, squabbles break out, beaks peck back and forth, some flipper bashing back and forth, lots more loud discussion, more jostling, more pecking, and finally the braver ones will jump in followed by an immediate chain reaction of everyone rushing to jump in the pool all at the same time, no waiting, every penguin for himself. Of course, this isn't good enough for some timid ones, who hesitate a bit and then decide the time just isn't right for them and stay back.

"It was a blast to watch this while I sat there right behind the penguins, which were close enough to touch. If I could translate into words a penguin group's vocal and bodily behavior while they decide to dive into the water, it would go like this: "'HEY, HERE COME SOME PENGUINS—Looks like a lot of them—Do you think we should go in?—NO, LET'S WAIT FOR MORE PENGUINS—Hey, I think

that's enough penguins; let's go in—I'M NOT GOING IN—Stop pushing (peck)—I DIDN'T PUSH; HE DID (peck back and peck at another penguin)—I didn't push; don't peck me (flipper bashing)—Hey, I'm going to move over here away from you rowdies—HEY, YOU STEPPED ON MY FEET (peck, peck)—You pushed me too (peck)—Hey, stop pecking me (peck, peck, peck)—Hey, that's a lot of penguins in the water—No it isn't, and I think there's a leopard seal lurking and ready to eat us—I'M JUMPING IN—DON'T JUMP IN YET—I'm going (splash)—I'M GOING TOO (splash)—DON'T JUMP IN—I'm going (splash)—I'm going (splash)—I'm going (splash)—I'm not going and I think you're stupid to go—Me, too; let them get eaten!'

"You get the idea. Incredibly loud discussion and commotion—jumping in happens when it seems to reach a fever pitch. Sounds silly but it isn't. After all, these Adélie penguins have to worry about getting caught and eaten by leopard seals and killer whales patrolling the shorelines. A penguin by itself is at greater risk than a penguin in a group with many eyes watching for predators and many voices to sound the alarm. If there are lots of penguins already in the water in front of you, then it is likely to be safe to go in. If you jump in as a group, you are safer than if you jump in alone. Watching the penguins go through their behaviors of marching up and down the shoreline en masse and then waiting for incredibly long periods of time to jump in starts to make sense if you are the chicken of the sea."

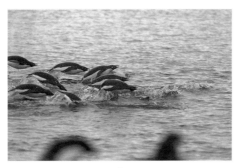

▲ page 72 PORPOISING ADÉLIE PENGUINS, CAPE BIRD

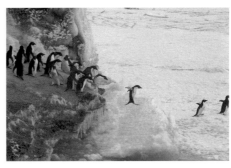

▲ page 73 ADÉLIE PENGUINS LEAVING THE ROOKERY, CAPE BIRD

The shoreline of Cape Bird is quite different from the sea ice edge. Although a black sand beach slopes into the water, the meeting of land and sea is not always visible. In some years, the entire shore is covered with huge boulders of pack ice heaped upon one another, forming cliffs of ice that rise a dozen feet above the water.

The view of the ocean from Cape Bird changes every hour. Sometimes pack ice drifts in and covers the ocean for miles around. A few hours later, the scene may be completely clear of ice. When the wind pushes the ice against the shore, the sound of crushing and grinding is audible from quite a distance away.

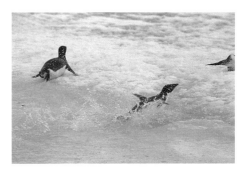

▲ page 74 ADÉLIE PENGUINS LEAVING THE WATER, CAPE BIRD

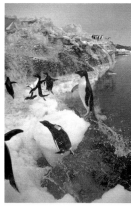

◄ page 74
ADÉLIE PENGUINS
EXITING THE
WATER, CAPE BIRD

We hid behind blocks of ice along the shore to photograph these penguins as they jumped out of the water, landing right in front of us. Although they couldn't see us before they launched themselves, in midflight the closer penguins would spot us, and great expressions of surprise would cross their faces. Landing on their feet or belly, they decided we posed no threat and continued on their way, entirely unconcerned.

In the distance behind them, yet another group of penguins approaches Cape Bird. Watching these penguins rocket out of the water to the top of an ice shelf up to 3.7 meters (12 feet) high was fascinating. Often, the following scenario would occur: An Adélie penguin would pop out of a crack between floes fifty yards from shore and land on the floe feet first, fall over on its belly, and skid across the ice at top speed . . . before falling off the far edge of the floe into the sea! In rapid succession, a number of other penguins would pop out of the water and do the same—though most of them managed to halt their movement in time. They would then stand staring at the water between them and the shore, as if calculating whether there weren't some way to avoid swimming the rest of the distance.

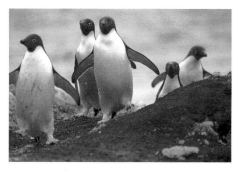

▲ page 75 ADÉLIE PENGUINS RETURNING TO THE
ROOKERY, CAPE BIRD

These penguins are invigorated, plump, and healthy from two to three weeks at sea, feeding on the huge schools of krill that swarm in Antarctic waters. They often stop along the way to chew on bits of ice, the first fresh water they have come across since departing the rookery weeks before.

▲ pages 76-77 SEA ICE SCOURED BY WIND, WITH
FIELD CAMP IN THE DISTANCE, COULOIR CLIFFS,
GRANITE HARBOR

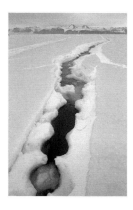

◄ page 78
SEA ICE CRACK,
COULOIR CLIFFS,
GRANITE HARBOR

Our team was fortunate enough to spend one week diving at Granite Harbor, 125 kilometers (78 miles) across the sound from McMurdo base, staying at a field camp kindly shared by scientists James McClintock and Bill Baker. It was an entirely different environment from where we had been diving. Here, a sea ice crack extending from our camp at Couloir Cliffs across the bay allowed us easy access to the water. I returned to this site two years later, and the crack was in exactly the same position, indicating that the forces creating it operate in the same way from year to year.

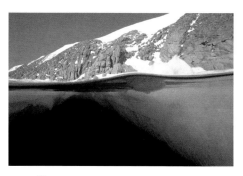

▲ page 79 CRACK IN SEA ICE, COULOIR CLIFFS,
GRANITE HARBOR

This was my last view as I entered the water through the sea ice crack shown on page 78. It was a bright, sunny day, and the rocks of Couloir Cliffs can be seen in the background.

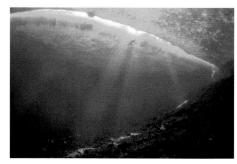

▲ pages 80-81 SUN RAYS STREAMING THROUGH ICE
CRACK, COULOIR CLIFFS, GRANITE HARBOR

We dived out of cracks in the ice near granite cliffs, where beams of light spilled through to illuminate

the urchin-covered boulders below. Down the slope were huge sponges. Up the slope, near the rock cliffs, were frozen waterfalls and sea ice stalactites. The lighter, rounded spotting on the underside of the sea ice ceiling is from our air bubbles, which dislodged the thin, dark algal film growing there. You can see the tiny figure of a diver in this photo. My team members spent entire dives as models, swimming back and forth, back and forth under these cracks. Photographing a diver within the scene conveys the scale and grandeur of this dramatic underwater setting.

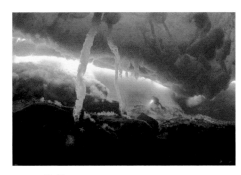

▲ **pages 84-85** SEA ICE STALACTITES, COULOIR CLIFFS, GRANITE HARBOR

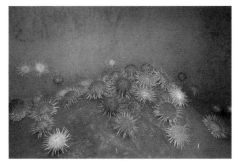

▲ **page 89** SEA URCHINS EATING ALGAE ON AN ICEFALL, DISCOVERY BLUFF, GRANITE HARBOR
As the summer progresses, the ice in shallow water becomes dark with plant growth. These sea urchins are harvesting the algae with scraping teeth located on the bottom of their shell.

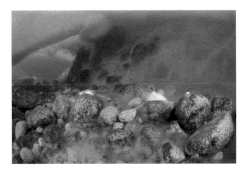

▲ **pages 82-83** UNDERWATER ICEFALL, COULOIR CLIFFS, GRANITE HARBOR
Above the sea ice tower the Couloir Cliffs—granite rock faces nearly 5 kilometers (3 miles) wide and 30 to 60 meters (100–200 feet) high, named after their numerous chimneys and couloirs (steep mountainside gorges). As the exposed rock soaks up the sun's warmth, the snow melts. Fresh water trickles down the cracks and runs under the sea ice, freezing as it flows into the colder seawater. The steep rock walls below the surface become coated with ice, forming magical underwater icefalls. This scene reminded me of a cascade splashing down on granite boulders in the Sierra Nevada—only in this case, the waterfall was solid ice.

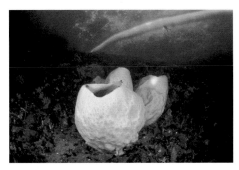

▲ **pages 86-87** VOLCANO SPONGES, COULOIR CLIFFS, GRANITE HARBOR
Sponges are animals that use a primitive system of water canals and a current generated by beating flagella (lashlike appendages) to filter food particles out of the water. I found large volcano sponges like these *(Anoxycalyx [Scolymastra] joubini)* at many sites; they were the largest objects on the sea floor, sometimes exceeding 1.2 meters (4 feet) in diameter.

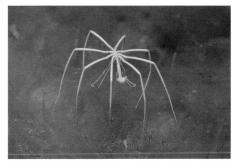

▲ **page 89** PYCNOGONID ON ANCHOR ICE, COULOIR CLIFFS, GRANITE HARBOR
With slow metabolisms and relatively few predators, many Antarctic invertebrates grow exceptionally large and live years longer than their cousins in warmer water. The pycnogonid, or sea spider, pictured above is the size of a human hand.

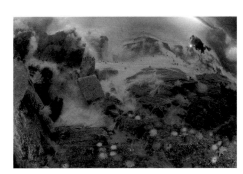

▲ **page 88** UNDERWATER ICEFALLS AND SEA URCHINS, COULOIR CLIFFS, GRANITE HARBOR

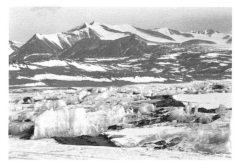

▲ pages 90-91 MULTIYEAR SEA ICE, EXPLORERS COVE, NEW HARBOR

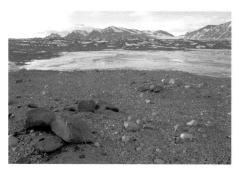

▲ pages 92-93 RESEARCH CAMP AT THE MOUTH OF A DRY VALLEY, EXPLORERS COVE

New Harbor, across the sound from McMurdo Station, has been studied for years by diving scientists interested in its similarities to the deep sea. The ice in New Harbor—"multiyear ice" that does not break up every summer—is up to twelve years old and has been weathered into bizarre formations.

Because of its protected position, its cold water, and its extremely thick multiyear ice cover (some 5 meters, or 16 feet, thick), New Harbor's shallow water is thought to mirror the conditions of the deep sea. And indeed, the strange animals of this place do seem similar to deep sea species.

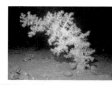
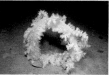
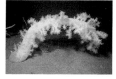

▲ page 94 SOFT CORAL SWEEPING BOTTOM FOR FOOD, NEW HARBOR

These photographs (of several individual *Gersemia antarctica* corals) simulate a sequence of a soft coral bending down to sweep the bottom for food.

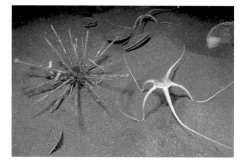

▲ page 95 PENCIL URCHIN AND BRITTLE STAR, NEW HARBOR

Diving at New Harbor was not initially as interesting as at other sites. The bottom consisted of a flat, sandy plain dotted with a few boulders. Scallops abounded here, as did brittle stars; the white stars would gallop away, flailing their arms frantically, if a predatory orange star came near.

Diving under 4.5 meters (15 feet) of ice was fun, though. At the end of a dive, making a safety stop, I merely had to approach the sea ice ceiling and inflate my dry suit. I was then pinned at the required safety stop of 15 feet. I'd often pull my hands out from the dry suit's five-fingered gloves and back into the sleeves to flex my fingers and keep them warmer. When I reinserted my hands, I could feel that ice crystals had formed in the gloves. My hands were always the biggest problem in my dives in Antarctica: there was nowhere for the moisture from my skin to go, so it stayed in the gloves, seeming to conduct the cold straight into my fingers.

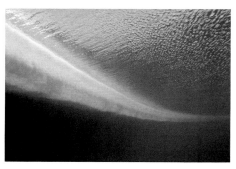

▲ pages 96-97 ICE EDGE FROM UNDERWATER, MCMURDO SOUND

The ice edge, where the open ocean meets the frozen sea ice, is a dynamic place that can change shape and mood in an instant. It is here that we encountered penguins, minke whales, and orcas.

At the beginning of the season, the ice edge can be over 160 kilometers (100 miles) away from McMurdo Station, impossible to reach. In late October and early November 1997, when I took this photograph—which shows a clean 1.2-meter (4-foot) edge of ice extending to the limit of visibility, over 150 meters (500 feet)—the ice edge was relatively "normal," about 50 kilometers (30 miles) away from the base. In 2001, however, the spring was exceptionally cold and the ice edge remained unreachable all season long.

When we were able to access the ice edge itself, entering the water was reserved for exceptionally calm days. Even so, the cold could be intense. On this day, the wind chill was so severe that when I spat in my mask to keep it from fogging during the dive, my saliva immediately turned to ice. Trying to rinse the mask out was impossible, as the seawater froze instantly. So I had to put my gear on without being able to see through my mask, then clear the mask by rinsing it once I was in the water. It is no easy task to seal a mask snugly to your face underwater when wearing thick gloves and two neoprene hoods (though I got much better at it after three seasons of diving). If I lifted my head out of the water for more than a few seconds, the mask would again freeze until I put my head back in. Once I was completely in, though, it was like diving in the tropics: clear water and sunshine, with a white beach (of ice) behind me.

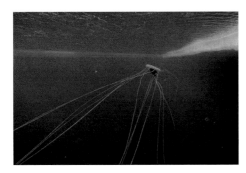

▲ pages 98-99 GIANT ANTARCTIC JELLY AND ICE
EDGE, MCMURDO SOUND

This jelly is the same as the one shown on pages
26–27. The difference is that this one is floating in
its usual home, bottomless ocean. I call this a
"happy" jelly, and in such an environment its ten-
tacles can attain a length of over 9 meters (30 feet).

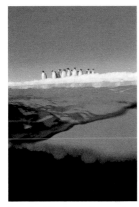

◄ page 100
EMPEROR
PENGUINS AT
THE ICE EDGE,
MCMURDO
SOUND

I took this shot of penguins on the ice edge right
as I entered the water, holding the camera half in
and half out of the water. The ice edge is a clean
1.2 to 1.8 meters (4 to 6 feet) thick. The water it-
self appeared extremely clear, blue, and inviting. In
fact, it was much warmer— -1.86°C (28.6°F)—
than the air temperature, which was -34°C (-30°F)
with the wind chill.

To find penguins to photograph underwater, we
patrolled the ice edge by helicopter, looking for
groups of penguins standing around—a sure sign
that more would soon be arriving from the water.
If the weather is abnormally cold—as it was in the
summer of 2000–2001—the ice edge will spread for

miles in a thin layer of newly frozen ice, making it
impossible to land a helicopter. Because of these va-
garies of nature, in three seasons of working from
McMurdo Station for this book and a subsequent
natural history film, I was able to work at the ice
edge for a total of perhaps six days.

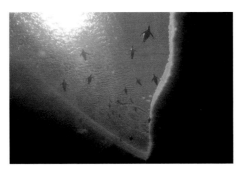

▲ page 101 EMPEROR PENGUINS SWIMMING,
MCMURDO SOUND

In the water near the ice edge, a group of emperor
penguins *(Aptenodytes forsteri)* swim languorously,
their heads out of the water, looking for a good place
to exit. Seeing another group standing at the ice
edge, the penguins fling themselves onto the ice in
the "V" formed where a floe cracked and drifted off.

Emperor penguins, the champions of diving
birds, rely on a collection of specialized adaptations,
from waterproof swimsuits of interlocking feath-
ers to solid, dense bones that help them overcome
a flighted bird's natural buoyancy. So sleek are these
birds that they have one of the most streamlined
body shapes in nature.

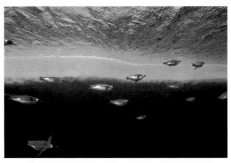

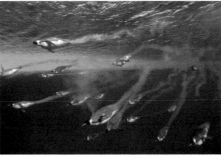

▲ pages 102-3 EMPEROR PENGUINS SWIMMING,
MCMURDO SOUND

Conditions on the ice edge can change instantly,
making it a potentially very dangerous place. The
idea of being swept under the ice edge by the current
and not being able to retreat is a frightening one.
You have to watch out for currents, monitor chang-
ing conditions, and observe diving safety rules.

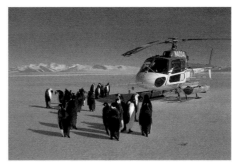

▲ page 104 EMPEROR PENGUINS AND HELICOPTER,
ICE EDGE, MCMURDO SOUND

Only two species of penguins make their home in
the harsh environment of high-latitude Antarctica:
the knee-high Adélie penguin and the waist-high
emperor penguin.

Adélies, small and nervous, would inevitably scatter and run for the water if they so much as caught a glimpse of us. Emperor penguins, in contrast, would calmly watch as our helicopter passed by overhead, then, as soon as it landed, make their way over to it (even though we made a point of landing at least a hundred meters away), trumpeting and cooing. Emperor penguins use these calls to greet one another. In this case, it was almost as if they were welcoming the giant bird from the sky!

The penguins would surround us as we unpacked our gear. When we finished unloading and moved away from the helicopter, most of them would stay there, much more interested in the helicopter than in us. Eventually the penguins would tire of the mechanical bird and surround our temporary worksite, sitting and lying around us. A few brave Adélie penguins might wander up to join the party, and we would be the center of attention for thirty or so penguins as we worked. Since there was literally nothing else going on in that endless expanse of ice at water's edge, we were by far the best show in town.

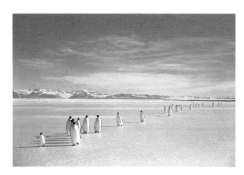

▲ page 105 EMPEROR PENGUINS AND LONE ADÉLIE PENGUIN, ICE EDGE, MCMURDO SOUND
This Adélie penguin, standing only half the size of the emperors and bustling along with frenetic, hyperactive energy, was a comical contrast to the emperor penguins' stately grace.

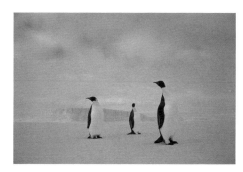

▲ page 106 EMPEROR PENGUINS, CAPE BARNE GLACIER

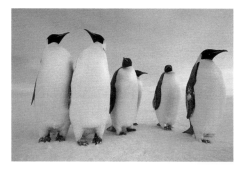

▲ page 107 EMPEROR PENGUINS, ICE EDGE, MCMURDO SOUND

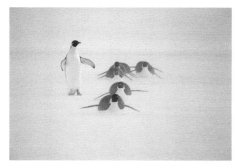

▲ page 108 EMPEROR PENGUINS IN A BLIZZARD, NEAR INACCESSIBLE ISLAND

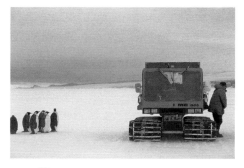

▲ page 109 EMPEROR PENGUINS AND SPRYTE, NEAR BIG RAZORBACK ISLAND
It is impossible not to like emperor penguins. Here, a group of curious penguins more than 32 kilometers (20 miles) from the ice edge watches as our team takes a break.

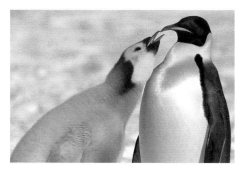

▲ page 110 EMPEROR PENGUIN AND CHICK, CAPE WASHINGTON

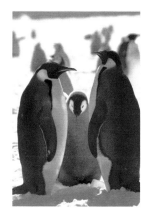

◄ page 111 EMPEROR PENGUINS AND CHICK, CAPE WASHINGTON

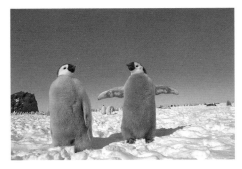

▲ page 112 EMPEROR PENGUIN CHICKS, CAPE WASHINGTON

We were fortunate to have the opportunity one day in December to fly to Cape Washington, site of one of the world's largest emperor penguin rookeries. Although the colony was almost deserted by this time in the season, with the chicks well along in growth and most adults out foraging, we still got an eyeful—and an earful—of penguins being penguins.

While their parents are off hunting, emperor penguin chicks periodically call out for food, making sounds that only a parent could love. The result, with more than 20,000 chicks at the Cape Washington colony contributing to the din, is a true cacophony. Imagine tuning in to a single distinctive call in the midst of this. But that is what the returning parents must do to locate their chick—an incredible feat. Whenever an adult approaches, the calls become increasingly insistent, and several chicks will mob a returning adult in hopes of receiving food. Once parent and chick are reunited, the youngster feeds on food regurgitated by the adult. Skuas wait nearby to dart in and scoop up any spilled goodies.

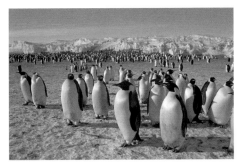

▲ page 113 EMPEROR PENGUIN COLONY, CAPE CROZIER

A tiny emperor penguin rookery has existed sporadically on a finger of sea ice at Cape Crozier, sheltered in a valley formed by the Ross Ice Shelf. Emperor penguins breed on level, stable sea ice (only two colonies are known on land). Because emperor penguins breed only in places where the sea ice exists year-round, there are relatively few rookeries—only thirty-five are known—scattered around the entire Antarctic continent, home to some 400,000 emperor penguins.

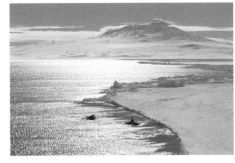

▲ pages 114-15 ORCAS ALONG THE ICE EDGE, MCMURDO SOUND

In this photograph, a pod of orcas is cruising along the ice edge, and Mount Erebus is visible in the background. The air is extremely clear in Antarctica. We are probably 80 kilometers (50 miles) from Mount Erebus, a 12,444-foot peak.

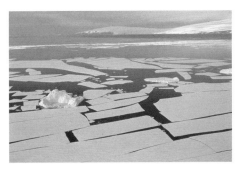

▲ pages 116-17 ICEBERG AMONG SPLITTING SHEETS OF SEA ICE, ICE EDGE, MCMURDO SOUND

I spent two summers in Antarctica photographing an annual spectacle: the breakup of the sea ice, together with the explosion of marine life that appears in its wake. As the summer progresses, the ice edge breaks off into football-field-sized floes. Long leads sometimes open up, creating passages for larger marine animals to travel deep into the sound.

When this picture was taken, we had had twenty-four-hour daylight for four months already. All around the coast of Antarctica, the ice was cracking and disintegrating, and the expanse of sea ice had shrunk from its October maximum of about 21 million square kilometers (8 million square miles) to its minimum of only about 2.6 million square kilometers (1 million square miles). Because of the constant presence of the sun, plankton was blooming, and the 150-meter (500-foot) underwater visibility of spring had given way to visibility of less than 1 meter. It was extremely dangerous to dive without a tether now; a diver without a line would never find his way back to the all-important air and exit hole.

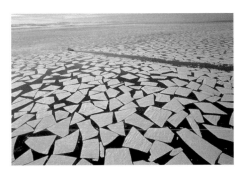

▲ pages 118-19 COAST GUARD ICEBREAKER, MCMURDO SOUND

One of two U.S. Coast Guard icebreakers, the *Polar Star* or *Polar Sea*, arrives each summer to cut a passage for a freighter to bring supplies to McMurdo Station. In the strips of open water behind the icebreaker, orcas and minke whales often appear, seizing the opportunity offered by the ship channel to travel far into the ice.

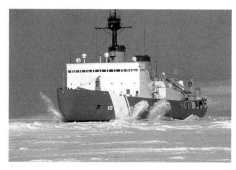

▲ page 119 COAST GUARD ICEBREAKER "POLAR STAR," MCMURDO SOUND

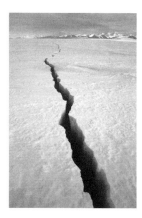

◄ page 120

CRACK IN THE

SUMMER SEA ICE,

MCMURDO SOUND

▲ page 121 SUMMER SEA ICE LEAD, MCMURDO SOUND

Flying along the ice edge, we looked for leads, long channels of open water that reach deep into the ice's interior. These leads can sometimes extend for miles, and orcas are quick to travel into them, despite the risk of the ice closing again. As the leads

opened up, we tried to find spots where we could get close enough to the whales to photograph them, both topside and underwater.

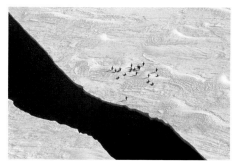

▲ page 121 ADÉLIE PENGUINS GATHER AROUND SEA ICE LEAD, MCMURDO SOUND

One fine, calm summer day we landed near the ice edge. While we unloaded our diving gear and cameras, our helicopter sat on a small, barely noticeable crack in the ice. Luckily, John Losure, the pilot, decided to move the aircraft, because after only half an hour the crack had turned into a 2-meter-wide (6.5-foot) lead, which we scrambled to cross.

On another fine day we again landed near the ice edge, close to a pod of several orcas. The water was as calm as a lake, and when we drilled down we discovered that the ice was several feet thick, perfectly safe to walk on. As we carried our gear to the ice edge, we noticed the icebreaker passing by, miles away. Suddenly, the waves from the icebreaker began to slap on the ice, and the ice started to break up all around us! This was a terribly dangerous and unforeseen situation. We rushed to gather ourselves and all our gear on one large floe, whereupon the expert pilots from Petroleum Helicopters International (PHI), hovering overhead, picked us up. In the meantime, the orcas had immediately moved in to investigate the new cracks in the ice. Why would they be so interested in the breakup of the ice edge in this instance, which represented only some 30 meters (100 feet) of horizontal advantage and would not help them if they were diving for Antarctic cod (which they clearly weren't)? All I can guess is that they had been hunting penguins or seals that had fallen into the water when the ice suddenly broke up around them.

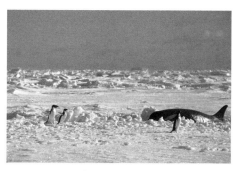

▲ pages 122–23 ADÉLIE PENGUINS AND SURFACING ORCA, MCMURDO SOUND

Although it is commonly thought that orcas eat penguins and seals, no researcher has actually seen a penguin eaten by an orca here, so we don't know for sure that this population preys on penguins. Still, Adélie penguins, nervous by nature, are perhaps wise not to tempt fate.

▲ pages 124–25 ORCAS TRAVELING DOWN OPENING LEADS, MCMURDO SOUND

It is thought that orcas *(Orcinus orca)* take advantage of opening leads in the ice to dive under the ice edge to hunt. Their principal prey may be the giant Antarctic cod or toothfish *(Dissostichus mawsoni),* which weighs up to 100 kilograms (220 pounds) and may use the sea ice for shelter.

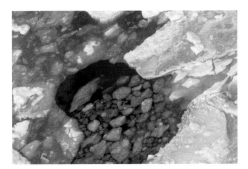

▲ pages 126-27 RESTING ORCA, McMURDO SOUND

Orcas are very aware of what is happening overhead. As we circled this open pool of water in our helicopter, I noticed this orca looking up at us from beneath the surface of the water.

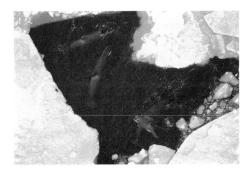

▲ page 127 POD OF ORCAS RESTING IN POOL OF OPEN WATER, McMURDO SOUND

Sometimes, orcas traveling deep into the sea ice will rest in small pools of open water for hours, waiting for the ice around them to clear so that they can swim back to the open ocean. Or they may use these pools simply to catch their breath before diving deeper under the ice.

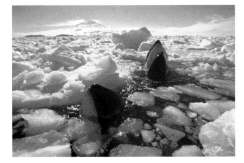

▲ pages 128-29 SPYHOPPING ORCAS, McMURDO SOUND

In the clear air of Antarctica we could often see 65 kilometers (40 miles) across the sound. As we neared the leads we could see orcas spyhopping, their heads bobbing up and down, looking a lot like jack-in-the-boxes. They may have been looking for landmarks by which to navigate or, if the pool they were in was locked in by sea ice, searching for other patches of open water. Whenever we landed near a pod of whales, they would spyhop, checking us out. My good friend, ex–Navy helicopter pilot Beez Bohner, was the first to tell me about this behavior. He said friendly orcas would approach him and his fellow Antarctic pilots, and they would play catch with snowballs.

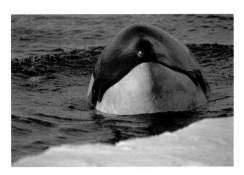

▲ page 130 ORCA ALONG THE ICE EDGE, McMURDO SOUND

In the 1970s Russian researchers killed 906 orcas in Antarctic waters as part of a scientific study. They found two basic types of orcas. One type ate fish almost exclusively; the other preyed primarily on marine mammals. The fish eaters, moreover, differed from the mammal eaters in being resident (nonmigratory), smaller, and less sexually dimor-

phic, and having different skull shapes and tooth counts. Similar kinds of differences are seen in the North American Pacific Northwest population of killer whales, although the two groups of Antarctic orcas show even greater differentiation.

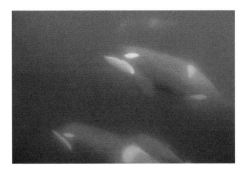

▲ page 131 ORCAS UNDERWATER, McMURDO SOUND

It is always exciting to be in the water with such large, powerful animals. It is also unsettling. Often, when I first entered the water, an orca would swim under me, then assume a head-up posture, obviously regarding me. Sometimes, too, it would blow a bubble ring up at me. This king of the sea was sending me some kind of message, but I had no idea what it meant.

There has never been a documented attack by a wild orca on a human being. Because I knew that these whales were hunting fish, not larger prey, I felt comfortable enough getting in the water with them. In any case, I have found that most large predators—even tiger sharks and great white sharks—are in fact quite cautious about approaching divers too closely. Divers, with their loud bubbles and awkward movements, are probably so alien to these large predators that they are not regarded as food items.

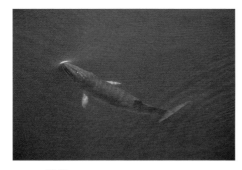

▲ pages 132-33 ANTARCTIC MINKE WHALE NEAR
THE ICE EDGE, MCMURDO SOUND

Antarctic minke whales *(Balaenoptera bonaerensis),* the smallest and most common of the Antarctic baleen whales, are quick to take advantage of the receding ice edge and ship channels. They feed by gulping huge quantities of water and straining the microscopic plants and animals of the plankton with their specialized baleen plates. They can range for miles, seeking patches of krill and plankton under the ice and returning to the ice edge or open cracks to breathe. Minke whales are still hunted in Antarctic waters by the Japanese. I took this photograph from a U.S. Coast Guard Dauphine helicopter on a perfectly still day.

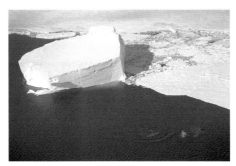

▲ page 133 ICEBERG AND SPOUTING MINKE
WHALES, MCMURDO SOUND

In the summer of 2001 we often saw groups of minke whales swimming, turning together in the water as they swam. We also frequently saw orcas swimming together with minkes.

▲ page 134 MINKE WHALE RESTING IN POOL OF
OPEN WATER, MCMURDO SOUND

Minke whales can swim long distances beneath the ice before needing to surface to find air. If I saw minke whales in a pool of open water far from other air sources, I knew that within one or two days orcas would be appearing as well.

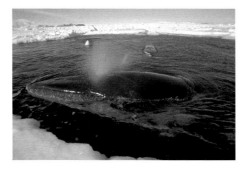

▲ page 135 RESTING MINKE WHALES, MCMURDO
SOUND

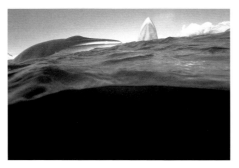

▲ pages 136-37 SPYHOPPING MINKE WHALE,
MCMURDO SOUND

One day in the icebreaker channel we discovered a small pool being used by half a dozen minke whales.

Being in the water with these huge animals was nerve-racking, with visibility less than a meter (3 feet)—not to mention the fact that the whales had to surface occasionally to blow, within mere feet of us. They were either resting or trapped here after having pushed deep into the ice, since the nearest open water was over 3 kilometers (2 miles) away.

I took this photograph with the camera half in and half out of the water.

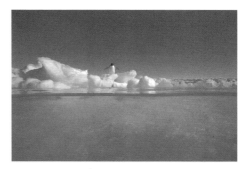

▲ pages 138-39 ADÉLIE PENGUIN ON AN ICE FLOE,
MCMURDO SOUND

From the water off the ice edge, I photographed this Adélie penguin *(Pygoscelis adeliae)* as it stood on a recently separated ice floe, with my camera half in and half out of the water.

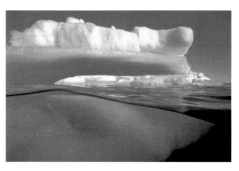

▲ page 140 OVER-UNDER VIEW OF ICE FLOE,
MCMURDO SOUND

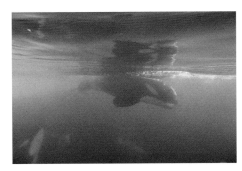

▲ page 141 ORCA WITH GIANT ANTARCTIC COD CARCASS, MCMURDO SOUND

This is a rare photograph. About twenty orcas were resting at the end of a mile-long lead, breathing heavily after having evidently dived deep. As I swam toward them, they maintained a distance from me of about 6 meters (20 feet). The water was green with plankton. From below, an orca approached the surface, and I could see that it had a giant Antarctic cod or toothfish *(Dissostichus mawsoni)* in its mouth. I obtained two still photographs of this orca—probably the only underwater photographs ever taken of a wild orca eating a giant Antarctic toothfish.

The toothfish is the subject of thirty years of study by Art DeVries of the University of Illinois. Weighing up to 100 kilograms (220 pounds), it has glycoprotein compounds in its blood that act as antifreeze. Its close cousin, the Chilean sea bass, is the focus of an intense deep-sea fishery off the coast of Chile, and the two fish are similar in taste and texture. New Zealand is considering a fishery for the giant Antarctic cod—a proposal that has stirred much debate.

▲ pages 142-43 GREASE ICE FREEZING AS SUMMER ENDS, MCMURDO SOUND

As summer ends and temperatures drop, the sea off the ice edge begins to freeze over once again.

ACKNOWLEDGMENTS

Logistical support for my expeditions was provided by the United States Antarctic Program, National Science Foundation. I thank NSF's Office of Polar Programs for their support of my time in Antarctica, particularly Guy Guthridge, Erick Chiang, Dwight Fisher, Nadene Kennedy, and Polly Penhale.

At Raytheon Polar Services, I thank Robin Abbott, Ted Dettmar, Mimi Fujino, Steve Kottmeier, Kevin Moore, Trent Myers, Tom Quinn, Rhonda Rodriguez, Kristin Scott, Buck Tilley, Brett Wilson, and the many dive tenders who helped us in the field. The pilots and staff of Petroleum Helicopters, Inc., and Kenn Borek Air, Ltd., endured my many requests for flights and open doors with good cheer. Thanks to Chris Dean, Richard Dipboye, Barry James, Jack Hawkins, Greg Liebert, John Losure, David Medley, Scott Pentecost, and Henry Perk.

Organizations that deserve applause for their work in Antarctica include the U.S. Air Force, Air Mobility Command (AMC); 109th Tactical Airlift Wing, New York Air National Guard; and the U.S. Coast Guard, including Aviation Polar Operations, Detachments 146 and 149.

Scientists and their crew showed me their work, allowed me to use their camps and fish huts, and welcomed my intrusion during their short work season. Thanks to Bill Baker, Sam Bowser, Randy Davis, Paul Dayton, Art Devries, Lee Fuiman, Bill Hagey, Kevin Hoefling, Markus Horning, Stacy Kim, Liz Kintzing, Gerald Kooyman, Diana Laird, Hunter Lenihan, Adam Marsh, Jim McClintock, Teri McLain, Paul Ponganis, and Terrie Williams.

The following companies have been particularly helpful in my work in Antarctica and elsewhere. I could not do what I've done without their support: Ikelite Underwater Systems, Lowepro USA, Oceanic Products, Pelican Products, and Really Right Stuff. Repro Images in Vienna, Virginia, provided the 70mm duplicate transparencies for the printing of this book. Thanks to Ike Brigham, Bryan Geyer, Jim Graham, Nicole Mummenhoff, Barry Warner, and Jeff Whatley.

My expeditions received support from the following sponsors: A&I Color, Air New Zealand, Dive Discovery Travel, Diving Unlimited International (DUI), Fuji Film, Kodak Professional, Light & Motion, Nikon, Sea and Sea Underwater Photography, Sherwood Scuba, Tiffen, and UR-PRO Color Correction Camera Filters. For the two seasons of filming, the following companies provided equipment and service: Anton/Bauer, Inc.; Backscatter Photo and Video; Camera Tech; Canon USA, Inc.; Fujinon Inc.; Extron Electronics; Light & Motion; Pace Technologies; Sony Electronics; and Sub-Aquatic Repair. Dan Blodgett, Kirk Kreutzig, Chuck Lee, Vincent Pace, LuAnn Teodosio, and Berkley White were particularly helpful.

Thanks also to Bob and Cathy Cranston, Steve Drogin, Patrick Gambuti, Jim Mastro, Michael Parfit, and Dan Walsh. The folks at Thirteen/WNET Nature deserve applause for supporting this first-time filmmaker: Janet Hess, Patty Jacobsen, Fred Kaufman, Bill Murphy, and Janice Young. The staff in my office helped keep things going during my many months away: Kathryn Beliunas, Katy Barber, Andrew Fornasier, Camilla Mann, and Mike Ready.

My wonderful parents, Dr. James and Mei Wu, have always supported me and my wild dreams and deserve acclaim for bringing up a difficult child. My wife, Deanna Mah, deserves kudos for putting up with the same.

The members of my Antarctica teams were instrumental to the success of this project: Peter Brueggeman, Dug Coons, Andy Day, Christian McDonald, Doug Quin, D. J. Roller, and Dale Stokes. A special thanks to Beez Bohner, Kristin Larson, Robbie Score, and Rob Robbins, who helped me navigate treacherous waters.

NORBERT WU

This work draws on the efforts of many scientists from several disciplines, and I am indebted to them all. For their invaluable advice and assistance with the manuscript, I d like particularly to thank Chuck Amsler, Jim Barry, Sid Bosch, Sam Bowser, Paul Dayton, Kristin Larson, Jim McClintock, and Diane Stoecker. I also extend special thanks to Peter Brueggeman, librarian at the Scripps Institution of Oceanography, for his unflagging assistance with research and for his tremendous efforts in establishing a comprehensive taxonomic database and field guide for Antarctic marine organisms.

JIM MASTRO

GLOSSARY

ADSORPTION

The process of adhesion of a molecule of gas, liquid, or dissolved substance to a surface.

ADVECTION

Vertical or horizontal movement of a mass of seawater, as in a current.

AMPHIPOD

Member of the order Amphipoda. Small crustacean, generally characterized by a laterally flattened body.

ANAEROBIC METABOLISM

Metabolism that takes place in the absence of oxygen.

ASCIDIAN

Member of the phylum Chordata, class Ascidiacea. Filter-feeding marine animal characterized by a saclike body and a tough outer covering, or tunic. Also called sea squirt or tunicate.

ASTEROID

Star-shaped animal in the phylum Echinodermata, class Asteroidea—sea star.

AUTOTROPHIC

Term describing living organisms that produce their own energy supplies, such as algae.

BALEEN

The horny material that grows from the upper jaws of whales in the order Mysticeti. The whales use the comblike structure of baleen like a sieve to filter plankton and small nekton from the seawater.

BENTHIC

Of or pertaining to the benthos or, more generally, to the animal community of the sea floor.

BENTHOS

The conglomeration of organisms that live on or in or are associated with the sea floor.

BIVALVE

Mollusc with two separate but articulated shells, such as a clam or scallop.

BRACHIOPOD

Member of the phylum Brachiopoda, characterized by hinged upper and lower shells and armlike appendages with tentacles used for guiding food to the mouth.

BRYOZOAN

Member of the phylum Bryozoa. Colonial marine animal that forms branching or encrusting colonies and reproduces by budding.

CALCAREOUS

Composed of or containing calcium carbonate or calcium, such as the shell of a mollusc.

CAUDAL

Pertaining to the tail region.

CEPHALOPOD

Member of the phylum Mollusca, subphylum Cephalopoda. Includes squids, octopuses, and cuttlefish.

CILIA

Hairlike appendages used for locomotion or to propel material across tissue surfaces.

CNIDARIAN

Member of the phylum Cnidaria (jellyfish, sea anemones, hydroids, and corals). Soft-bodied, invertebrate animal characterized by stinging cells (nematocysts) and a single opening for ingesting food and eliminating waste.

COELEMIC

Pertaining to the coelum, or main body cavity of most higher animals, in which the viscera are located.

COMMENSAL

Referring to an organism involved in a symbiotic relationship with another species in which one of the species benefits and the other is not harmed by the arrangement.

COPEPOD

Small crustacean in the class Copepoda. Copepods browse the plankton and are a key link in the food chain.

CRINOID

Member of the phylum Echinodermata, class Crinoidea. Flower-shaped, suspension-feeding relative of sea urchins and sea stars. Also called a sea lily.

CRYOPHILIC

Cold loving.

CTENOPHORE

Member of the phylum Ctenophora. Soft-bodied, jellylike marine organism that propels itself through the water by means of rows of cilia.

CYTOTOXIC

Poisonous to cells.

DEMERSAL

Living on or close to the bottom of the sea.

DIATOM

Microscopic, autotrophic algal organism contained within a characteristic two-part box of silicon dioxide. All diatoms are members of the class Bacillariophyceae.

DIATOMACEOUS
Pertaining to diatoms.

ECHINODERM
Member of the phylum Echinodermata, characterized by a hard, spiny skeleton, a radial body pattern, and a water vascular system. Includes sea stars, brittle stars, sea urchins, sea cucumbers, and sea lilies.

ECHINOID
Sea urchin.

ECTOTHERM
Organism characterized by an inability to control internal body temperature by physiological means, so that body temperature varies with the environment. Ectothermic organisms typically can tolerate a wide range of body temperature.

ENDEMIC
Native to a particular region; i.e., having evolved in that region and not elsewhere.

EPIBENTHIC
Refers to meiofauna living at the sediment-water interface.

EPIFAUNA
The benthic organisms that live on or move over sediment, rock, or another substrate surface.

EPIZOOITE
An organism, parasitic or commensal, that lives on the outer surface of another organism.

EUPHAUSIID
Shrimplike, free-swimming crustacean. Member of the phylum Arthropoda, class Malcostraca, order Euphausiacea. Also called krill.

EUTROPHIC
Nutrient rich.

FLABELLIFERAN ISOPOD
Member of the arthropod order Isopoda, suborder Flabellifera. Small marine or freshwater crustacean generally characterized by large, well-developed eyes and robust mouthparts.

FLAGELLATE
Single-celled organism endowed with one or more whiplike appendages called flagella, used for propulsion through water.

FORAMINIFERAN
Protistan member of the order Foraminiferida. Single-celled marine organism typically characterized by a calcareous or agglutinated shell with tiny holes, through which slender cytoplasmic appendages called pseudopoda are extruded to gather food.

GYRE
Circular ocean current.

HETEROTROPHIC
Referring to organisms that do not produce their own energy supplies but must procure them by consuming others.

HEXACTINELLID SPONGE
Member of the class Hexactinellida, characterized by the production of an internal skeleton composed of six-rayed siliceous spicules. Hexactinellids are also called glass sponges.

HOMEOTHERM
Organism able to maintain internal body temperature within a very narrow range by physiological means. Typically, maintenance of temperature within that narrow range is necessary for survival.

HYDROID
Member of the phylum Cnidaria, order Hydroida. Small, suspension-feeding, polyp-like marine animal.

HYPO-OSMOTIC
A condition wherein the body fluids of an organism are less salty or have a lower concentration of dissolved material than the surrounding environment.

INFAUNAL
Pertaining to organisms that live in or burrow through the sediment on the sea floor.

ISO-OSMOTIC
A condition wherein the body fluids of an organism have the same salt or solute concentration as the surrounding environment.

ISOPOD
Member of the order Isopoda. Small crustacean typically characterized by a flat, oval body and seven pairs of walking legs, each pair attached to a segment of the thorax.

KATABATIC
Term describing winds generated by gravity. Cooler air is denser (and therefore heavier) and will naturally flow downhill.

KRILL
See euphausiid.

LAMELLARIAN GASTROPOD
Member of the phylum Mollusca, class Gastropoda, family Velutinidae (formerly Lamellariidae). Characterized by a single small, thin shell that is partially or completely enveloped by a ridged or wartlike mantle.

MACROFAUNA
Benthic organisms that are larger than 1 millimeter.

MEDUSA
Organism with a cup-shaped body form and tentacles lining the perimeter of the cup—jellyfish.

MEIOFAUNA
Bottom-dwelling organisms between 62 micrometers and 0.5 millimeter in size. These organisms typically live and move about between the grains of bottom sediment and are therefore also called interstitial fauna.

MESOPELAGIC
Referring to the zone of permanently dark open ocean between 200 and about 1,000 meters' depth, or to animals that live in this zone.

METABOLITE
Any chemical compound produced by or involved in metabolic processes.

MORPHOMETRIC
Referring to the measurement and statistical analysis of size, shape, and form.

MOTILE
Able to move about.

NEMATOCYST

Stinging cell characteristic of all cnidarians.

NITRIFICATION

A form of primary production wherein bacteria oxidize nitrogen-containing molecules (especially ammonium) to derive energy. The energy is used to produce organic molecules that are incorporated into cellular material.

NOTOTHENIOID

A fish in the order Perciformes, suborder Notothenioidei, characterized by a large head, mouth, and pectoral fins; the absence of a swim bladder; and, in most species, the presence of antifreeze molecules in the blood and tissues.

NUDIBRANCH

Shell-less gastropod, or sea slug.

OLIGOTROPHIC

Nutrient poor.

OSCULUM

A large opening in the body wall of a sponge. Water is pulled in through small pores in the body wall by the action of cilia, filtered for food particles, then passed out through the osculum (or oscula).

PARASITIC

Referring to an organism that lives in or on a member of another species and either eats the host's tissues or appropriates some of the host's food, to the benefit of the parasite and the detriment of the host.

PELAGIC

Pertaining to the open waters of the ocean.

PENNATE

Wing shaped.

PHYLOGENETIC

Pertaining to the evolutionary development of species.

PINNIPED

Refers to members of the order Pinnipedia (seals, sea lions, and walruses).

PISCIVOROUS

Fish-eating.

PLANKTER

Planktonic organism.

PLANKTON

All drifting or free-floating organisms whose large-scale vertical and horizontal movements are dictated by water motion.

POLYCHAETE

Annelid (segmented) worm characterized by a pair of bristled, leglike appendages on most segments.

POLYNYA

Area of open water surrounded by ice.

PRIMARY PRODUCTION

The process whereby autotrophic organisms capture energy from the sun or from inorganic chemicals and store it in organic compounds that the organisms produce.

PROTISTAN

Member of the kingdom Protista. Single-celled organism with a nucleus, such as an amoeba or foraminiferan.

PTEROPOD

Free-swimming, thin-shelled or shell-less gastropod mollusc with winglike lobes on the foot.

PYCNOGONID

Member of the phylum Arthropoda, subphylum Chelicerata, class Pycnogonida. Sea spider.

PYGOSCELID

Referring to the three "brush-tailed" penguin species—Adélie, chinstrap, and gentoo.

ROSSELLID

Pertaining to a sponge in the family Rossellidae. Typically cuplike or sac-shaped, and often attached to the substrate with a stalk.

SCYPHOMEDUSA

True jellyfish.

SECONDARY METABOLITE

A metabolite that is not required for any primary metabolic process, such as respiration or photosynthesis.

SESSILE

Affixed to the substrate and unable to move about by its own devices.

SILICEOUS

Composed of silicon.

SKUA

Gull-like, predatory marine bird.

SPICULE

Six-rayed shard of silicon dioxide produced by glass sponges to provide internal structure and sometimes defend against predation.

SYMPAGIC

Living in or closely associated with ice.

TANAID

Member of the phylum Arthropoda, class Malocostraca, order Tanaidacea. Small crustacean.

TAXON (PL. TAXA)

A taxonomic category.

TUNICATE

See ascidian.

ZONATION

Prominent horizontal bands occupied by different organisms or organismal assemblages.

ZOOXANTHELLAE

Autotrophic single-celled organisms that dwell symbiotically in the tissues of other marine organisms.

INDEX

ABOUT THE AUTHORS

NORBERT WU is an independent photographer and filmmaker who specializes in marine issues. His writing and photography have appeared in thousands of books, films, and magazines, including feature articles in *Audubon, Le Figaro, GEO, International Wildlife, National Geographic,* and *Omni,* and on the covers of *GEO, Natural History, Time,* and *Terre Sauvage.* He is the author and photographer of sixteen books on wildlife and photography and the originator and photographer for several children's book series on the oceans. Exhibits of his work have been shown at the American Museum of Natural History, the California Academy of Sciences, the National Academy of Sciences, and the National Museum of Wildlife Art. His background includes degrees in electrical and mechanical engineering from Stanford University and doctoral studies at the Scripps Institution of Oceanography.

He was awarded National Science Foundation (NSF) Artists and Writers Grants to document wildlife and research in Antarctica in 1997, 1999, and 2000. In 2000, he was awarded the Antarctica Service Medal of the United States of America "for his contributions to exploration and science in the U.S. Antarctic Program." His recent films include a high-definition television (HDTV) program on Antarctica's underwater world for WNET/Thirteen New York's *Nature* series, which airs on PBS. In 1999, he was awarded a Pew Marine Conservation Fellowship, the world's only prize dedicated to marine conservation. Through 2003 he used this grant to document, in stills and high-definition video, the world's most unique and threatened underwater habitats. He was named Outstanding Photographer of the Year for 2004 by the North American Nature Photographers Association (NANPA), the highest honor an American nature photographer can be awarded by his or her peers.

JIM MASTRO holds a bachelor of science degree in zoology from San Diego State University and a master's degree in English from the University of New Hampshire. Over the years, he has worked as a seal trainer, a fisheries biologist studying the tuna-porpoise problem, and a field biologist studying seal physiology and behavior. Jim first went to Antarctica in 1982 and ended up spending nearly six years at the bottom of the Earth, first as a biology laboratory manager, then as a researcher, and finally as the diving coordinator for the U.S. Antarctic Program. During that time he made 250 dives under the ice. His photography and writing career began in 1978, and since then his work has appeared in numerous books and magazines, including *International Wildlife, The Sciences, GEO, Discover, Skin Diver, and Lonely Planet Antarctica.* His photo memoir is titled *Antarctica: A Year at the Bottom of the World.*

DESIGN & COMPOSITION: Nicole Hayward
TEXT: 9/12 Adobe Garamond
DISPLAY: Bauer Bodoni
CARTOGRAPHY: Pease Press, San Francisco
INDEX: Ellen Davenport
PRINTING & BINDING: CS Graphics, Singapore